The Artistic
Touch 3

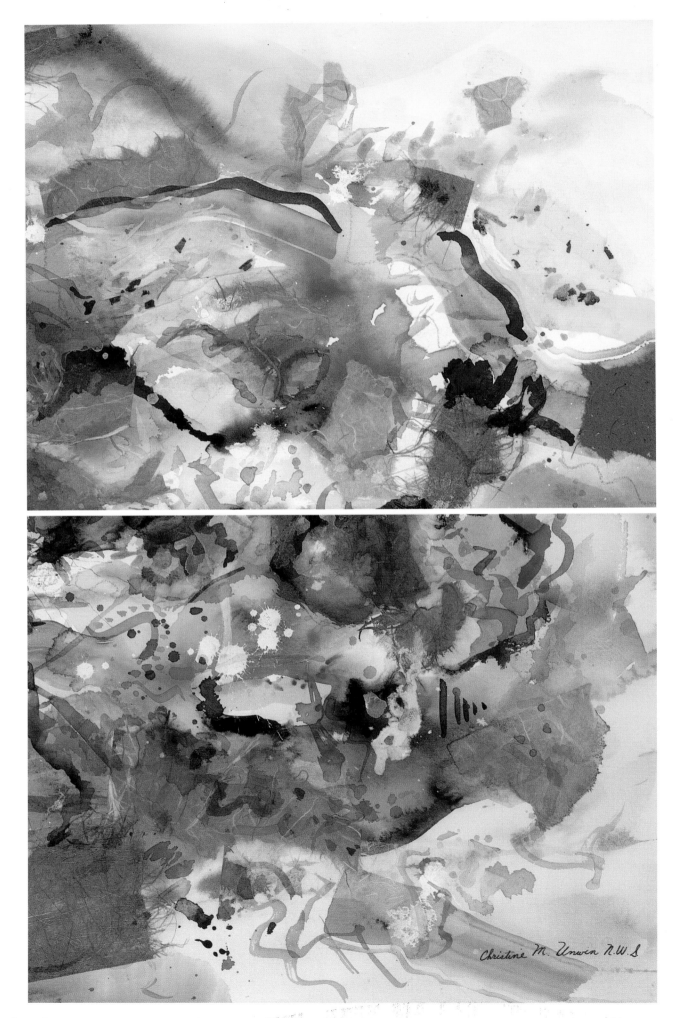

Christine M. Unwin, NWS *Maui Memory* **30" x 44" Watercolor**

The Artistic Touch 3

By Christine M. Unwin, NWS

Best wishes!
Chris Unwin, NWS

Creative Art Press

West Bloomfield, Michigan

Acknowledgments

I wish to thank my husband, Don, who spends countless hours inputting all of the artists' work into the computer and initially edits the written comments. It is Don who is totally left-brained. He organizes my madness and helps to keep me focused. His "artistic eye" is greatly appreciated. Truly he is "the wind beneath my wings."

I also wish to thank Jack Sanecki who edits the final manuscript. Jack, I am forever indebted to you. Thanks go also to Christel Sanecki, Jack's wife, for her valuable insights into the making of this book.

Lastly, I would like to thank all the contributing artists for sharing with me their most treasured paintings.

Now, lets push on and enjoy the show!

The Artistic Touch 3

Copyright © 1999 by Creative Art Press

ISBN 0-9642712-4-9
Library of Congress Catalog Card Number 98-94783

Cataloging data for this book is available from the Library of Congress

Printed in Hong Kong

First Edition, 1999

Table Of Contents

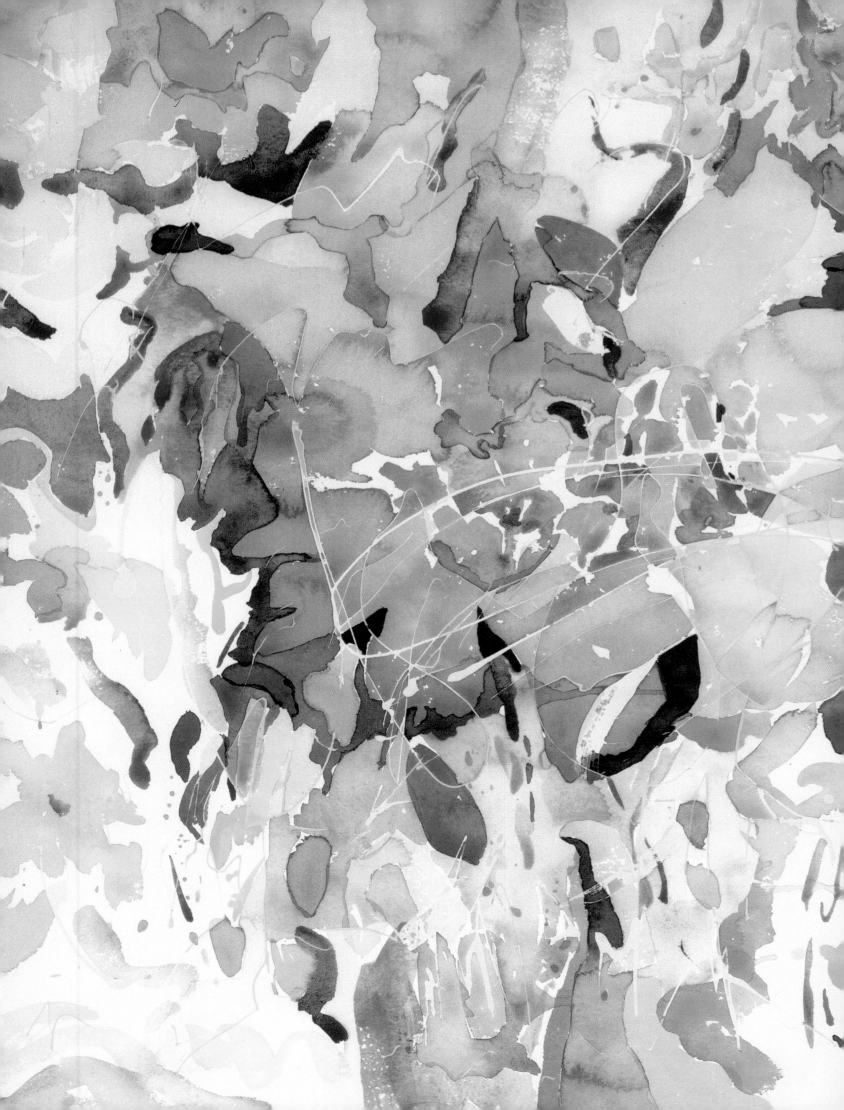

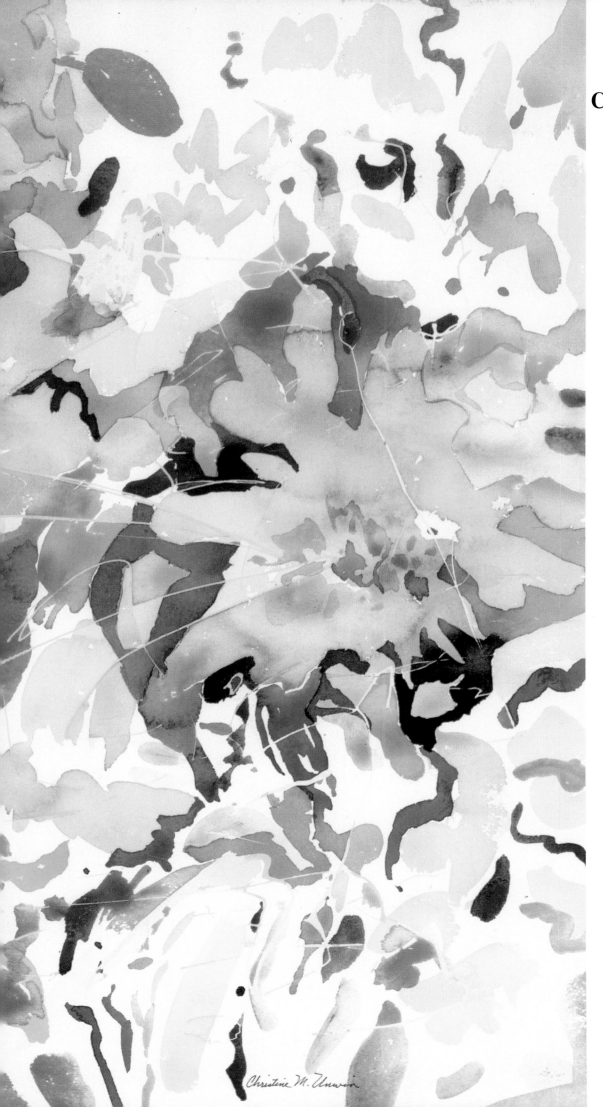

Christine M. Unwin

Christine M. Unwin, NWS

Peonies 22" x 30"

Watercolor

I started this painting the same way that I started ***Dinosaurs***. I put on some lively music and began drizzling rubber cement around the page. Elmer's Glue™ or maskoid can be substituted for the rubber cement. Often I collage on pieces of rice paper, and add salt, alcohol, white ink, black ink or whatever I have on hand. This is the playful part of the painting. Next comes the thinking part. In this case, I really did not have a subject in mind. But after the initial wash, the peonies which were blooming in my yard influenced me. I think we are all subtly influenced by our surroundings. An important goal in this painting was to make sure I used a variety of brush strokes. Here's where my No. 20 round brush came in handy. I started with it and then worked my way down to a No. 12 Chinese wolf-hair brush, a No. 5 western brush and finally a rigger or lettering brush.

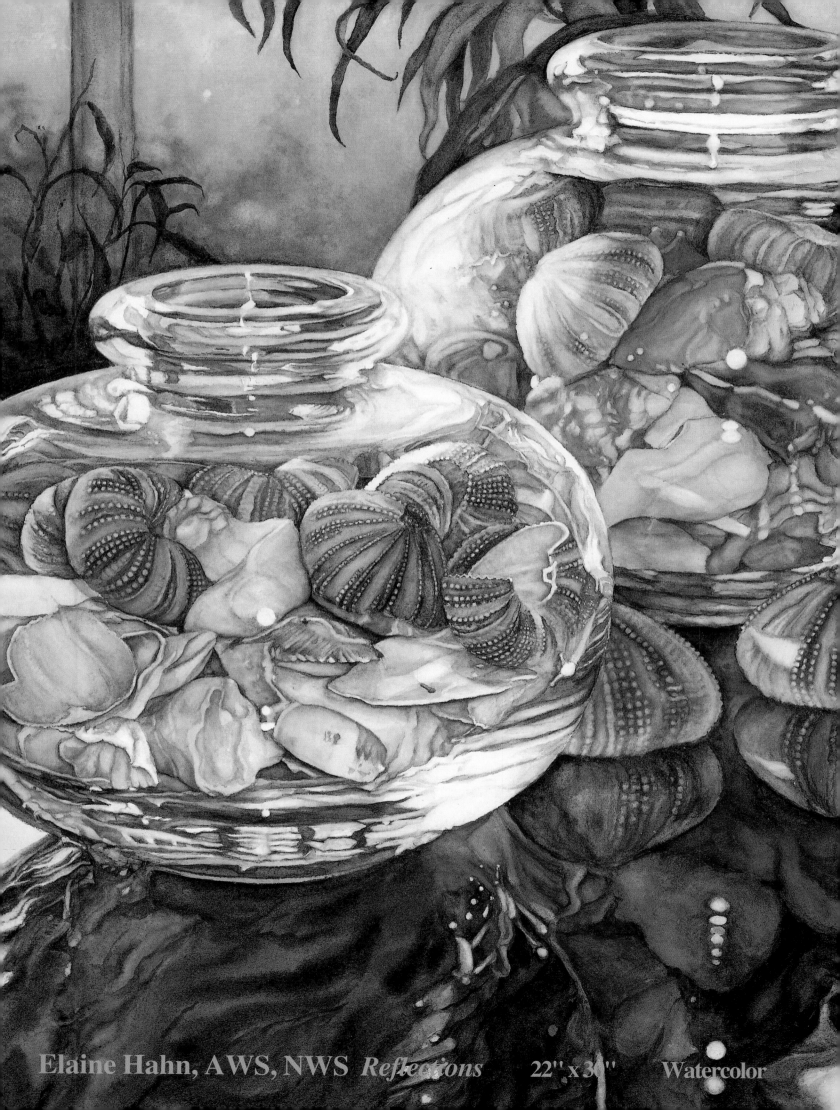

Elaine Hahn, AWS, NWS *Reflections* 22" x 30" Watercolor

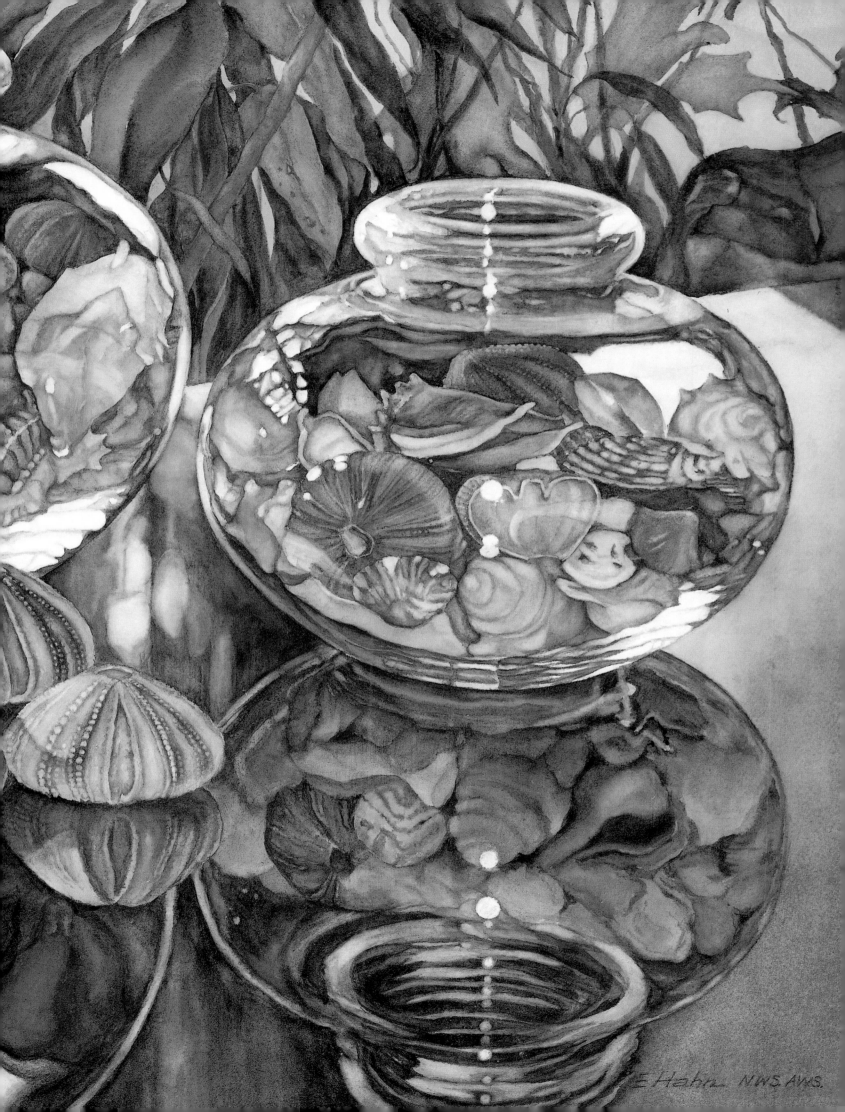

INTRODUCTION

Once again, selecting the finalist paintings which appear in the *Artistic Touch Series* proved to be a fascinating — and exhausting — challenge. Because there are so many fine artists who sent us paintings for consideration, we ended up with space for only a fraction of the number submitted. We feel these are among the very best.

As artists, we struggle to define ourselves through our work. As we grow and change, so too, does our work. Sometimes people even encourage us *not* to change. But change we must! Our minds usually are racing far ahead of what we may be working on. After all, the most exciting painting is the one in our heads — the *next* painting.

What artists have to say about their work often is illuminating and even inspirational. For some of us who are temporarily adrift or plateauing, the artists' observations in this book may offer direction, affirmation and a nudge of encouragement to grow. Sometimes growing as a painter means one step forward and three steps back, even retreating to what formulated an earlier success — a very comfortable place to be. Though it can be scary to venture forward into fresh uncharted territory, we must do so. Otherwise, we can become bored and deadlocked in our work and we all agree that we *Must Never Be Boring*! I hope **The Artistic Touch 3** helps jump-start your engines and spurs you on to create new pieces of Art.

Chris Unwin, NWS

Still Life

After studying the peppers, I cut them into pieces and divided them into blocks so that each would work as an individual painting.

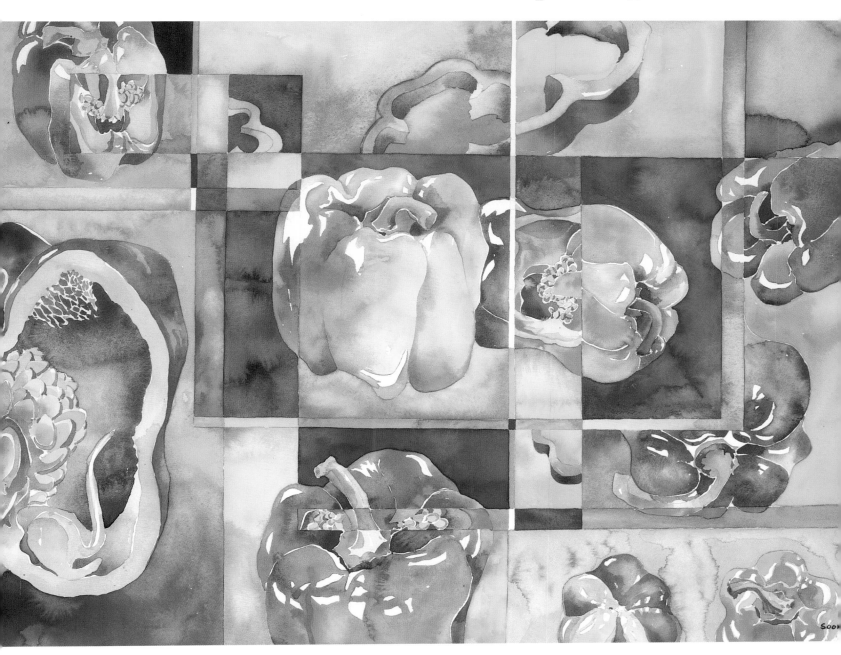

Sook-Kyung Hong *Peppers II* **20" x 28"** **Watercolor**

I always have liked the shape of peppers. After studying the peppers, I cut them into pieces and divided them into blocks so that each would work as an individual painting. Bright colors make the vegetables sculpture-like. I used masking tape to give the painting a clean edge.

11

. . . the large colander shadow was the dominant feature.

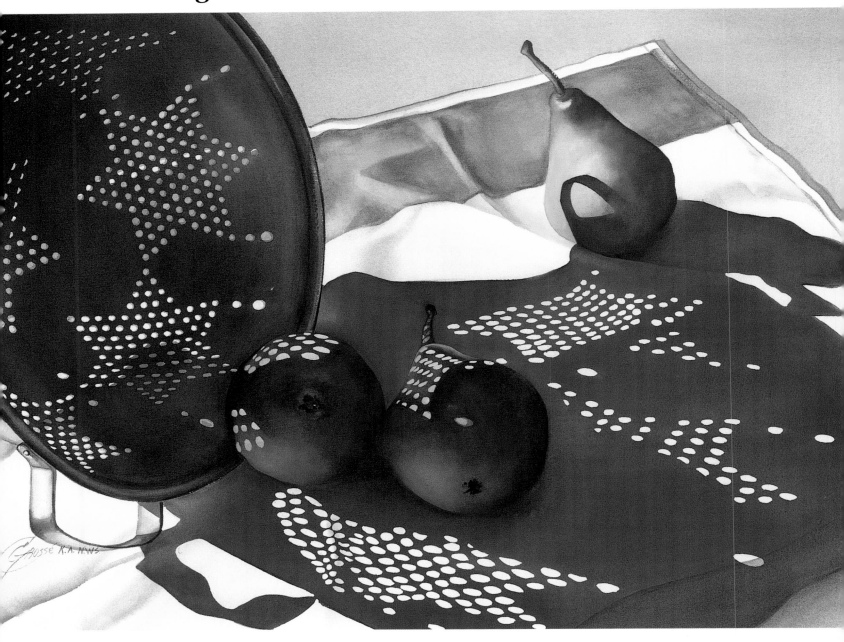

Carolyn Grossé Gawarecki, NWS *Starred Pears* 21"x 28" Watercolor

Starred Pears, which became a prize-winning watercolor, actually developed accidentally. I had purchased some red Bartlett pears for a picnic lunch. Their deep red and orange colors were so beautiful I took them outdoors and photographed them before I left on my trip. When I saw the elongated pear shadows cast by the early morning sun, I returned to my kitchen to look for a few interesting props and picked up the colander from the sink and a tea towel from the towel rack. I then was able to arrange this fascinating still-life with the light from the holes in the colander creating star patterns which curve over the pears and undulate across the towel. Then I went on the picnic and ate the pears.

Later, when I decided to paint the pears, I realized, after making a few color sketches, that the large colander shadow was the dominant feature. Because I wanted to paint the shadow a rich transparent blue-violet, I altered the real color of the pears from red to the complement of blue. The holes in the colander and the shadow were masked out and a line of liquid mask was brushed around the outside edges of the shadow. I then painted the pears yellow. The big colander shadow was painted rapidly with a two-inch brush, with the paper held vertically so the paint would flow and blend smoothly. Reflected lights were lifted from the pears before the shadow dried to give them a glow. After the mask was removed from the shadow edge, I painted the colander and the towel. When everything was dry, the mask was removed from all the holes and, like magic, the dots of light created star patterns across the painting. More yellow was then applied to the holes on the pears. I keep *Starred Pears* in my private collection as a personal reminder that you never know what will stimulate that next watercolor.

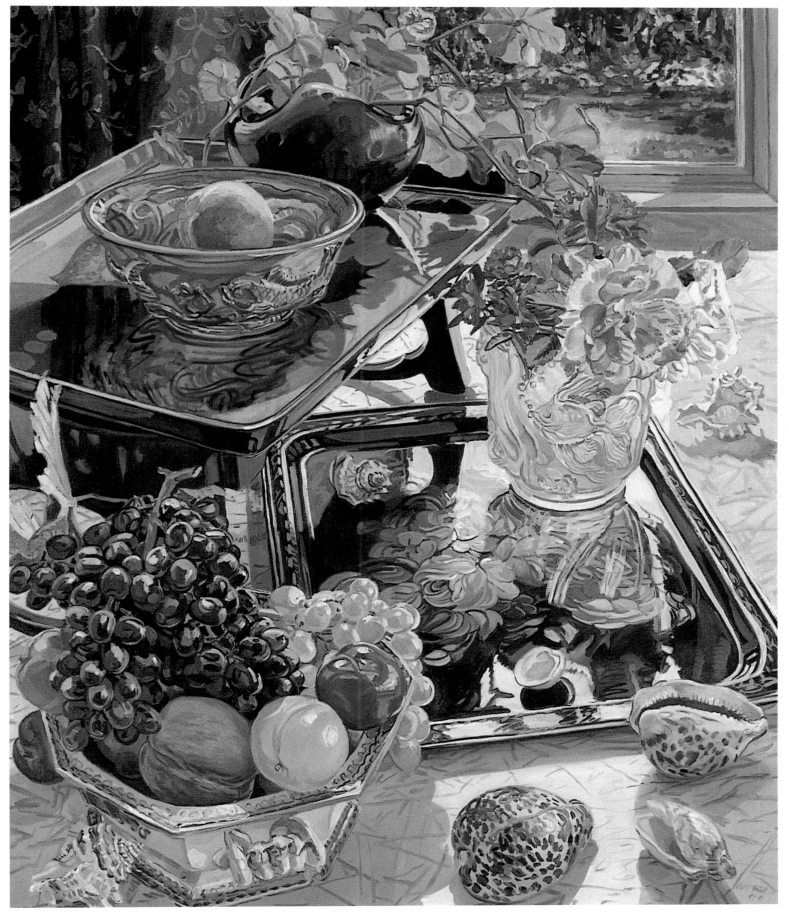

Janet Fish *Fish Vase* **48" x 60"** **Oil on canvas**

Patricia Abraham, MWS *Still Life with Striped Cloth* 22" x 30" Watercolor

Inspired by the simple yet visually appealing design, I began putting stripes in my paintings in 1975. Stripes allow me to design interesting patterns and exploit the flow of the lines. In *Still Life with Striped Cloth,* I'm intrigued with the geometric shapes in my grid pattern, as well as the spacial interplay of fruits and vegetables. For example: the placement of round objects in three, but not all four corners. I also played with numbers, for example 1, 2 and 3 objects of the same kind but never 4. Finally, the dancing of the stripes in and about these shapes creates a lyrical harmony.

I'm glad this painting has a home in Santa Fe.

Christine M. Unwin, NWS *Cathy's Vegetables, Santa Fe* 20" x 30" Watercolor

 I started this painting in my Santa Fe workshop last year. My sister Cathy, who lives in Santa Fe, saw it and asked me to give it to her for a wedding present. Cathy and John were married in August, and I finished the painting just in the nick of time.

 In teaching my workshop I stress the importance of patterns and specific details to increasé interest, to suggest a mood and give the viewer a better idea of where the painting was done. I'm glad this painting has a home in Santa Fe.

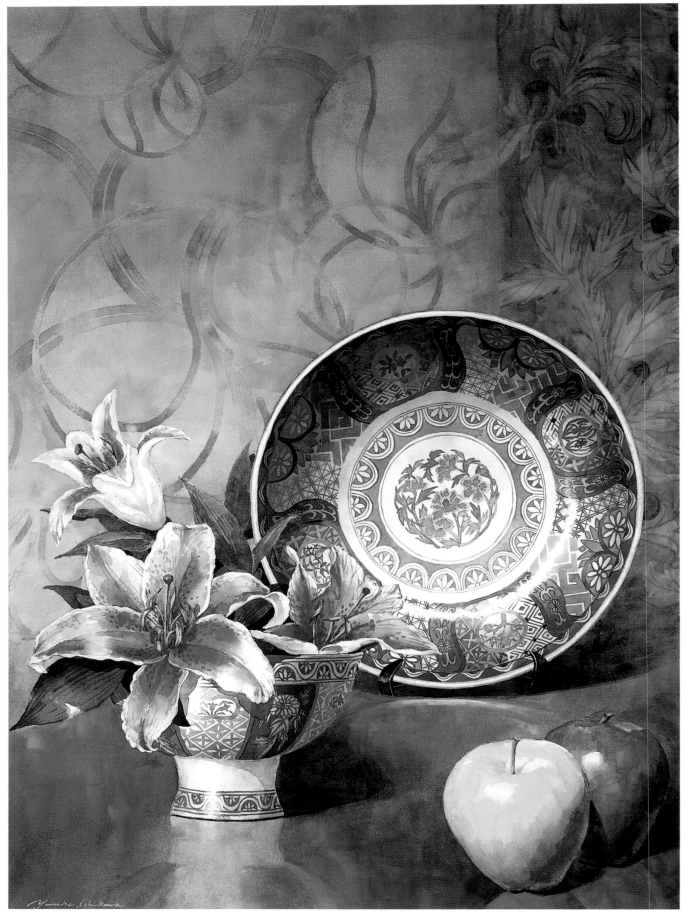

Yumiko Ichikawa *Imari & Lilies* 21" x 29" Watercolor

I like to use decorative and colorful patterns to infuse my representational paintings with brightness and liveliness. In this painting, I was attracted by the delicacy of the Imari ceramics and the colorful patterns in the fabrics. I used a fine Japanese brush to depict the detail. The layering of transparent watercolors creates the vibrant color effects.

I painted four versions of the same bowl of apples, each with a different background, for a class demonstration.

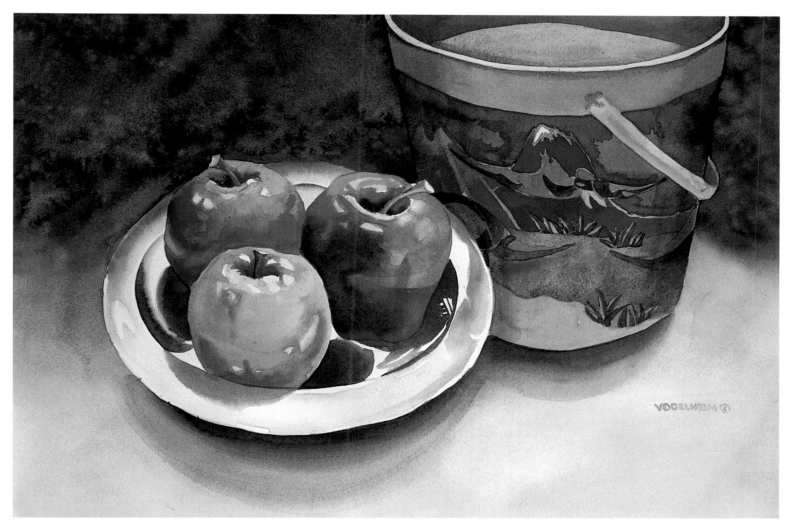

Donna Vogelheim, NWS *Pterodactyl Apples* 15" x 21" Watercolor

I painted four versions of the same bowl of apples, each with a different background, for a class demonstration. This was the most humorous attempt. An old peanut butter pail used for rinsing brushes set the tone. This painting was purchased by singer Aretha Franklin.

*There is a certain spirituality in taking time to talk
and to listen to others, and to share as tea is sipped.*

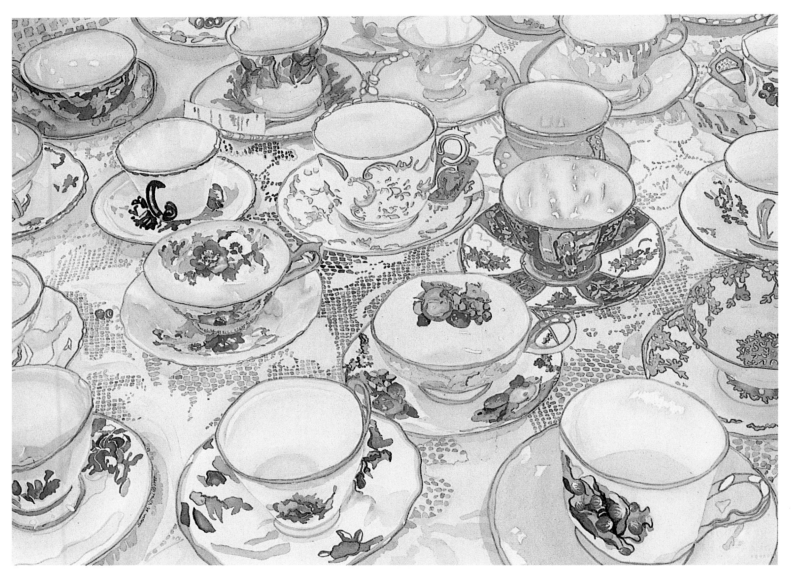

Susan M. Vitali *High Tea* 22" x 30" Watercolor

So often in today's world we rush through life trying to find the quickest, easiest way possible to get things done. ***High Tea*** is about taking time to stop, sitting down with good company and savoring the moment. There is a certain spirituality in taking time to talk and to listen to others, and to share as tea is sipped. The subject is classic: dainty tea cups of all shapes and sizes set upon a lace tablecloth. Does it remind you of your own grandmother, mother or aunt? Do you experience a warm feeling as you recall tea parties from the past? If so, I've accomplished my goal. Have tea with a friend today!

I also like to use the reflections of glass in my work.

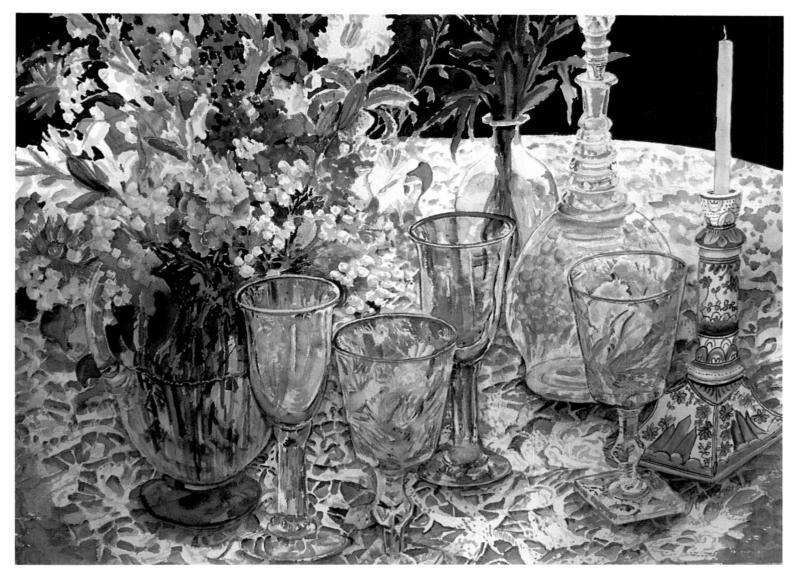

Audrey Sanders Ratterman *Glass & Lace* **32" x 40" Watercolor**

I emphasize color when painting gardens, flowers and patterns. I also like to use the reflections of glass in my work. The more intricate the subject, the better the challenge.

What drew me to this subject was the strong light source that emphasizes the monochromatic shadow effect.

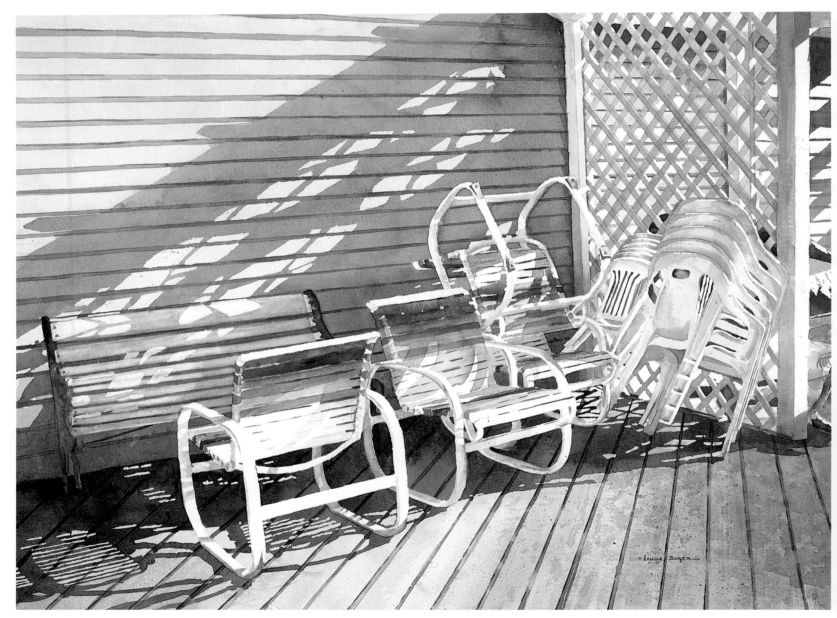

Linda Baker *Coming & Going* **22" x 30"** **Watercolor**

What drew me to this subject was the strong light source that emphasizes the monochromatic shadow effect. I used splashes of primary colors to bring the painting to life and give it drama.

. . . the challenge of the blinds and the highlights on the glass and porcelain make it necessary to use a masking fluid.

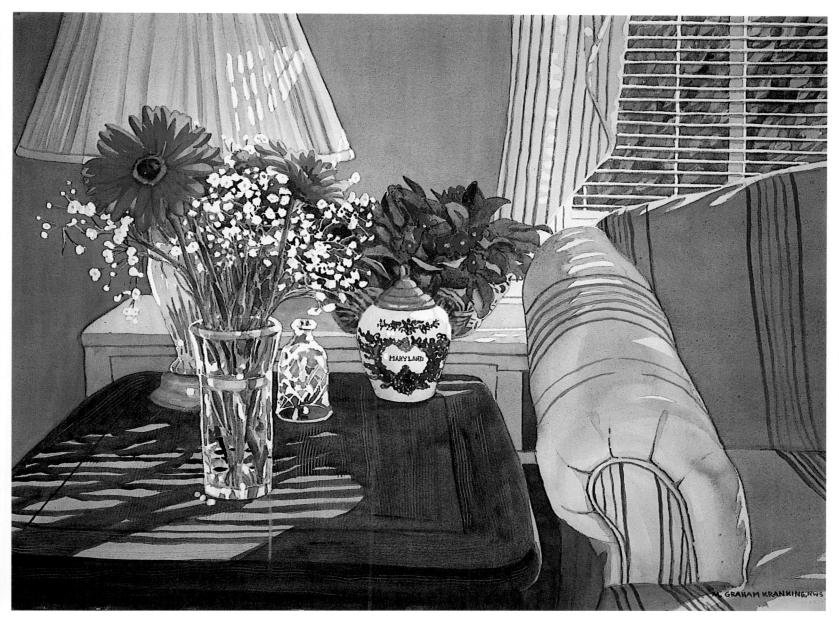

Margaret Kranking, NWS, MWS *Morning Light, Charleston* 22" x 30" Watercolor

When I chance upon a moment of spectacular light effects, I can't contain my excitement. One morning, a corner of my son's home in Charleston, South Carolina, provided just this sort of moment. The early sunlight streaming through the blinds produced a luminous glow on the walls, fabric, and glass and threw fantastic shadows on the wood and lampshade, jump-starting my creativity!

Although I prefer to create whites negatively, the challenge of the blinds and the highlights on the glass and porcelain make it necessary to use a masking fluid. The glow on wood, wall, and fabric is a result of a series of glazes.

Morning Light, Charleston is my favorite type of composition. Light-filled scenes occur naturally in everyday life. They are casual in arrangement and can be found in the corners of my home, my friends' homes, and in familiar shops and inns.

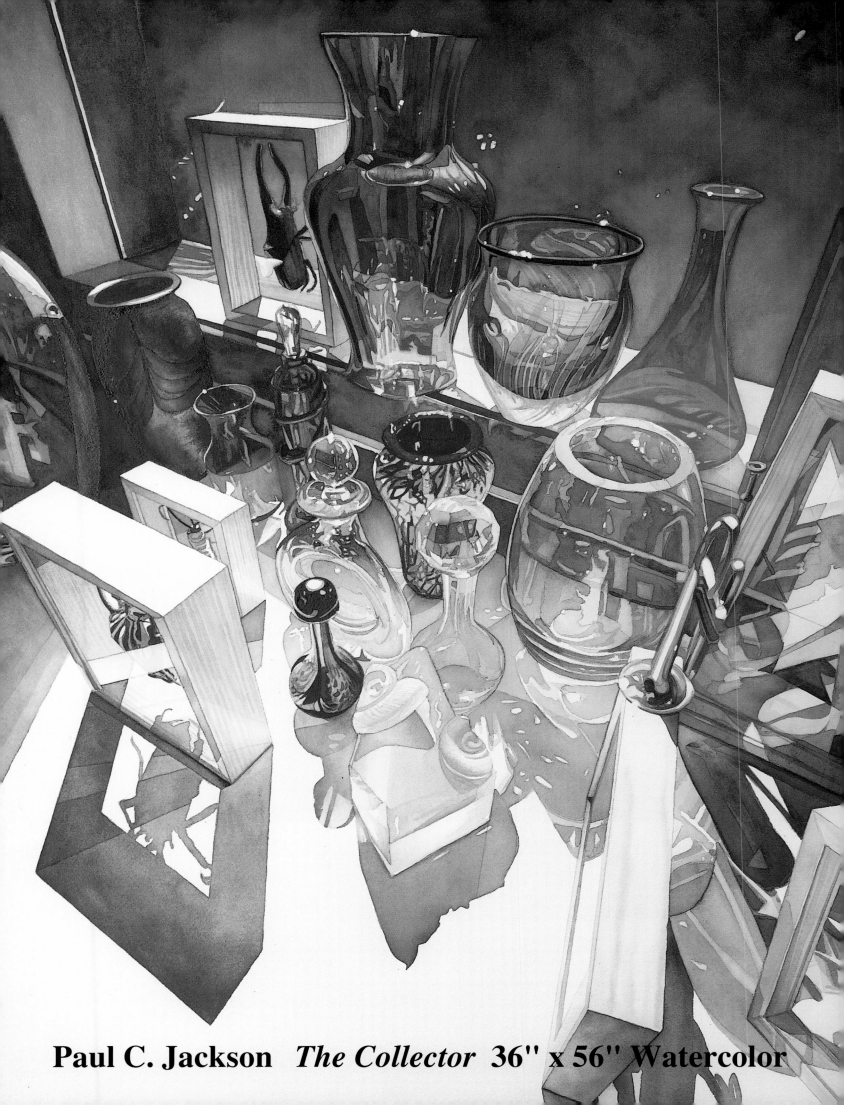

Paul C. Jackson *The Collector* 36" x 56" Watercolor

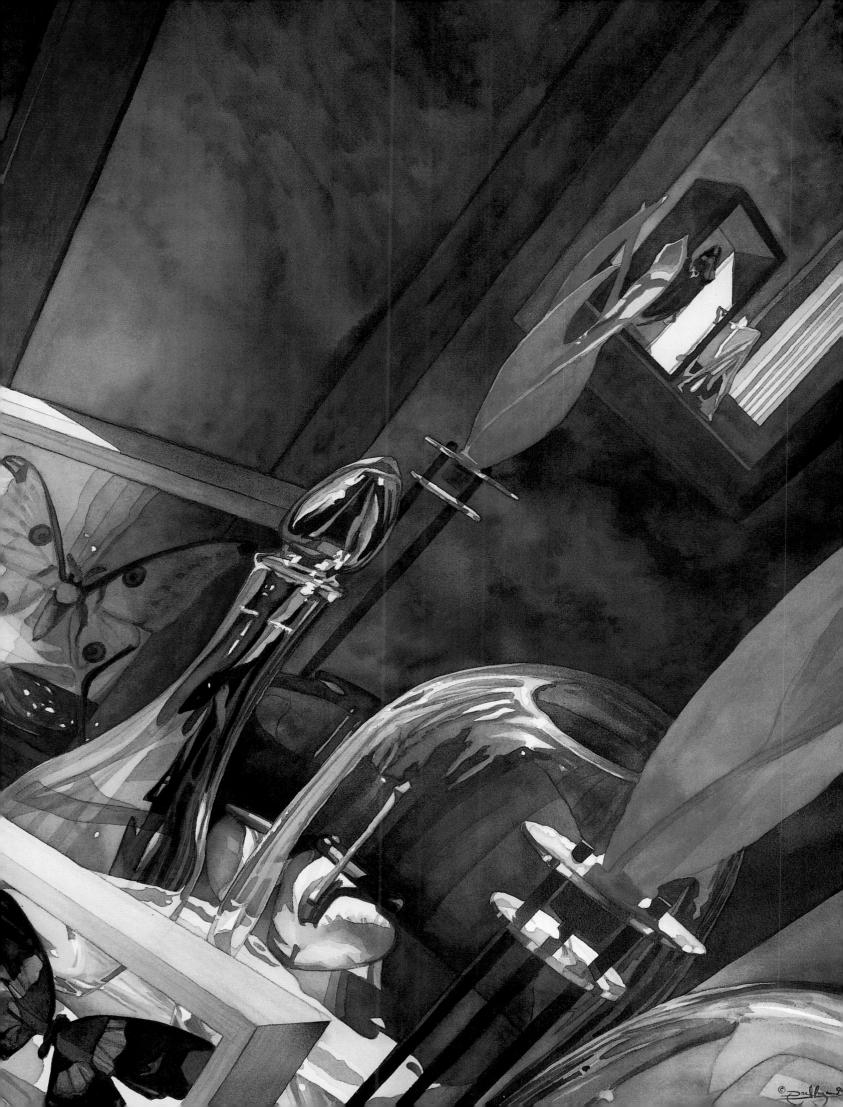

The transparency of the overlapping bottle images was achieved with inks, watercolors and glazings.

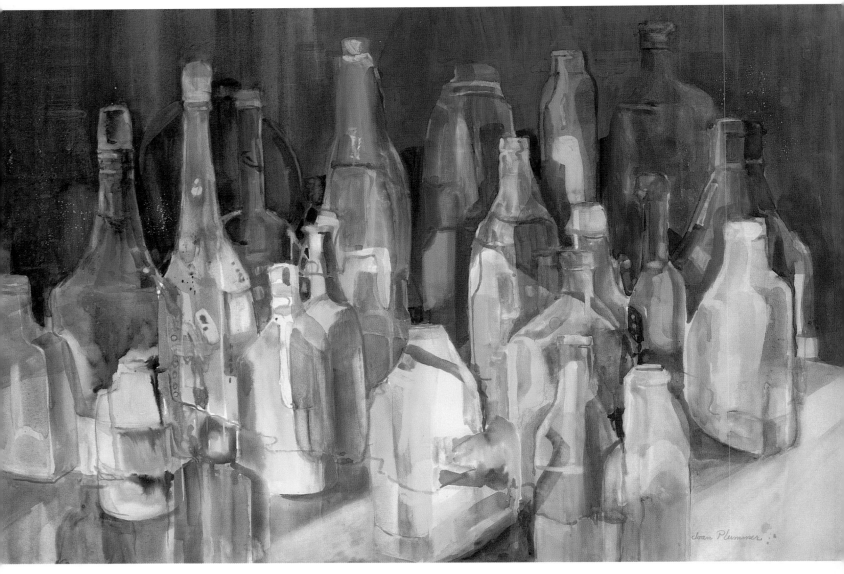

Joan Plummer *Frangible Lights* 20" x 30" Mixed Water Media

Frangible Lights was originally a workshop demonstration to show my students how to combine mixed media effectively. The transparency of the overlapping bottle images was achieved with inks, watercolors and glazings. Gouache near the focal area heightened color richness.

I used calligraphy for edge definition as well as articulating movement through the composition. Later in the studio, I further refined some areas to emphasize the light passing through the various glass shapes.

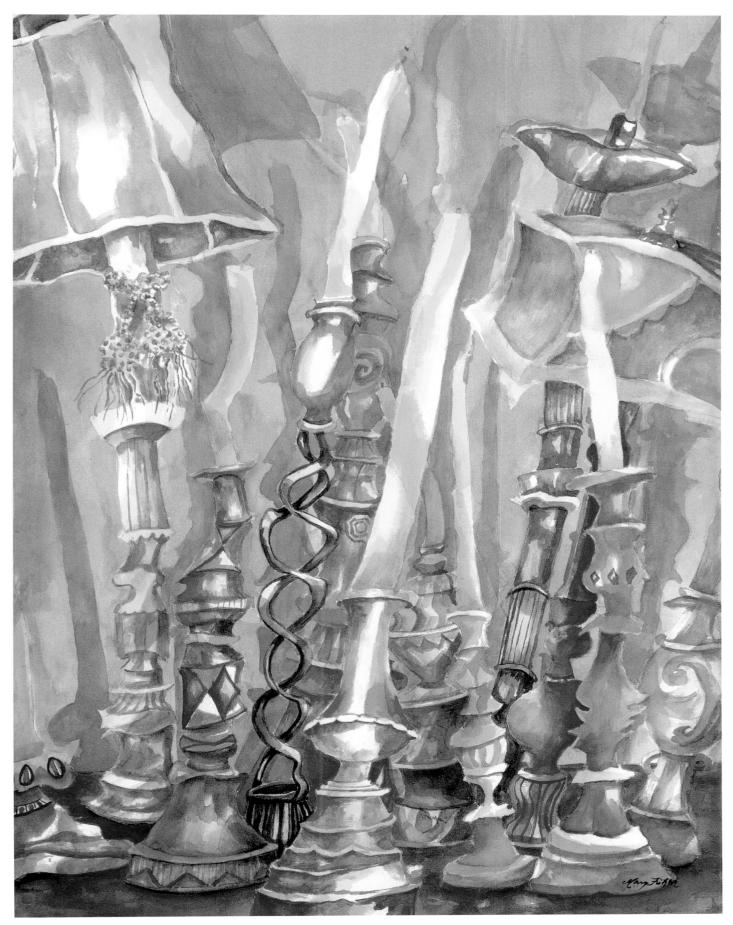

Mary Elizabeth Fisher *Light Up Your Life* 22" x 30" Watercolor

I composed *Light Up Your Life* while wandering around in a friend's home, collecting candlesticks, candles and lamps found in different rooms into one composition but without physically moving anything. The shapes and the distortion of these shapes sets the mood and builds tension. The colors give the painting a glow and a feeling of warmth.

From my studio window, I watched all the colors of my palette dancing around in those "whites."

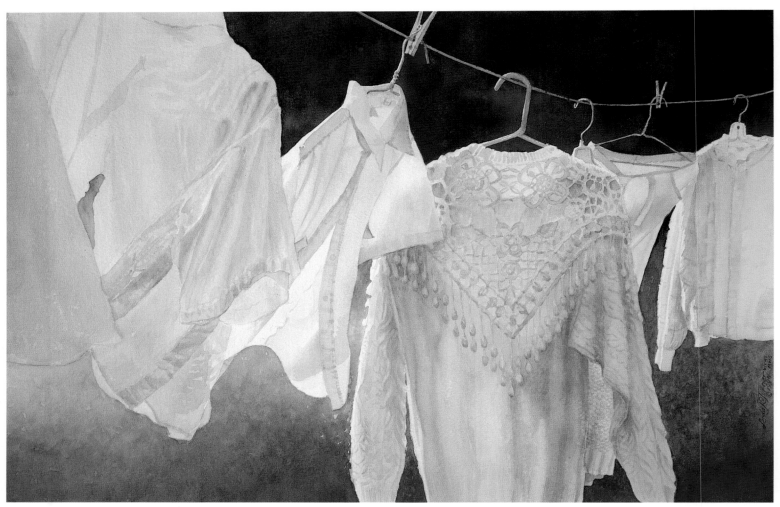

Linda J. Chapman Turner, MWS *White Wash* 14" x 21" Watercolor

White Wash was the artistic result of hanging my "white stuff" out to dry one fall day. The sun was shining brilliantly in a low trajectory. From my studio window, I watched all the colors of my palette dancing around in those "whites." Backlighting revealed the construction of the clothes; a breeze added the oblique lines. The lighter pieces were executed rapidly, mostly on the first pass, while the heavily textured sweater required many glazes. Strong color was then rapidly flooded into the background over the masked line and hangers.

People

My students say I have an infatuation with shadows, reflective light and of course, with Prussian Blue.

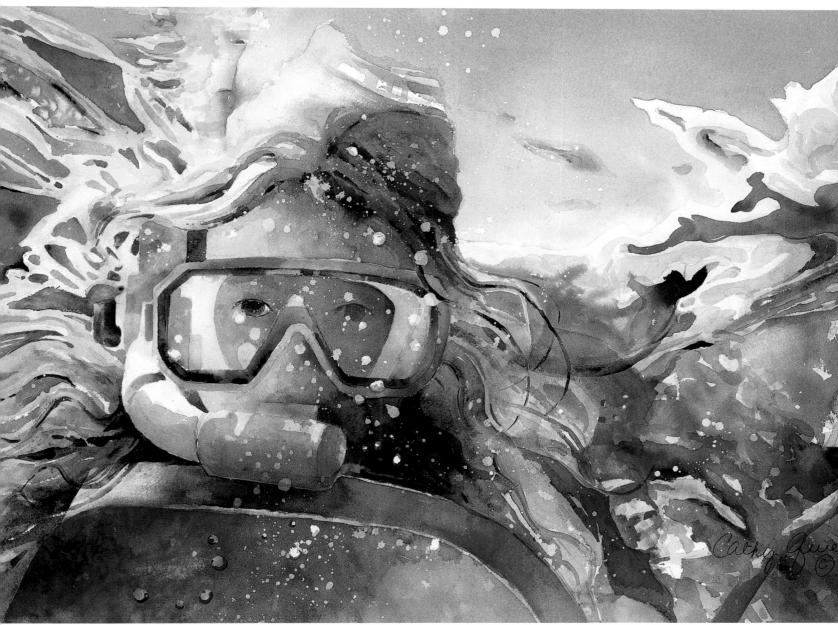

Cathy Quiel *Submerged I* **15" x 22"** **Watercolor**

One never knows when a new idea for a series will pop up. ***Submerged I*** was a commission piece that was pure delight to paint. It also became the catalyst of a new series. In pursuing the idea, I "submerged" in my neighbor's pool with an underwater camera. I requested friends of all sizes to jump in, play with toys and serve as art aids while I photographed from below the surface. My current push in painting is to deal more with the large and abstract shapes. The abstract shapes in ***Submerged I*** were an artist's joy — pure expression of undulating value and color change. My students say I have an infatuation with shadows, reflective light and of course, with Prussian Blue.

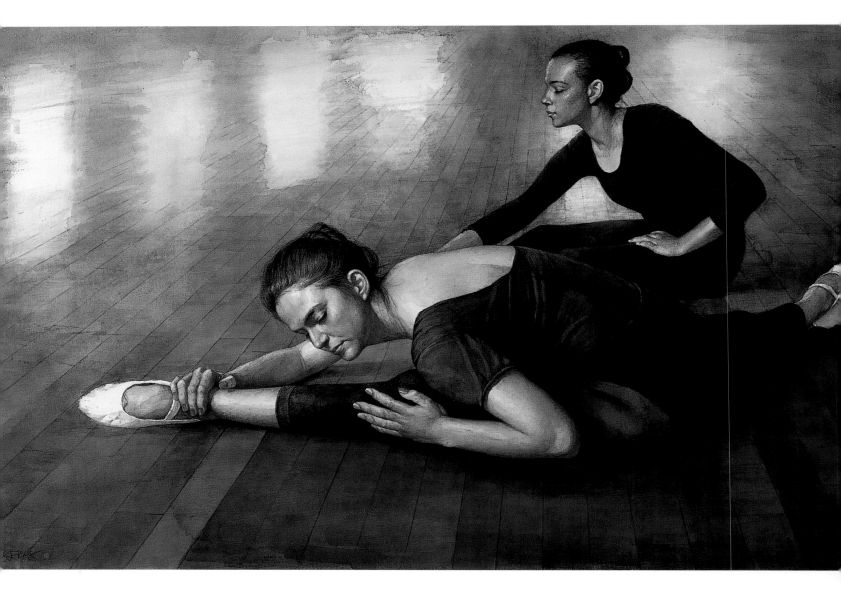

Z. L. Feng, AWS, NWS *Morning Glories* **29" x 40" Watercolor**

I begin a painting by manipulating abstract shapes, working with them until recognizable forms emerge.

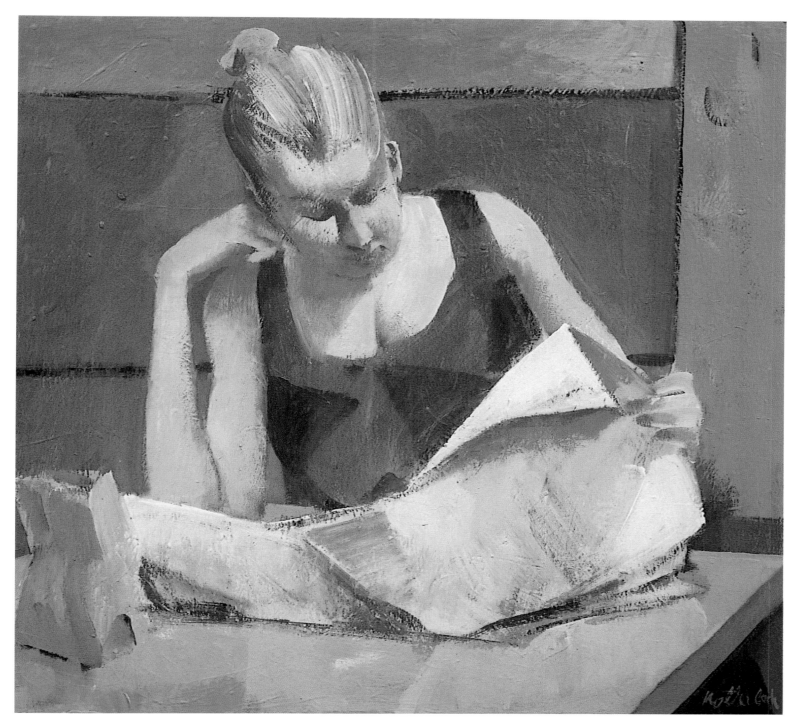

Serge Hollerbach, AWS *Blond Girl with Newspaper* **29" x 32" Acrylic**

Fundamentally, all art is abstract. I begin a painting by manipulating abstract shapes, working with them until recognizable forms emerge. I stop short of obvious realism, however, to avoid robbing the painting of certain esthetic simplicity, visual attractiveness and its sense of mystery.

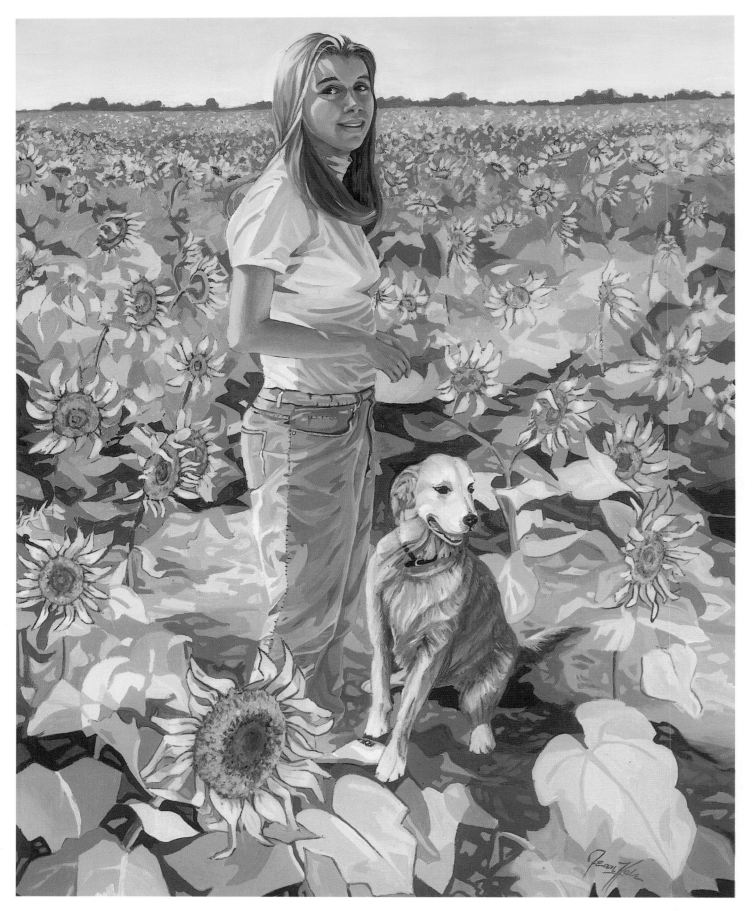

Mitzie Jean Hale *Jessica in a Field of Sunflowers* 24" x 30" Oil

My granddaughter Jessica was 15 and a lover of sunflowers when I painted this. The sunlight in her hair and the glowing parts of her clothes and skin capture her radiance and youth. I tried to illustrate a bright and warm summer day. After finishing the painting, I was surprised to see that her dog, Chance, has a surrealistic quality. It wasn't intended, but I think it adds interest. The shadows and the sunlight filtering through the background create a design leading the eye to the purple and yellow horizon of *Jessica in a Field of Sunflowers*.

I added many washes to achieve the final result.

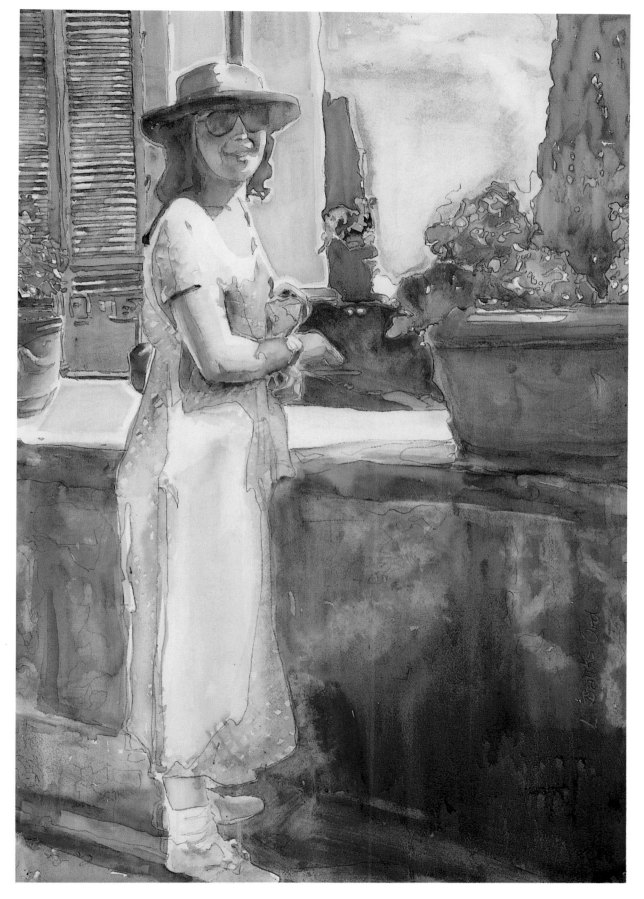

When we visited the Villa di Medici high on its hill above Florence, my friend posed for me in this beautiful historic setting. I later used elements from several photographs to create the resulting image on my computer. I readjusted the figure and totally exchanged the original background. When I had created an image I was excited about, I used a #2 pencil to draw the image. I tacked the drawing to my studio wall and mixed the colors directly on the paper, allowing them to mingle as they meandered towards the bottom of the painting. After getting my colors and values down with the initial application of paint, I added many washes to achieve the final result.

The City of Florence is famous for the quality of its light which creates a beautiful interplay of radiance and shadow. My shadows here are quite intricate; the colors and values reinforce this atmosphere. I was trying to capture the romantic antiquity of the Villa through the colors and other formal elements I used in the painting.

Linda Banks Ord *Florence Series, #2* **22" X 30" Watercolor**

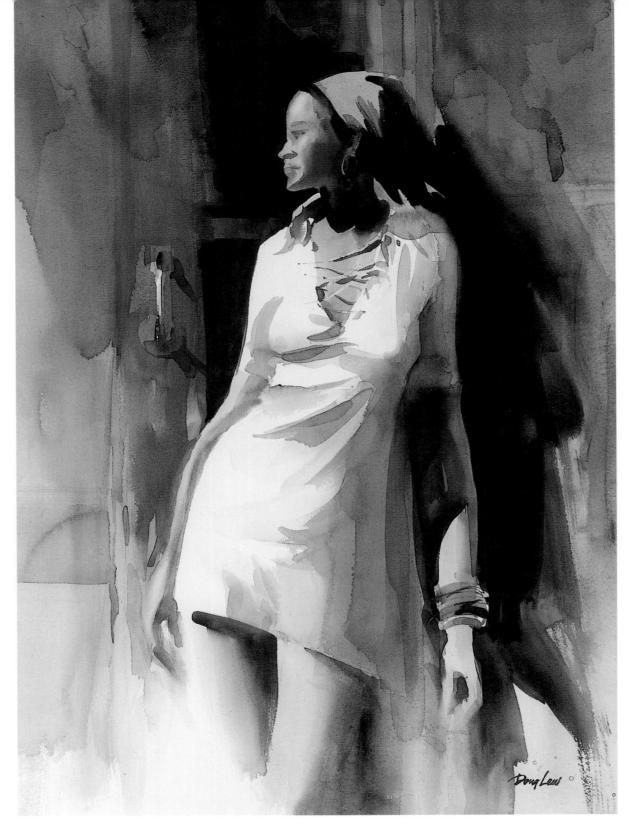

Douglas Lew, MWS *Bahama Girl* 20" x 28" Watercolor

I was first struck by the voluptuousness of the figure dressed in white against the dark screen door. My attention was also caught by the tightness of the woman's dress in contrast to the looseness of the untied string around her neck. The soft edges created by the dress against her breasts played sharply against the hard shadows cast by sunlight falling on the crisscrossing string. All these contrasts were interestingly summed up and counter-pointed by her languid slouch.

As I began to draw the figure in small preliminary sketches something else happened. An accurate and well-drawn figure just didn't seem enough. I felt an urge to exaggerate the slouching attitude of the body. I pushed the exaggeration, almost to the point of discomfort. The whole process became more riveting. Having done that on a small scale, my challenge now is to move on to a larger one. For myself, the difficulty has always been to maintain and reproduce the freshness of a small sketch onto a large painting; the larger the painting the more difficult the task — especially in watercolor. I seldom succeed on the first attempt. My cast-away bin is filled with those half-successful "failures." I am happy with this one, though.

Life is precarious!

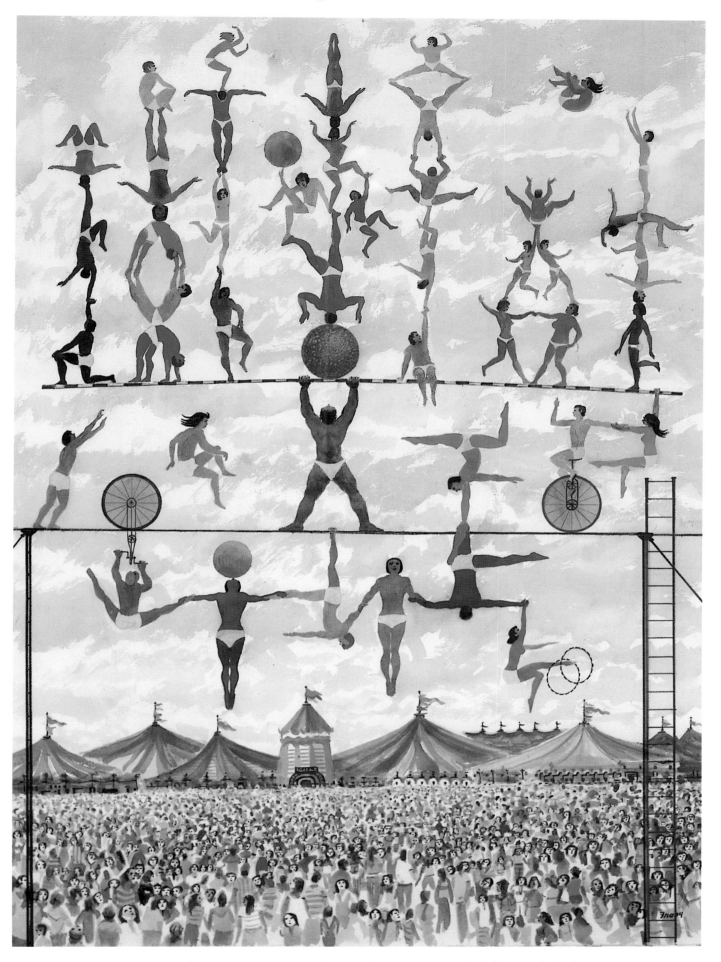

Michael Frary, NWS *Great Balancing Act* **29" x 40" Watercolor**

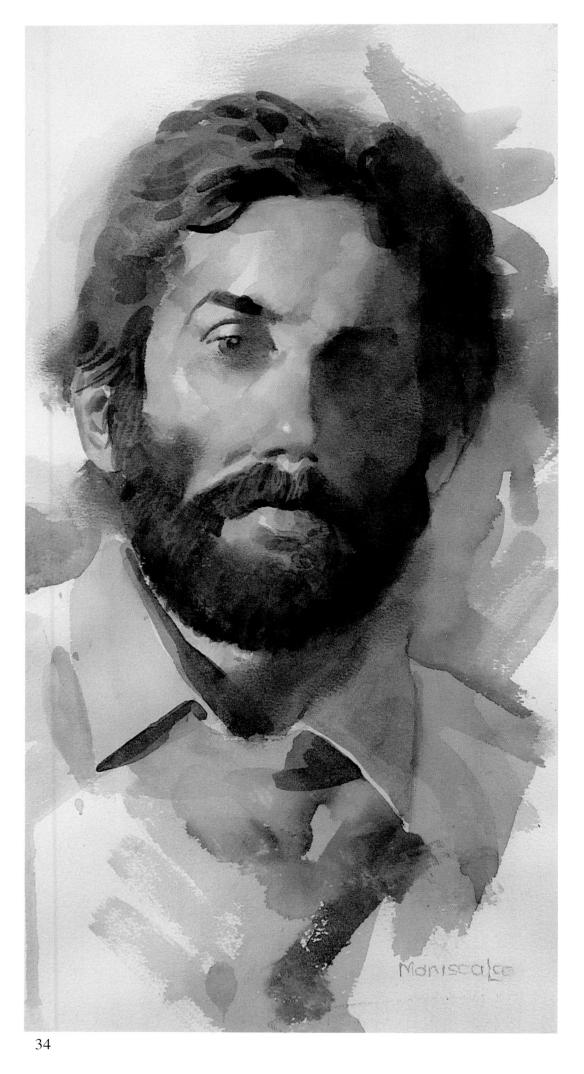

Joseph Maniscalco

Jay

12" x 18"

Watercolor

When I was 14 I did my first oil painting of an American Indian from imagination. This was followed by many years of life drawing and painting classes.

Through the years, I have painted hundreds of commissioned portraits from photographs. Although the photograph is an indispensable tool for the artist, it's crucial for the figurative artist to constantly draw and paint from life.

In order to produce a "painted-from-life"quality in these portraits, I seek out opportunities to paint non-commissioned figurative watercolors from life. This watercolor of "Jay" captures not only his likeness but also the sensitivity of his character.

I came upon a group of French artists.

While visiting the Louvre, I came upon a group of French artists who were busily engaged in copying the masterpieces. I took several photographs of them. Later, I decided to create a painting based on that event. First, I selected several of the photographs and created a computer image which would work well in form. After drawing the scene by hand on watercolor paper, I tacked the paper to a wall and painted directly, trying to achieve my desired values and colors on the first attempt. I mixed colors directly on the paper by laying a wash down, then painted or dropped additional colors into it, allowing gravity to mix my colors for me. This painting differs from others in the series in that I saved the whites by using masking fluid. I then scrubbed out the middle value areas after applying the initial application of paints. Later, I spent a great deal of time adjusting the colors and values by alternately applying washes and scrubbing out pigment from the paper until I reached the result I wanted. I tried to convey the uniqueness of the situation — "an artist painting a painting of an artist painting a painting of another artist's work" — as well as a feeling for the atmosphere of the Louvre.

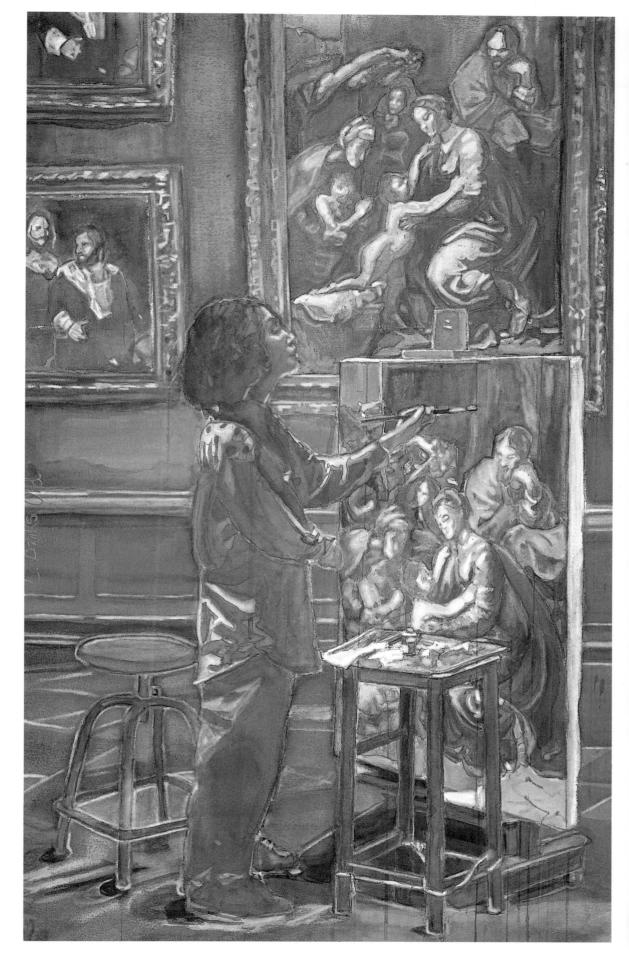

Linda Banks Ord *The Louvre Series, # 2* 25" x 40" Watercolor

35

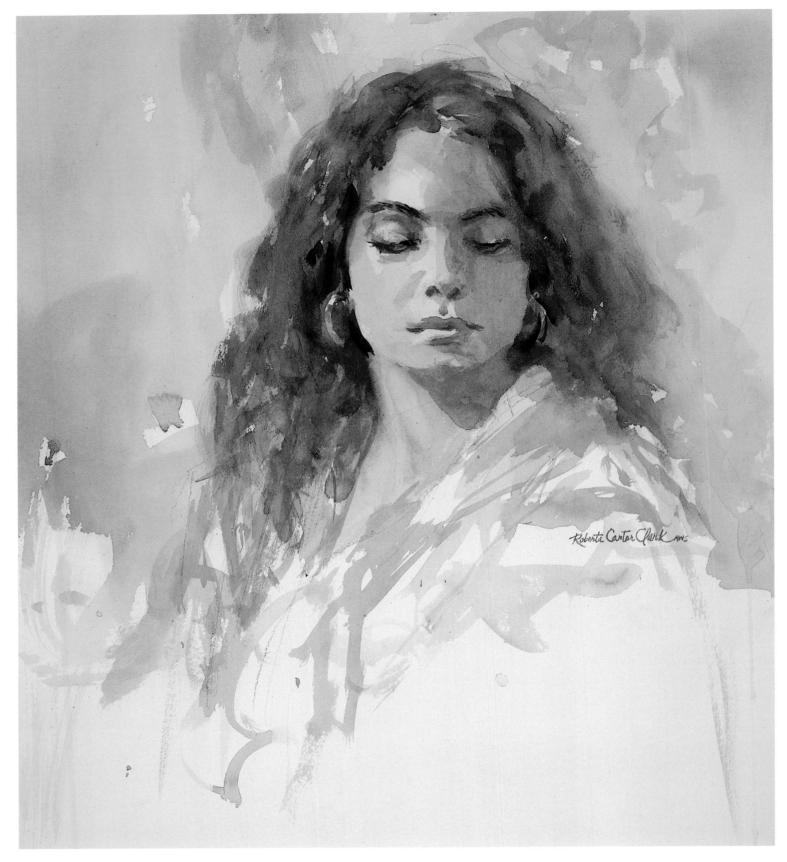

Roberta Carter Clark, AWS, MWS *Deanna* 22" x 28" Watercolor

When I teach a workshop, we make a practice of using a different model each day. I never know exactly what I'll teach until the model arrives. The model herself inspires the lesson. When Deanna arrived with her long dark hair, I decided to pose her straight-on in order to use the darkness of the shape of her hair to frame the face and show off her fair skin. This enabled me to teach the students how to lose the edge of the hair shape on the shadowed side of Deanna's face, and also how a very hard edge on the light side of her face could emphasize the face through a strong value change. I purposely had her look down. This gives her face a pensive look and the sense that she is alone with private thoughts, shutting us out. Downcast eyes allowed me to show the students the difference between painting eyes that are half-closed and eyes that are asleep. There is a difference.

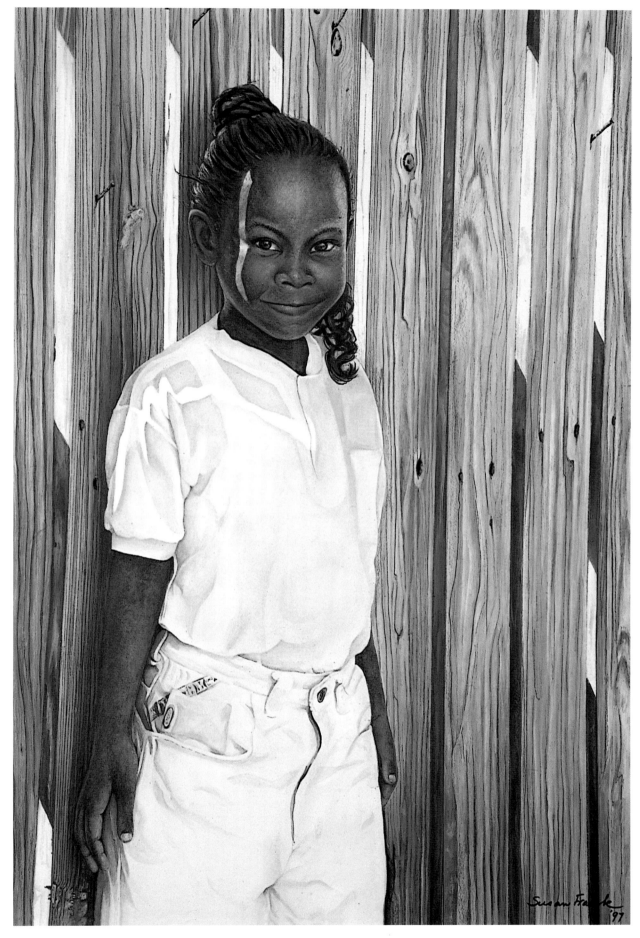

Susan Frank *Little Ray of Sunshine* 22" x 29" Watercolor

The attitude of this little girl seems to be one of quiet resolve. The way the sun strikes her face captured my attention. I begin painting by applying glazes to quickly establish values and tones. Later, I shift to drybrush, using smaller brushes and a thicker mixture of paint, paying close attention to texture and detail.

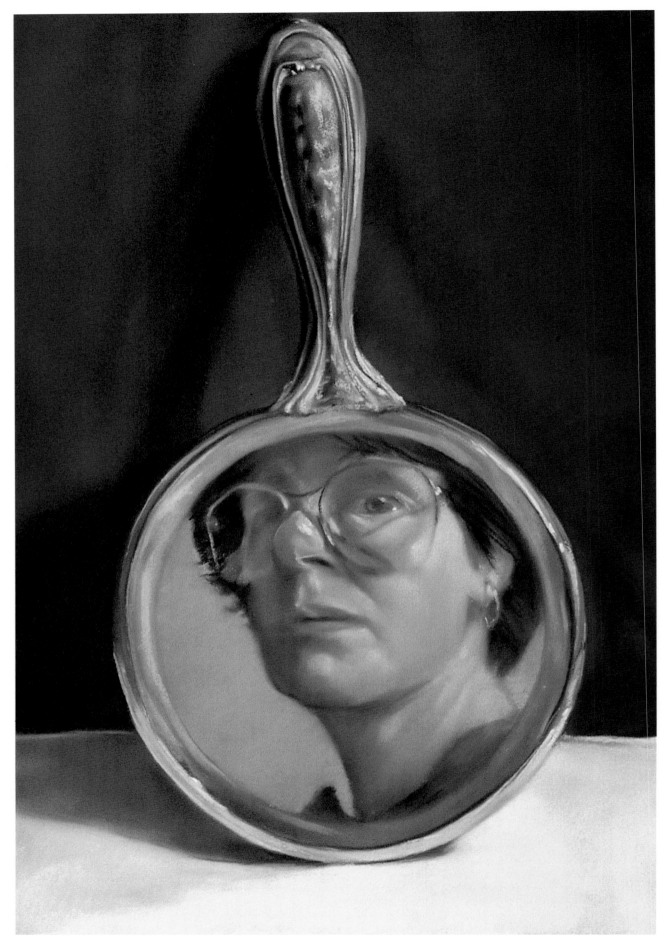

Mary Jean Waid *Grandmother's Mirror* 22" x 30" Pastel

What can be found reflected in grandmother's mirror? I find myself precariously balanced between the past and the future.

She reminded me of my own grandmother.

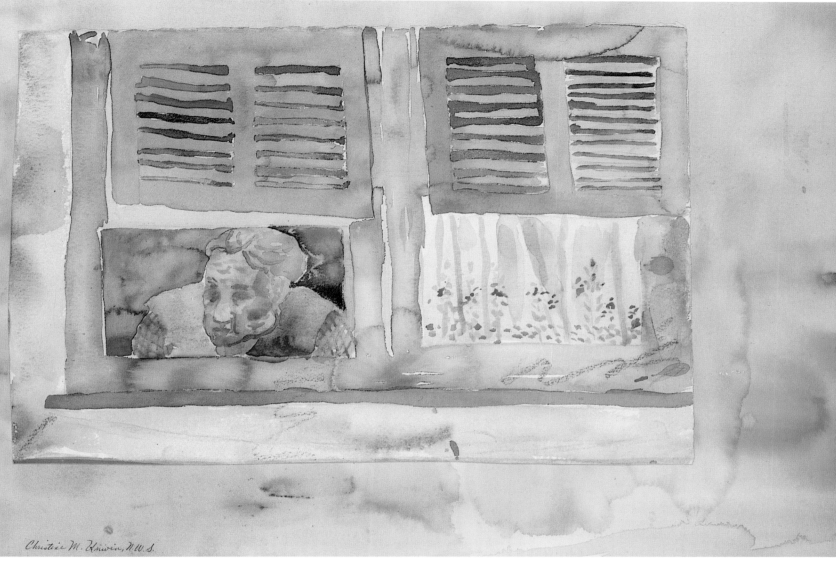

Christine M. Unwin, N.W.S.

Christine M. Unwin, NWS *Nonna* 22" x 30" Watercolor

We caught this Italian grandmother peering out her window in Venice. She reminded me of my own grandmother. Though I was pleased with my painting of her, I was unhappy with my wash on the building. The rich, warm yellows, reds, oranges, ochers and salmon colors of the walls in Italy are gorgeous! To solve this problem, I took the liberty of cutting out the window and grandmother and collaging it on a wash I thought was more interesting and clean looking — just like the walls of Venice. Crayon and colored pencil were used to add texture. When I exhibited this painting in a show aboard one of the cruise ships in Italy, three people came up to me and said "Oh yes, we saw her." What they did not know was that the underlying painting was from a trip two years earlier.

She has always had a fascination for my hat collection.

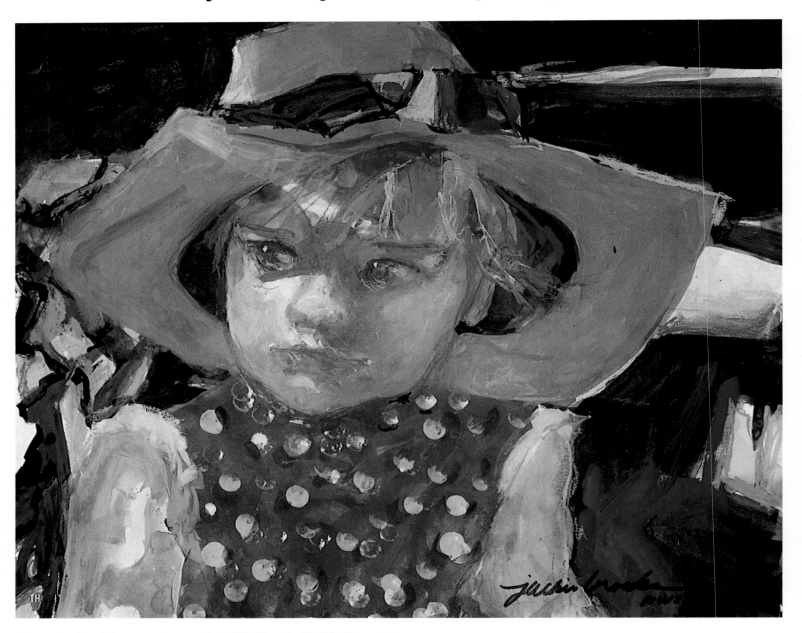

Jackie Brooks, NWS, MWS *Emma* 14" x 17" Watercolor Collage

Emma, my granddaughter, is now five years old. She has always had a fascination for my hat collection, once telling her father (my son) that she enjoyed coming to our house because my hats made her feel happy. This portrait was painted when she was three years old and though I did not capture an exact likeness, I did capture her spirit. This causes people to react to the picture and *that* I like!

I painted the background of the picture dark ... to show the children's brightly lighted heads to their best advantage.

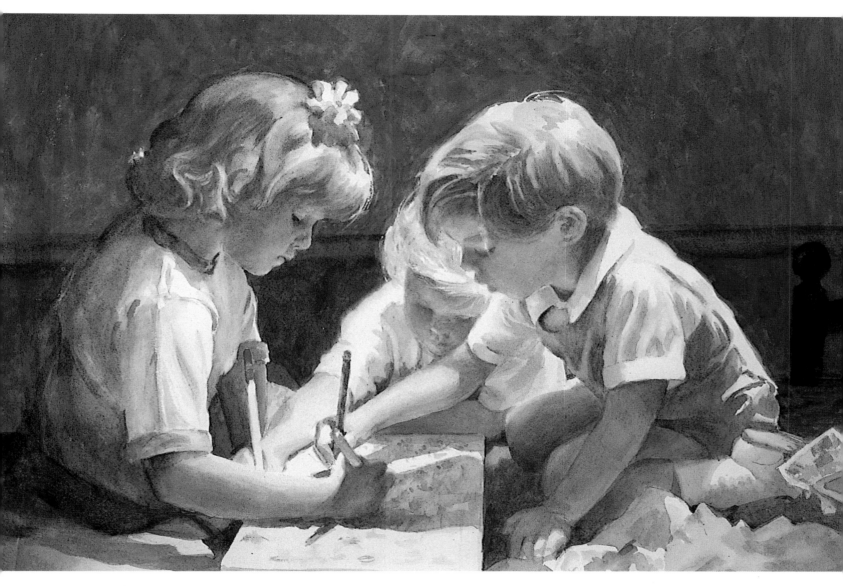

Roberta Carter Clark, AWS, MWS *Concentration* 22" x 30" Watercolor

As a portrait painter, I meet many wonderful children. I painted Patrice, the little girl in the back and her brother, Russell, on the right, in pastels. I had stopped by their house to visit with their mother, when I noticed Patrice and Russell with their little friend, sitting on the table under the skylight coloring designs on the wrapping paper of gifts they were going to take to a birthday party that afternoon. The light shining on their blond heads was so brilliant, I just had to quickly take an unposed photo so they wouldn't realize it.

I painted the background of the picture dark (it was lighter in the photo) to show the children's brightly lighted heads to their best advantage. I decided on blue because blue can be dark and still luminous, not heavy. I liked the small varied shapes made by the toys at the lower right. They were much more interesting than a dark area below Russell's leg would have been. The most difficult part was making the hands appear they were holding colored pencils so that the viewer could distinguish which hand held which pencil. People often don't consciously think about such things when they look at paintings, but if the actions are not clear, viewers will be confused.

I think the painting is helped by its pyramidical design. The box, as a vertical shape, comes right at us, and sets off the horizontal shape of the painting. I loved painting it!

I felt a marvelous sense of freedom in the use of colors and shapes while going down this new avenue of painting.

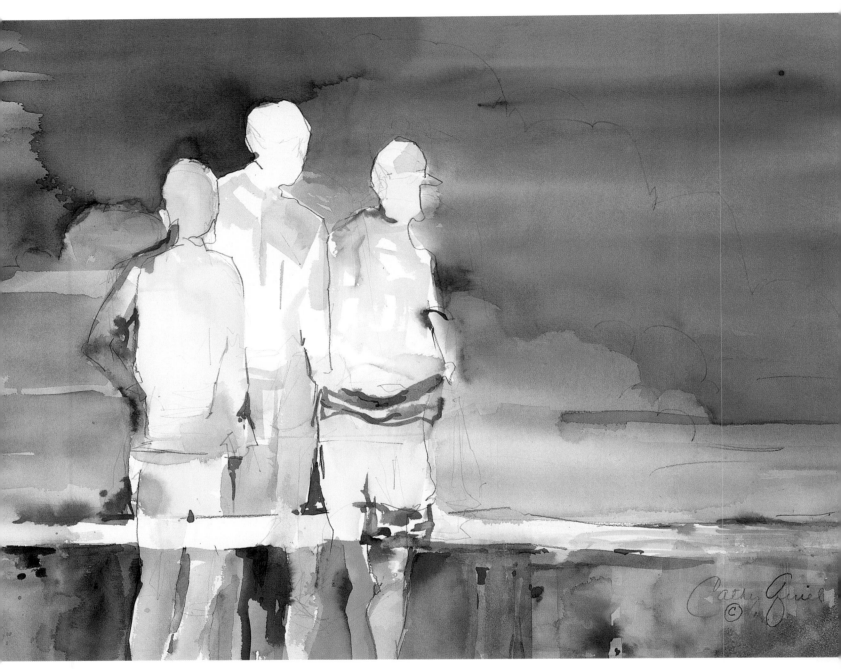

Cathy Quiel *Three Men Tall* **22" x 30"** **Watercolor**

After being exposed to the wonderful work of watercolorist Fran Larsen, I produced several paintings different from my usual representational style. This is one of them. It is more abstract and allows more space for viewer interpretation. I felt a marvelous sense of freedom in the use of colors and shapes while going down this new avenue of painting. *Three Men Tall* is a painting about the men I love in my life, my tall husband and my two tall sons!

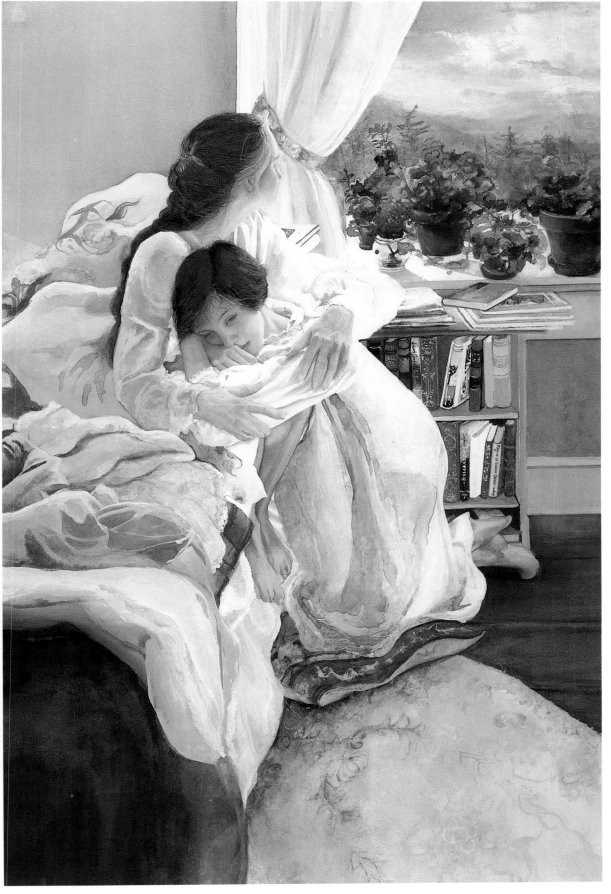

Fly child ... fly!
I am able to trust
the universe and God
to guide and protect you.
I've journeyed far
through fields of fear
to get to this place
of letting go and Trusting
what a Big word --

Trust

I see it in this image
I paint it ... here.
Tender, intimate touch
Come child --
under my wing
No words are necessary.
Rest here on my knee,
dear, sweet, honey child.
Mother - Mother Earth --
mothering
Mother -- say it
till it makes sense.
Still feeling the need
to be -- to have ...
Hold me
Kiss me softly --
tell me nothing
I paint the light --
the fragmented hope
that we all cling to
that appears --
and is gone.
But not forever.

Lynne Yancha, AWS *Interwoven Memories* **22" x 30" Watercolor**

Interwoven Memories speaks of my ever-present desire to comfort my child and to give some type of assurance that with the light of morning will come a new day with new opportunities. It is about tenderness, intimacy and touch, and the unbreakable bond that never really disappears, no matter what the age or circumstance.

The beach was a blanket of grey rocks but I thought painting them abstractly would be a more interesting approach.

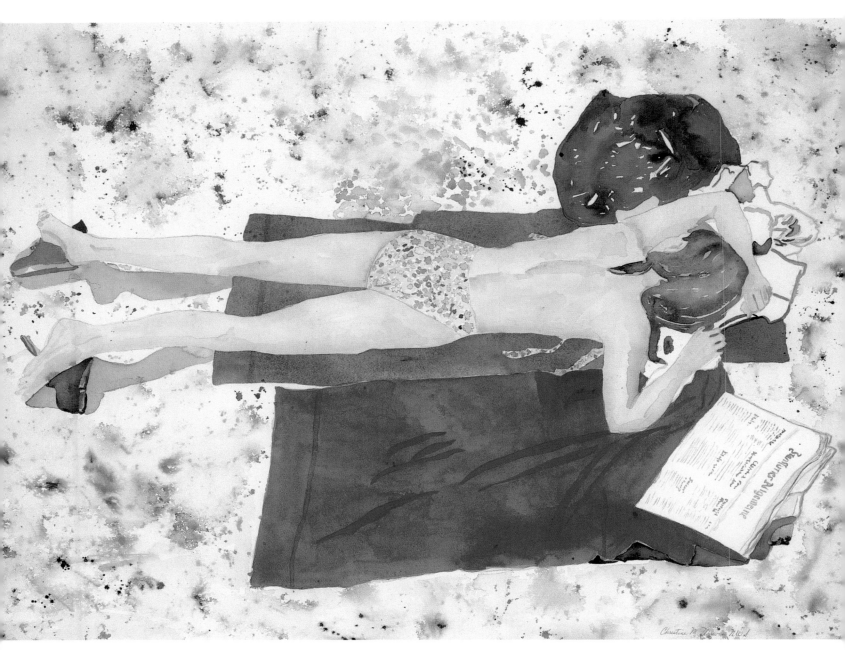

Christine M. Unwin, NWS *Amalfi Sun Worshipper* 22" x 30" Watercolor

I first spotted this young woman from a bridge above the beach. My attention also was drawn by a leather-clad lad who stopped on the bridge, helmet in hand, perched on his motorcycle. He was watching her intently. I did a quick sketch of her and thought I'd love to paint her. When my husband and I returned home, I discovered that he also had admired and photgraphed her. The beach was a blanket of grey rocks but I thought painting them abstractly would be a more interesting approach.

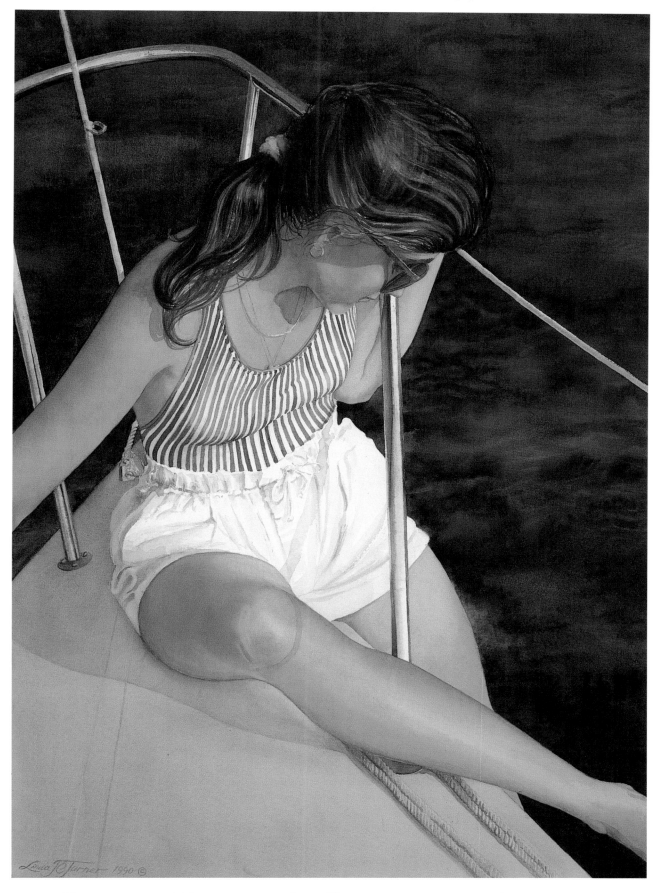

Linda J. Chapman Turner, MWS *Water Nymph* 14" x 21" Watercolor

Water Nymph depicts my daughter on a sailing excursion. As she tested the water with her foot, I noticed the strong diagonal lines of her position with the boat. For this transparent watercolor, I used controlled washes, glazes and a technique I have dubbed "dew," or dry-edge into wet. Her hair was defined by wet-into-wet, calligraphic strokes, and lift-out. Clothing folds were indicated by enough paint and water to flow from the brush. A series of glazes built the surface of the deck, and the water resulted from rapidly applied wet-into-wet. The resulting blue-green and oranges color scheme is a mixture of warm and cool primary colors.

I began to observe the reactions of other weary travellers.

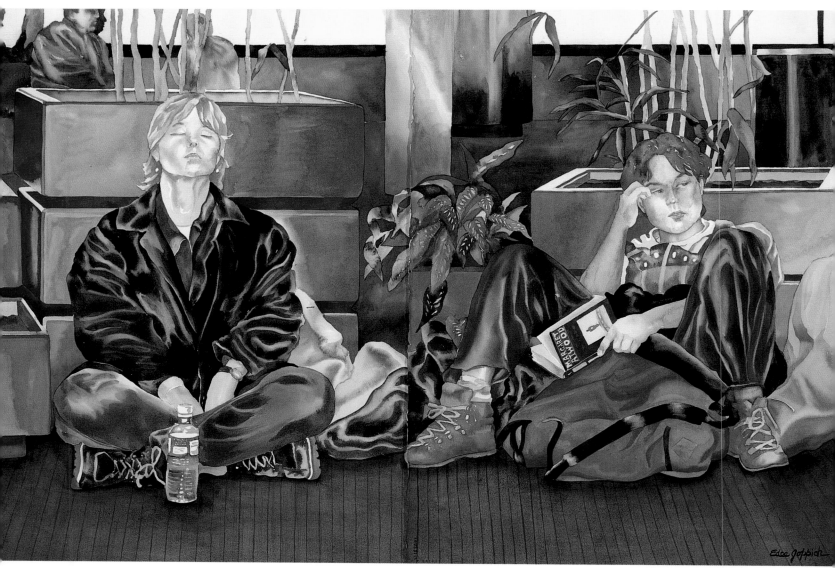

Edee Joppich *Miles to Go - SFO* 35" x 48" Watercolor

The airport delay stretched on endlessly. I began to observe the reactions of other weary travellers. The sketches I made of these young women caught the sense of resignation experienced by one who's ever been trapped in an airport with miles to go.

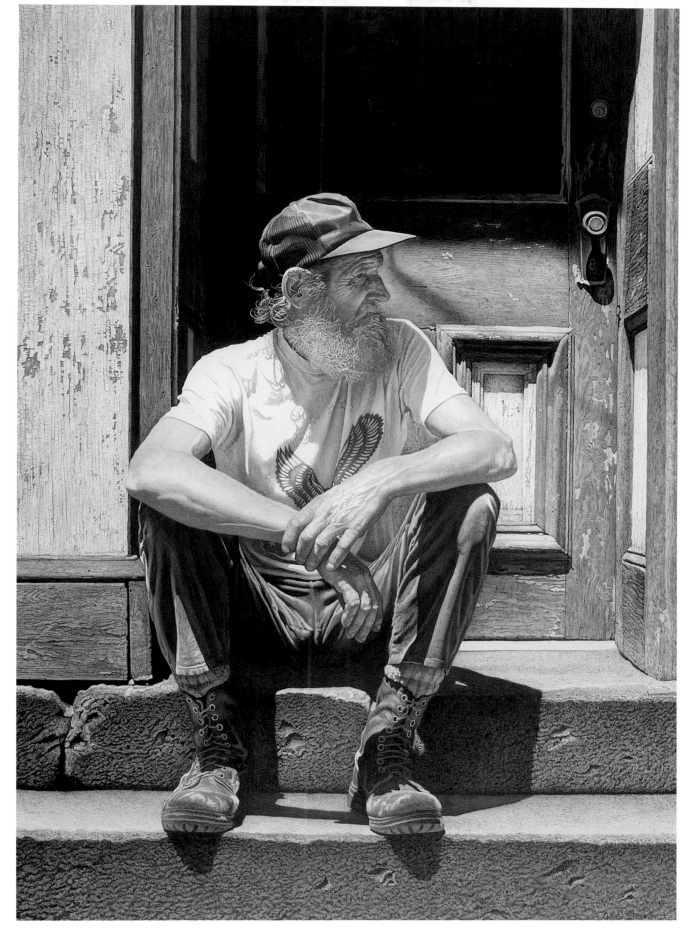

Douglas Wiltraut *Reds* 40" x 57" Egg Tempera

I painted *Reds* while perched on the front steps of his home. From there he "doesn't miss a trick."

Because I have always been attracted to shadows, this scene gave me the opportunity to explore not only the complexities of light and shadow but also the endless variety of textures. This particular combination of strong light and a myriad of textures enabled me to use the medium of egg tempera to its fullest capabilities.

Waterscapes

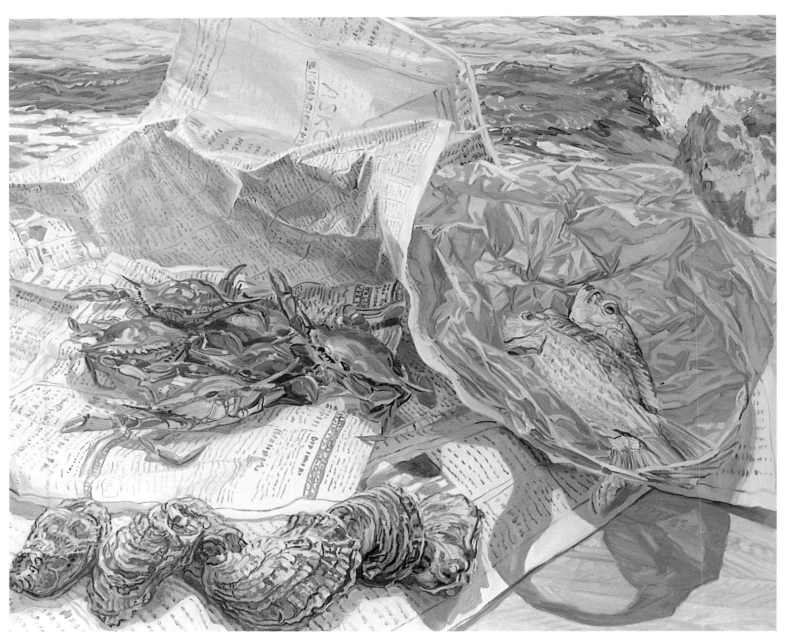

Janet Fish *Ocean* **48" x 60"** **Oil on canvas**

... when all ... the agitation, fascination and commotion had run it's course, I was left with a foreground, part of a middleground and just a suggestion of a backround.

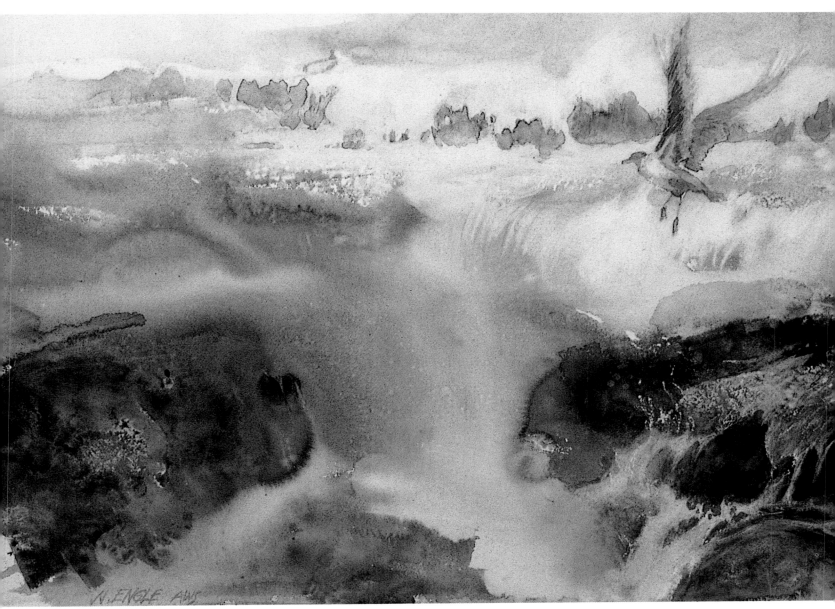

Nita Engle, AWS *Blown Away* 15" x 20" Watercolor

This painting began as one of a series of sea demos meant to introduce students to the concept of playing with running water, paint, palette knife, and spray bottle on illustration board. Pure action painting, with no drawing and no thinking — just reacting to the paint.

I instruct students to follow whatever the paint and water lead to. In this case when all the paint was dry and all the agitation, fascination and commotion had run it's course, I was left with a foreground, part of a middleground and just a suggestion of a backround.

The strongest message I received when assessing the work was a feeling of a lot of wind and spray action — so I finished the painting by adding more backround and the blown-away seagull.

I chose the subjects for their varied shapes, kaleidoscopic patterns and striking colors.

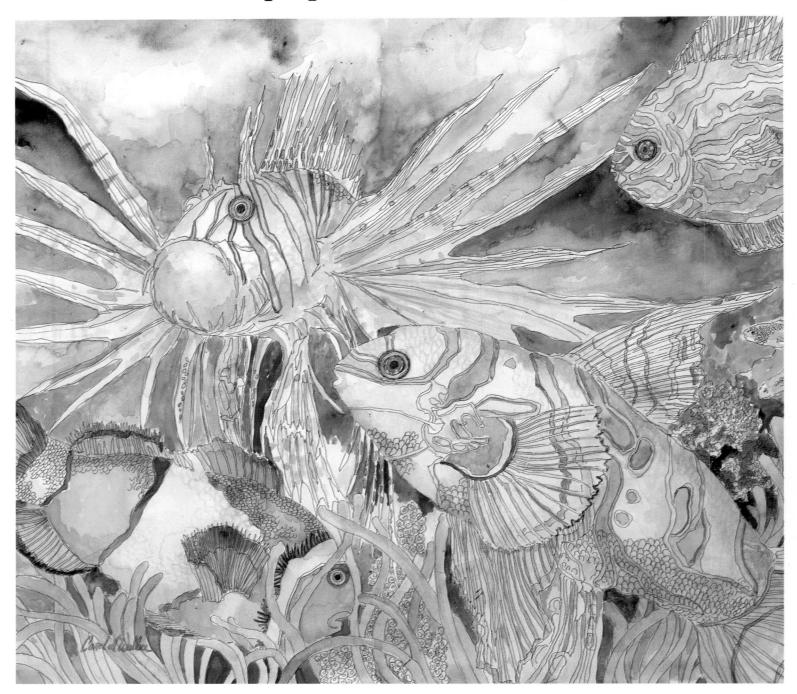

Carol Wallace *Strange Encounters of the Tropical Kind* 18" X 21" Watercolor

My fascination with tropical fish inspired this whimsical interpretation of an underwater world. I chose the subjects for their varied shapes, kaleidoscopic patterns and striking colors. Appropriately, it was painted wet-in-wet with watercolors, iridescent acrylics and ink.

Some research of ichthyology was involved as well as some snorkeling adventures and numerous trips to aquariums around the country. In this painting the lionfish, clownfish, and mandarinfish of the South Pacific live in harmony with the freshwater discus from the Amazon Basin. I added a touch of humor to the piece by giving the fish "personalities." ***Strange Encounters of the Tropical Kind*** is a fun diversion from my landscape paintings and ***Preserve America***™ collection of posters and cards for which I am better known.

. . . a brush full of color is swept across the page. The color collides with the liquid surface, dances about and helps design the painting.

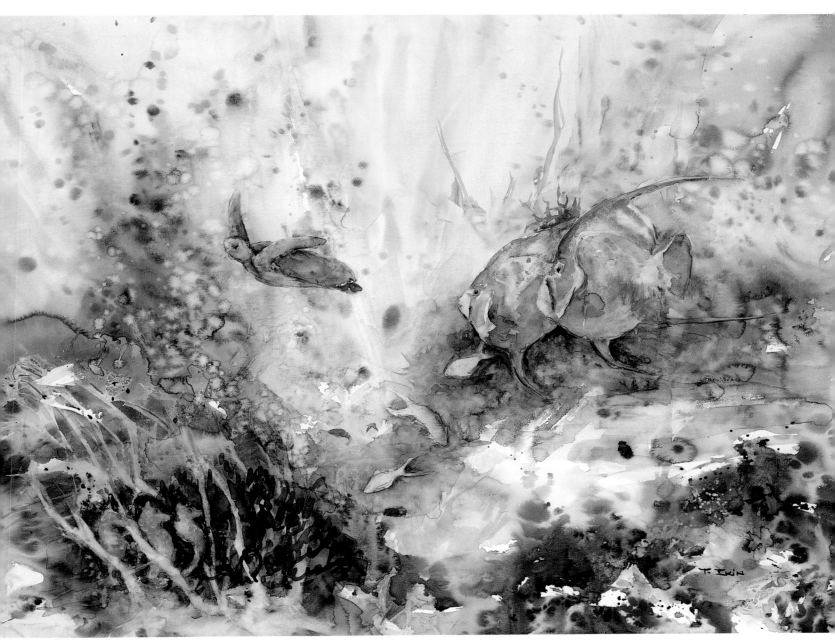

Taylor Ikin *Hide & Seek* 30" X 40" Watercolor

Snorkeling in the West Indies left me with memories of water world images just below the surface of the Caribbean. *Hide & Seek* is from a series about life on a reef which shows the different sea critters at play in their habitat.

First, I drop large pools of water on illustration board. Then, a brush full of color is swept across the page. The color collides with the liquid surface, dances about and helps design the painting. The process causes swirls and muted shapes which suggest the dappled light seen when one "goes below."

This series is meant to remind us of the fragile state of our reefs. I refer to theses paintings as *low maintenance aquariums*. When I first "went below," I had a much more casual approach to the fish and coral, but having completed many paintings in the series, I now strive for more accuracy, a sense of motion and try to invite a sharper sense of awareness, and sometimes humor, toward our sea creatures and their environment.

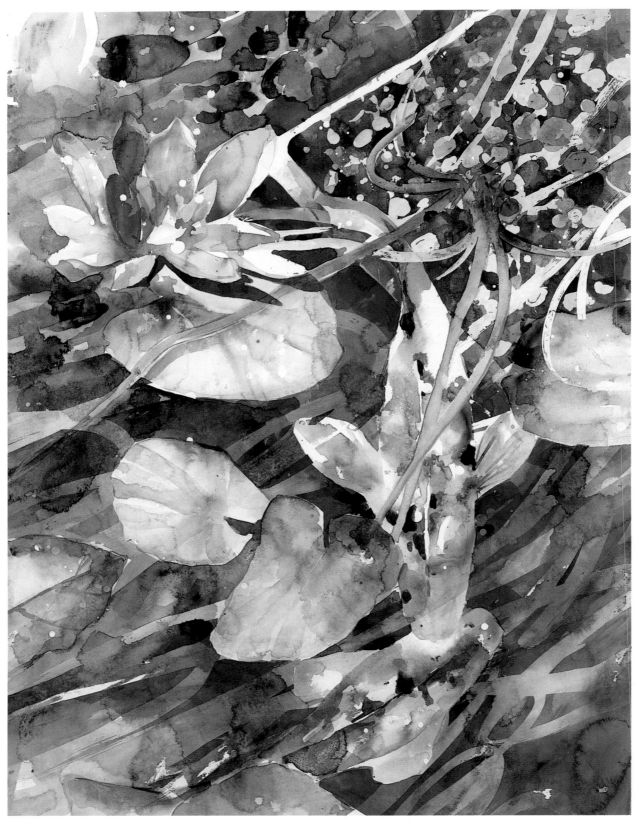

David R. Daniels *Koi* 22" x 30" Watercolor

These fish were painted in their natural surroundings. The perspective is ambiguous because the koi are viewed from above while the water lily is seen in partial profile. I find this subtle shift is visually appealing.

I used D'Arches™ 140 lb. hot pressed paper because it is extremely smooth and helps achieve the desired water-like quality. A more textured paper would restrict pigment flow and give a more rigid, restrained look. The clear jewel-like colors are achieved by direct, fluid paint application. Colors were mixed directly on the paper, allowing me to control color intensity. My work is often compared to traditional "Batik" because I use multiple layers of masking frisket to preserve white and colored areas of a painting. When the painting is finished, the frisket is removed and the many layers of transparent color are revealed to the viewer.

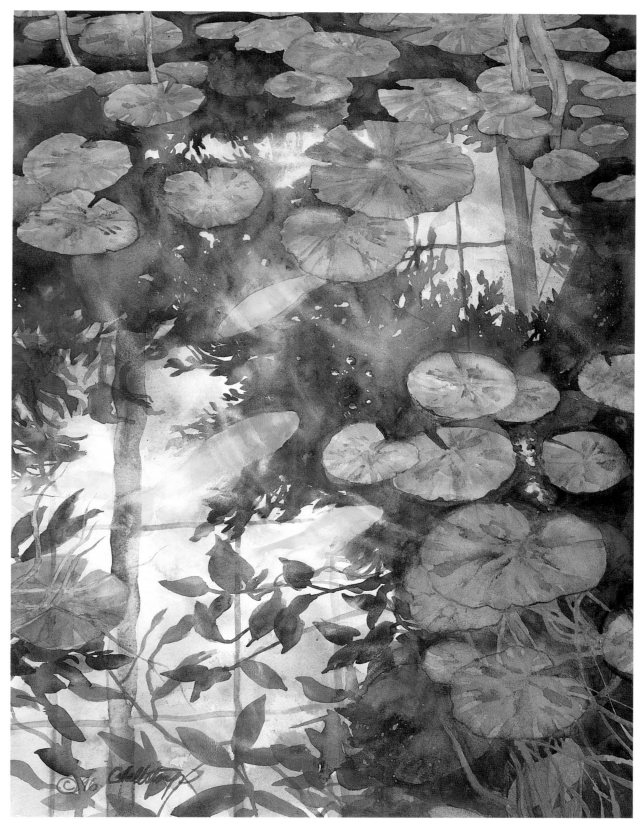

Marjorie Chellstorp *Matthaei Pond Reflections #3* 38" X 30" Watercolor

 The inspiration for the Matthaei Garden Ponds series stems from my fascination with the changing world of water, sky, fish and plants. When you gaze into the ponds you see the reflected sky through the glass ceiling and feel the silence and mystery of the fish as they appear and disappear under the plants and surface reflections.

 While working on this painting I washed out and lifted some areas until I knew the painting was complete with a flow of both dark and light values moving around the composition. This painting was in the "Michigan Watercolor Society's 50th Anniversary" show which opened at the Detroit Institute of Arts before traveling to various museums throughout Michigan.

Their colors are beautiful and the shapes are fascinating, especially when clustered in the net.

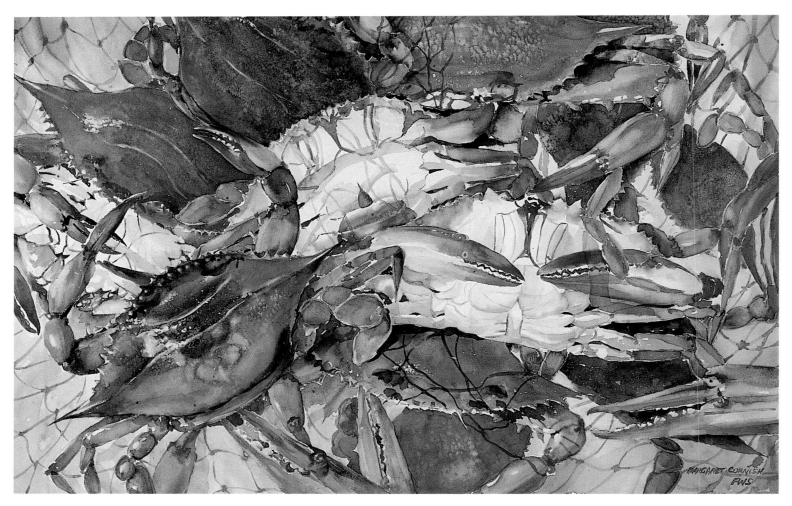

Margaret Cornish, NWS *Net Results* 23" x 27" Watercolor

I live on the river in Tarpon Springs, Florida. We always have a trap set out, and we are frequently rewarded with Blue Crabs. Their colors are beautiful and the shapes are fascinating, especially when clustered in the net. I used a Crescent™ watercolor board for this painting, treating the board with a diluted solution of gel medium and water. This makes the paint easier to lift, though it's not suitable for large washes.

It was very different painting crabs which were not brightly colored and that is why I used a very limited palette to help me capture this feeling.

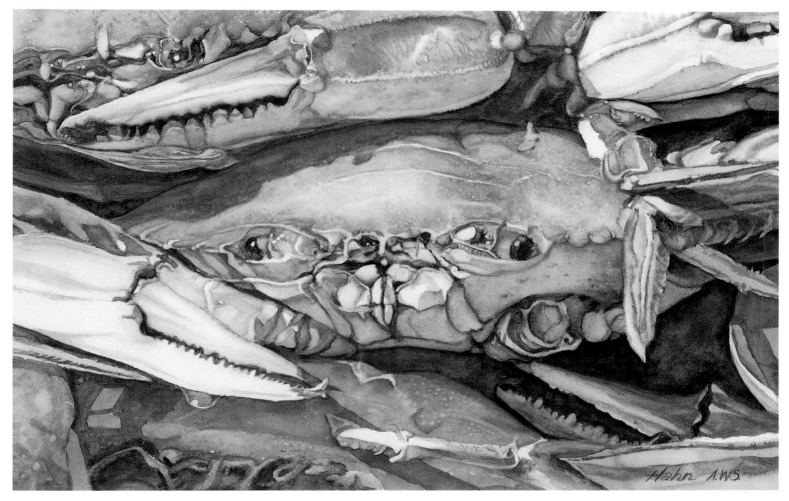

Elaine Hahn, AWS, NWS *Something's Missing* 9" x 14" Watercolor

I've done many *live* paintings of the colorful Maryland Blue Crab. While visiting the fish market for more reference photos, a bushel of *cooked* crabs caught my eye. The title came easily because one claw was obviously missing, but most importantly, so was *life*, and therefore the life *color* of the Maryland Blue! It was very different painting crabs which were not brightly colored and that is why I used a very limited palette to help me capture this feeling.

Landscapes

I sought to capture the rise of the sun behind the mountain, the spreading impact on the valley below and the sky above.

Lorraine Denzler, NWS *Evergreen Valley* 22" x 30" Gouache

Western Washington State has wondrous scenery from ocean shores to mountains, but nothing in my opinion surpasses the view of Evergreen Valley near the state capital of Olympia with Mount Rainier to the east and the Olympic Mountains to the northwest. Using artistic license, I sought to capture the rise of the sun behind the mountain, the spreading impact on the valley below and the sky above. Such a scene calls for brilliant color and surreal images. Voila!

I started with a realistic approach but ultimately moved on to form, design and especially mood.

Greta S. Greenfield, MWS *Moonlit Mountain* 20" x 30" Watercolor

Mountains laden with snow. Glistening in the moonlight with magical lights, intriguing forms, shadows. I tried to capture the essence of the moment in *Moonlit Mountain*. I used transparent watercolor and masked the white areas. I started with a realistic approach but ultimately moved on to form, design and especially mood.

I emphasized this quality with many overlays or glazes to bring color harmony to the objects I painted.

Dan Petersen, NWS *Ring of Gold* 25" x 40" Watercolor

"I will lift up mine eyes unto the hills from whence cometh my Help." From King David of ancient Israel to today's man on the street, the "High Country" gives renewal to the human spirit. John Muir was another man who loved the mountains. Of Nature's grand scheme in California's Sierra Nevada Range, he mused, "When we try to pick out anything by itself, we find it hitched to everything else in the Universe."

Borrowing from the observations of these two great outdoorsmen, I have selected as my subject for this painting a gorge high up in the Sonora Pass in the Sierras. Though the subject is hills, the theme I attempted to convey was natural harmony. My intention always is to capture the "wonder of the place" in an effort to refresh the soul and lift the spirit.

The methods that I used flow from this concept of harmony. Transparency is a distinctive feature of watercolor pigments. I emphasized this quality with many overlays or glazes to bring color harmony to the objects I painted. In addition, I attempted to incorporate subtle Cubistic devices designed to help tie up the many unrelated parts into a unified and pleasing whole. Freshness with control was achieved by using multiple layers of liquid stopout rubber. Objects were defined and detail explained, but each element was planned to help guide the eye back to the horizon and ultimately up to the Source of all creativity.

Finally, if I can cause the viewer to reflect, for a moment, upon the wonder of our world, crediting the manifest goodness to its Creator, I will feel that ***Ring of Gold*** has accomplished its mission. In conclusion, I affirm the words of King David in Psalm 121, "My help comes from the Lord who made Heaven and Earth."

I paint the dark values first, then add a series of transparent washes over . . . the paintings to gain desired light effects, soften edges and harmonize the picture.

Hank Cornille　　*Rocky Point*　　10" x 20" Watercolor

Early in the morning, high in the Smokey Mountains, there's a sense of intimacy with nature. The slowly rising fog obscures and mutes distant objects, bringing a greater sense of closeness with the foreground. Sky blends with mountains, mountains and forests run together and a line of trees, rising abruptly from the rock formation, stands in front of this majestic background.

In my watercolor landscapes, I try to convey the emotional response these scenes evoke in me. Although realistic, my work does not attempt to replicate a photograph. Rather I seek to express the excitement, awe and tranquility that I feel. I take artist's license in altering colors, lighting and occasionally composition to obtain an image which reflects my emotional response.

Technically, my paintings often deviate from traditional watercolor technique. I paint the dark values first, then add a series of transparent washes over all or portions of the paintings to gain desired light effects, soften edges and harmonize the picture. The dark valued underpainting carries the composition while the washes strike the mood.

With a good underpainting laid down, success or failure lies with the washes. Anxiety and anticipation mount with each succeeding wash. Will the dried wash be what was expected when the wash was wet? Things happen fast when the paper is wet. Little "accidents" inevitably occur in watercolor. Can I react quickly enough to use these to advantage or will a permanent flaw result? Will the washes make glowing colors or mud?　Success or failure in watercolor hinges on split second decisions. What great fun it is when you pull it off!

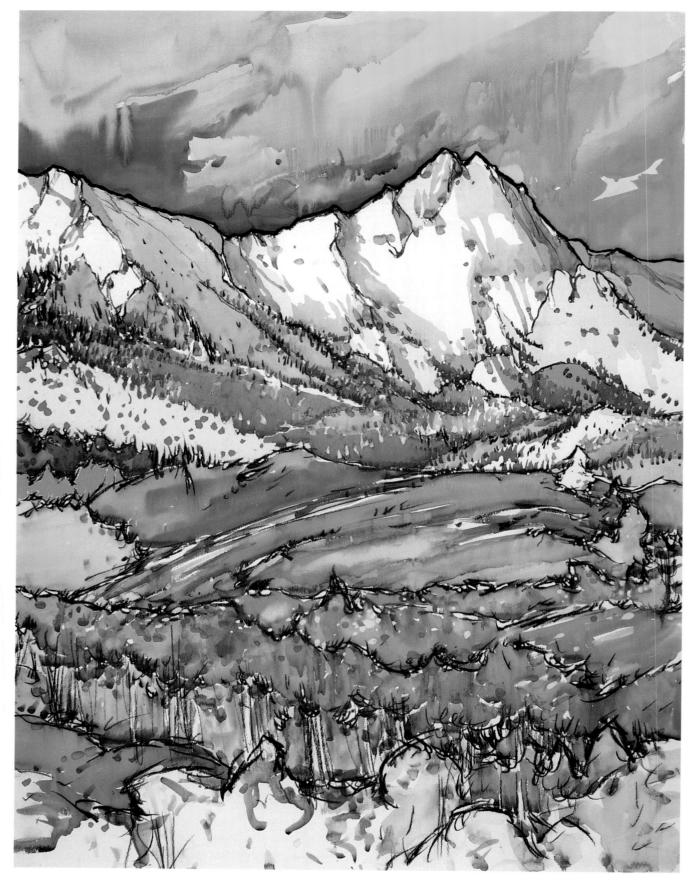

Bill Herring *Snow Mountain* **32" x 40"** **Watercolor**

Snow Mountain was painted from Colorado photographs using transparent watercolor and opaque paints. The opaque effects are a combination of "pro-white" mixed with transparent pigment. I intended to create a landscape with an explosive sky. The sky was painted all at once in an upright easel position. The combination of line and color is in the expressive, rather than the impressionistic tradition. Color is chosen not to describe but to express the artist's emotions. The drawing is in charcoal.

The sun's rays were dancing over the many different shapes of the cliff, changing them from minute to minute, from light to dark, from pastel to intense hues.

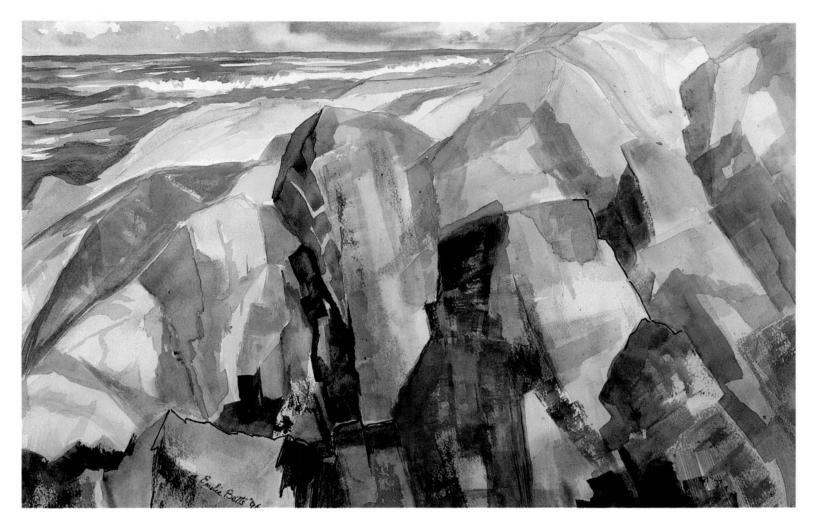

Emilie Betts *Rainbow Rocks* 14" x 21" Watercolor

It was a sparkling late summer day in Maine. The air was clear and crisp, with a friendly sun warming my back. As I sat there daydreaming, enjoying the beautiful day, I became aware of the unusual colors on the tumbled rock face in front of me. The sun's rays were dancing over the many different shapes of the cliff, changing them from minute to minute from light to dark, from pastel to intense hues. I sprang into action, intent on capturing some of this display before the day started to fade. It was an inspired two hours or so. At the end of the afternoon, I finally put aside my brush and looked with delight at the scene I had created. I felt it told the story of that lovely day. The contrast of the hot colors in the cliff against the cool blue of the ocean was very satisfying. Each time I look at this interpretation, I am transported back to Maine, reliving and loving each moment.

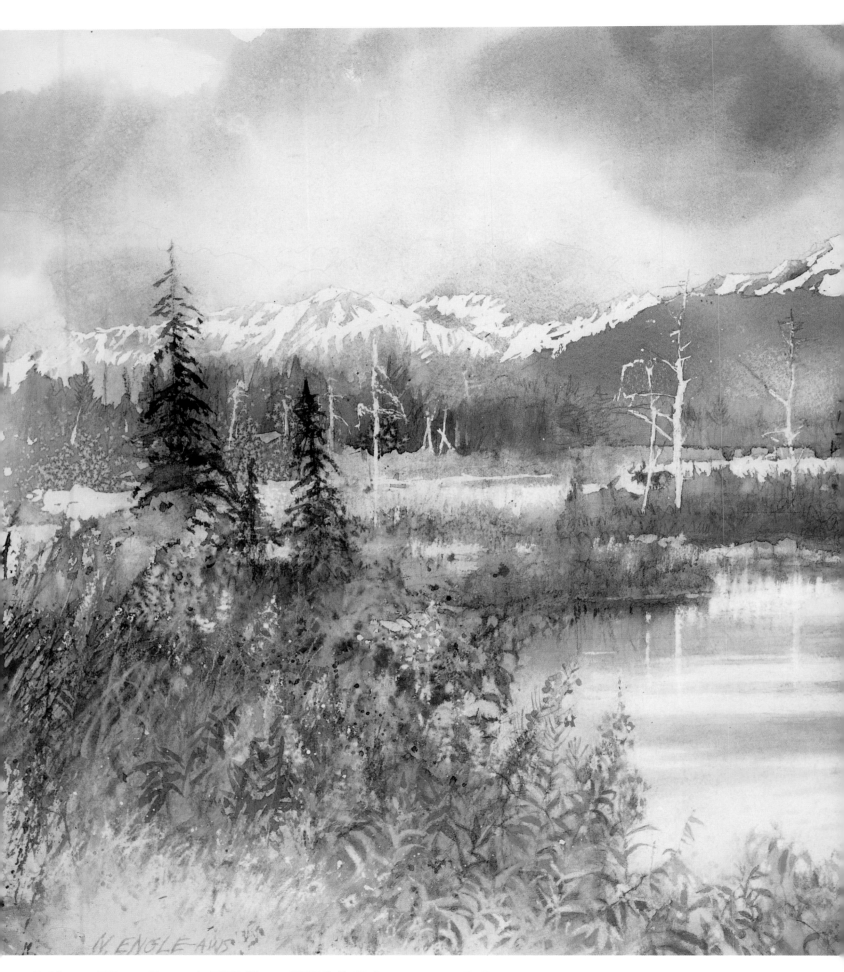

Nita Engle, AWS *Wild River — Moose* 27 " x 40" Watercolor

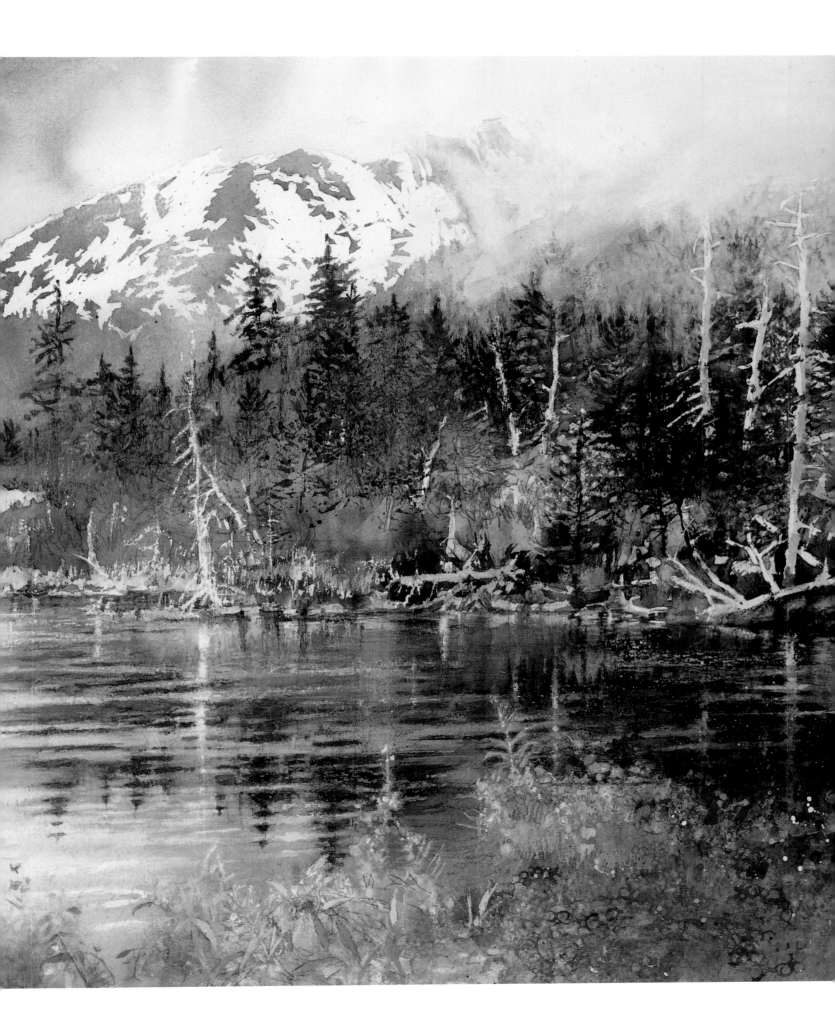

So, I'm always looking for good silhouette patterns. Often I find them in intimate small creeks and rivers.

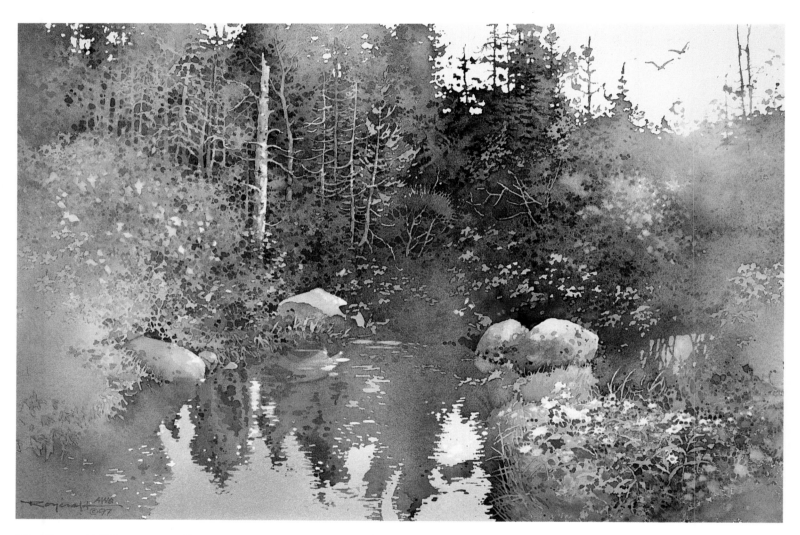

Roland Roycraft, AWS, MWS *Changing Seasons* 14" x 21" **Watercolor**

Low level backlighting is a staple in many of my paintings. So, I'm always looking for good silhouette patterns. Often I find them in intimate small creeks and rivers. The reflections and interesting textures common to these sites are adapted to my pouring and spattering techniques. I found this scene near my home in Michigan's upper peninsula.

The barn . . . was done about six years prior to the larger background piece. Yet in color, style and composition they mesh perfectly as a single concept.

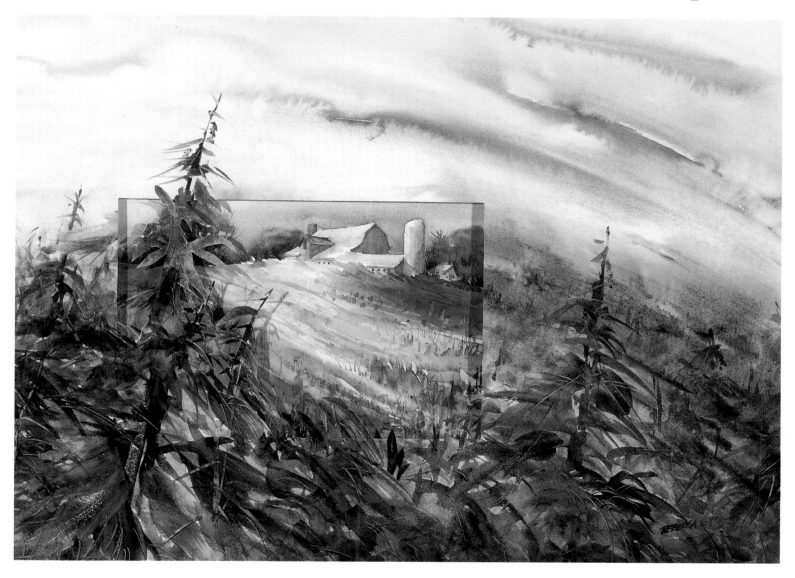

Rebecca Houck *Sunrise/Sunset* **22" x 29" Watercolor**

Last year produced some very interesting and surprising results when I collaged some older and unfinished works into new images. The barn scene inserted in this painting was done about six years prior to the larger background piece. Yet in color, style and composition they mesh perfectly as a single concept. The result is a unique image of simultaneous sunrise and sunset on the same landscape.

With a brush heavily loaded with pigment, I carefully charged the colors together on the wet surface.

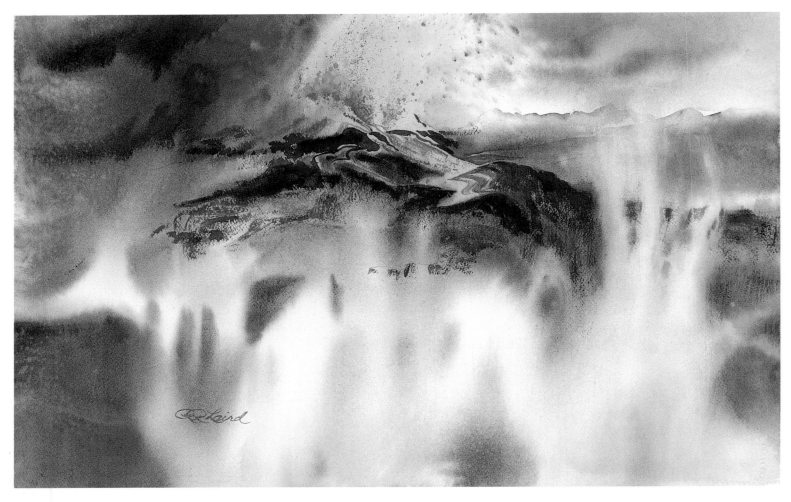

Robbie Laird *Volcano in the Mist* 15" x 22" Watercolor

To demonstrate Nature's transformations from solid, to liquid, to gaseous states, I chose an active volcano exploding into the sky, hurling up its own weather system of clouds, smoke, mist and fog. I began with a careful drawing which I transferred to Arches™ 140 lb. cold press paper. The paper was soaked for several minutes and placed on a sheet of Plexiglass to allow for longer time to work on a very wet surface.

With a brush heavily loaded with pigment, I carefully charged the colors together on the wet surface. My intention was to create a feeling of great force at work, so I ignored the detailed drawing and concentrated on the motion. The sense I wanted to convey is of solid rock becoming molten and exploding to become solid again while throwing off a new mixture of smoke, gases and steam. Additional motion was achieved by spraying water. When the first stage was thoroughly dry, I again transferred the drawing onto the underpainting and added just enough dry brush detail to give definition to the feeling of motion.

The entire paper was wet for each layer of pigment beginning with the lightest color first.

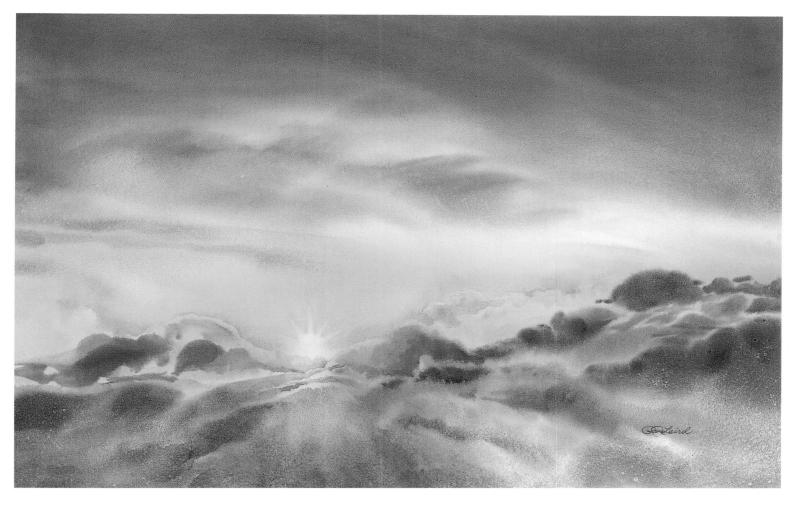

Robbie Laird *Haleakala Sunrise* 22" x 36" Watercolor

Luminous sunlight shines through clouds at sunrise. To give volume to the heavy moisture-filled clouds yet avoid making them appear solid, I painted in successive transparent layers. The entire paper was wet for each layer of pigment, beginning with the lightest color first. When each layer was thoroughly dry, selected areas were sprayed lightly with acrylic matte medium and allowed to dry before the next application of wet-into-wet pigment. The resulting effect is particles of light shining through moisture-laden clouds in varying densities.

Since my intent was also to convey the feeling of change in temperature from night to day, as well as darkness to light, I used color rather than detail. The intense light yellow back lighting is transformed to the cool purples in the clouds.

*After the outline was roughly sketched and underpainted,
I collaged a tattered layer of washi or handmade oriental
papers over the rocky foreground areas of the painting.*

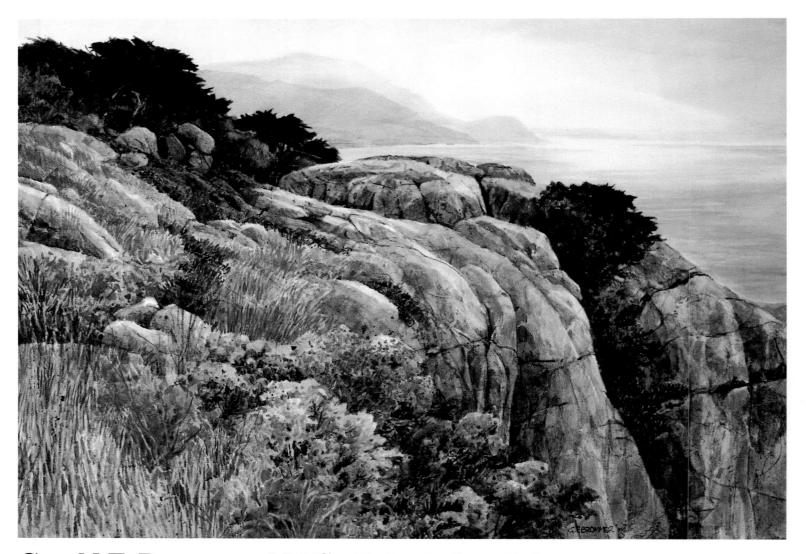

Gerald F. Brommer, NWS *Point Lobos Color* 22" x 30" Watercolor

The Point Lobos State Reserve area of the Central California Coast is one of my favorite painting places. However, this particular work was done in the studio from a sketch on location, and since the incredible textures of the rock surfaces were so exciting, I featured these in the painting. After the outline was roughly sketched and underpainted, I collaged a tattered layer of *washi* or handmade oriental papers over the rocky foreground areas of the painting. Pieces from about fifteen different papers were added to create the textural surface on which the painting was then built.

The complex textures and the hazy-bright light which characterizes and so often permeates this coastal area were the triggers that ignited my desire to paint this scene. Although much of the detail is not factual, but rather invented, the work is designed not to replicate a place but instead to stimulate a response similar to that which the viewer might feel at this location under these unique lighting conditions.

The poet Robinson Jeffers called this place, "the most beautiful meeting of land and water in the world." It was also a favorite locale of photographer Ansel Adams.

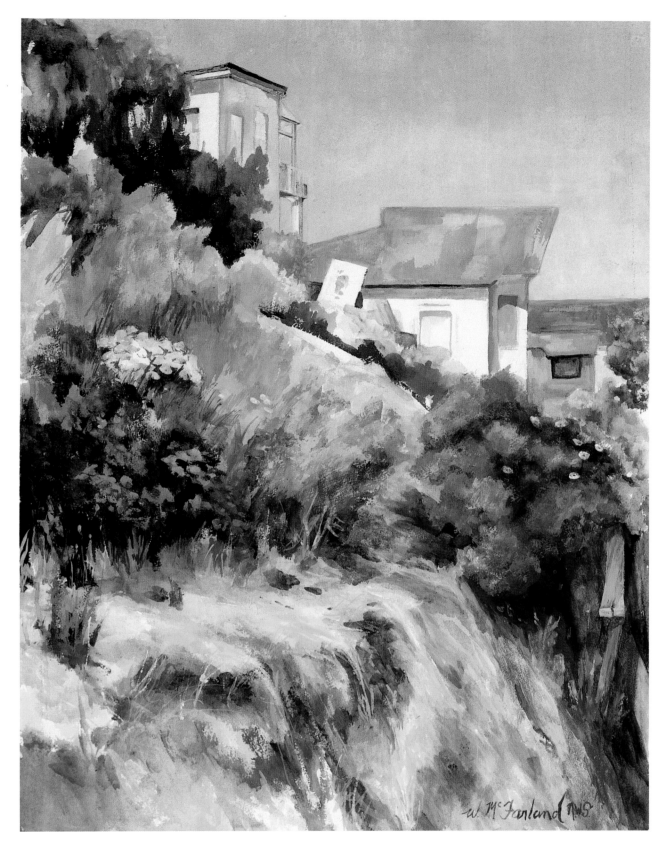

Willellyn McFarland, NWS *Catalina Hillside* 21" x 30" Watercolor & Acrylic

It was a bright, sunny morning on Catalina Island off the coast of California. Even the weeds in the vacant lot appeared brilliant and rich in color. The buildings' white walls and the sky and ocean contrasted against the complex textures of plant life. The lovely old cottages were from another time, and soon would be replaced by deluxe apartments. I had to paint this scene while I could.

I began by painting the dark shape of the trees in bold strokes of watercolor, not concerning myself with the transparent or opaque qualities of the paint. After the overall design pattern was established, thin washes of acrylic and some dry brush, for additional texture, were applied. The acrylic washes over the watercolor on Arches™ 300 lb. rough paper created a luminous quality that captures the mood of this special place.

*For me, color is the most exciting facet of painting.
The subject is often unplanned.*

Jacquelyn Fleming *After the Rain* 14" x 22" **Watercolor & Acrylic**

When painting intuitively, I "play" with the composition and the complementary colors. For me, color is the most exciting facet of painting. The subject is often unplanned. In this painting, I decided to experiment with some vibrant acrylic color over an unfinished watercolor. As the subject matter appeared, I considered value and composition and enhanced it when necessary.

The drawing for this painting was done while gazing at the landscape. I didn't look at the paper and I didn't lift the pen.

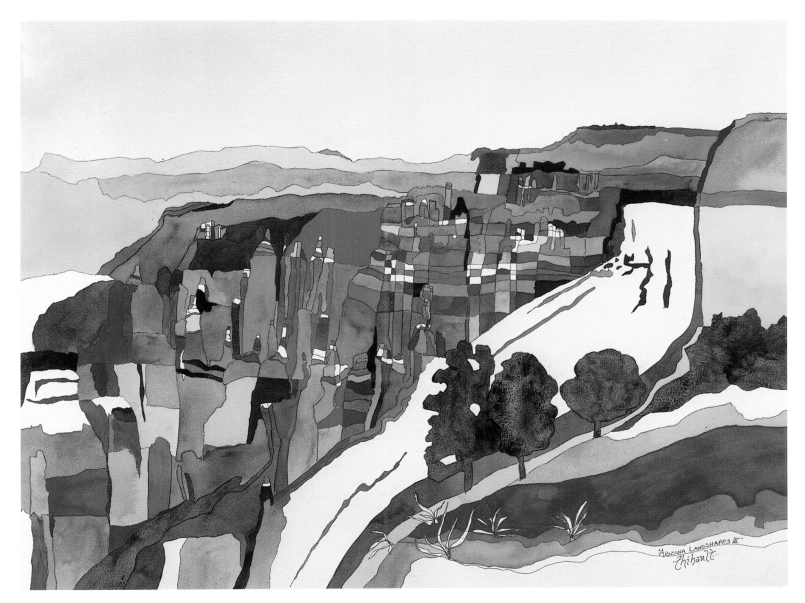

Deanna Thibault *Landshapes III* 27" X 35" Watercolor & Ink

The drawing for this painting was done while gazing at the landscape. I didn't look at the paper and I didn't lift the pen. This process is called contour drawing and works well because it brings out the artist's true observation of the subject. To be successful, the artist develops strong hand-eye coordination through practice. Once this skill is learned, the pen does what the eye sees — rather than what the artist thinks. This painting is from a photograph I took as my husband flew our airplane over the Grand Canyon.

Once the canyon shapes were on the paper, I selected a group of colors found in nature. These included reds, blacks, grays, browns, and others produced by combining red with green, orange with blue or yellow with purple. As the canyon developed, specific details just appeared. First the central figures, reminiscent of Native Americans draped in traditional blankets, took shape. Then a pueblo and finally the river bed itself appeared. While the shapes are abstract, there is just enough detail to entice the observer. Do you remember, as a child, seeing all those wonderful shapes in cloud formations?

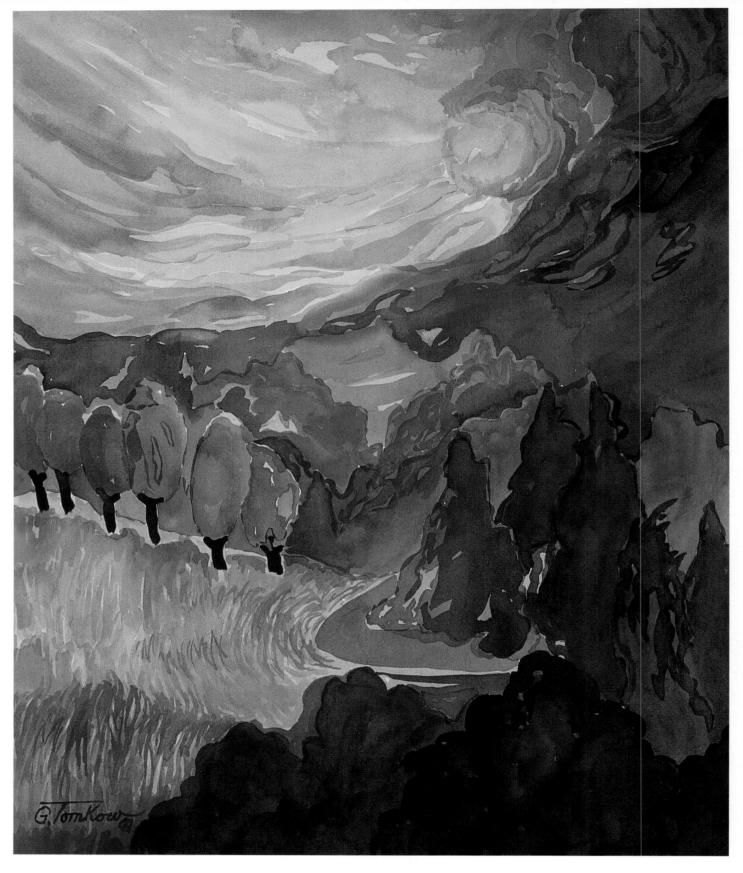

Gwen Tomkow, NWS *Path in the Night* 21" x 28" Watercolor

The vision in the heavens on this moonlit night, disturbing yet hopeful, remains etched in my memory. As morning broke the next day, my nightime experience surfaced again. I recalled driving the curved road up and over the hilly peninsula. The poplar trees were all aglow, guarding the plowed fields and orchards and holding back the wind. The tall spruce trees looking like animated triangular-shaped soldiers marching in place and nodding their heads as we pass by them. Veils of color floating across a cadmium-yellow moon. I see it still!

I begin with a five minute sketch. My pulse quickens, and I'm filled with a special energy as I reach for water and paint. Reacting from heart to hand, the paint literally flows off the tip of the brush. Hopefully, I've turned this fairytale night into an emotional, moving painting.

The shadows cast cool, velvet patterns in the sand. I can feel the swaying rhythms as I contemplate the scene before me.

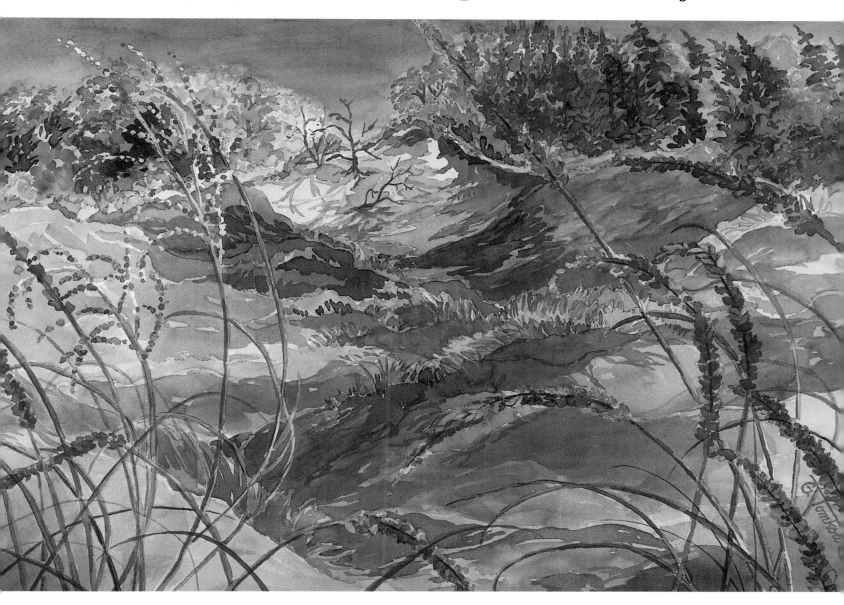

Gwen Tomkow, NWS *Velvet Dunes* 21" x 28" Watercolor

A trail of footprints left by early hikers are all that disturb the crystal sand. The fall afternoon is breezy, and the sunshine wraps around me like a cocoon. I'm luxuriating in the moment, thankful for the quiet solitude. The tall grasses resemble 4th of July sparklers as the sun's rays light their fuses. The shadows cast cool, velvet patterns in the sand. I can feel the swaying rhythms as I contemplate the scene before me.

The landscape artist must capture the moment quickly, so she learns how to hastily prepare, sketch and begin without adhering to realism. I mask the grasses to be lifted later, letting their sweeping movements reach all the way to the top of the paper. The viewer will feel as though he's peeking through them when the painting is complete. I use a Raphael™ #18 brush for washes, #10 Watercolor brush for trees etc., and Arches™ 140 lb. paper. Working on dry paper and layering many times, I gradually add my signature palette to the ever-changing view of the *Velvet Dunes*.

73

The Southwest

The ground was painted with a flat 1" watercolor brush, and the sky with a round brush.

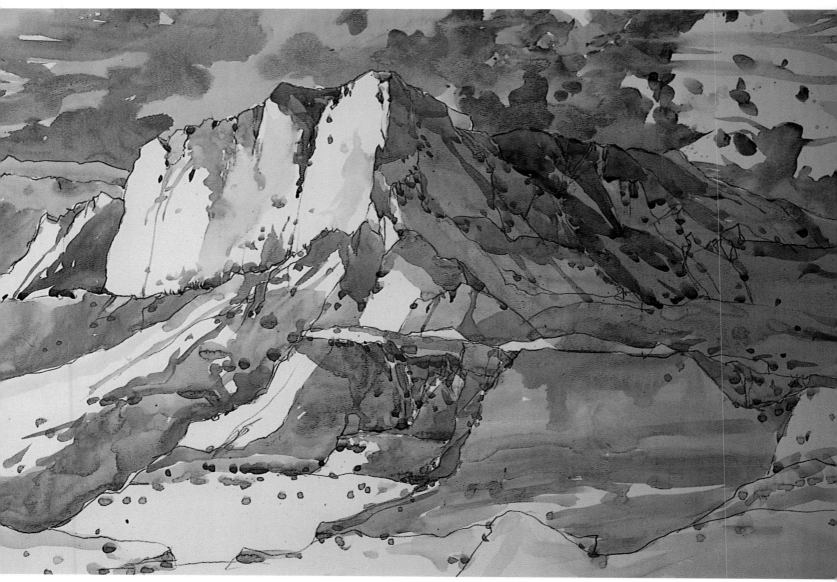

Bill Herring *Guadalupe Mountains* 22" x 30" Watercolor

 I tried to capture the intoxicating sky of the Southwest, using the highest mountains in Texas as a motif. Painted in my studio from photography, it was drawn first in graphite on 140 lb. cold press paper which caused an unusual texture. The ground was painted with a flat 1" watercolor brush, and the sky with a round brush. Color selection was arbitrary and indicative only of the whims of the artist.

Footwear offers the still-life painter wonderful convoluted shapes as well as all kinds of patterns and color combinations.

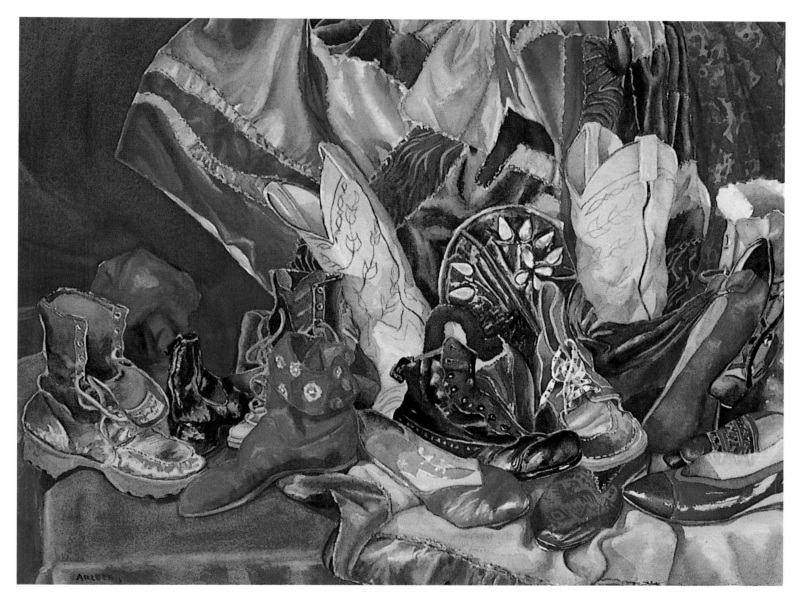

Arleen Ruggeri, NWS *Patchwork & Leather* 20" x 28" Watercolor

Shoes make an interesting still-life subject, revealing so much about their owner. A few years ago, the frozen body of a human male was found in Europe where he had lain in the ice for thousands of years. On his feet were primitive, handmade sandals which astonished archeologists because the sandals suggested a higher degree of civilization than had been believed possible for that era.

Footwear offers the still-life painter wonderful convoluted shapes as well as all kinds of patterns and color combinations. I prefer to paint old, used shoes because I feel as though I am studying a biography or solving a mystery about the person who once wore the shoes. In a way, it is a form of portraiture.

In *Patchwork & Leather*, the variety of shoes provides interest, color, shape and pattern. The patchwork is a skirt of hand-sewn velvet and satin which repeats the colors and adds contrasting shapes and textures. To keep the colors bright, I use only transparent paint and do repeated glazes after each coat of paint is very dry.

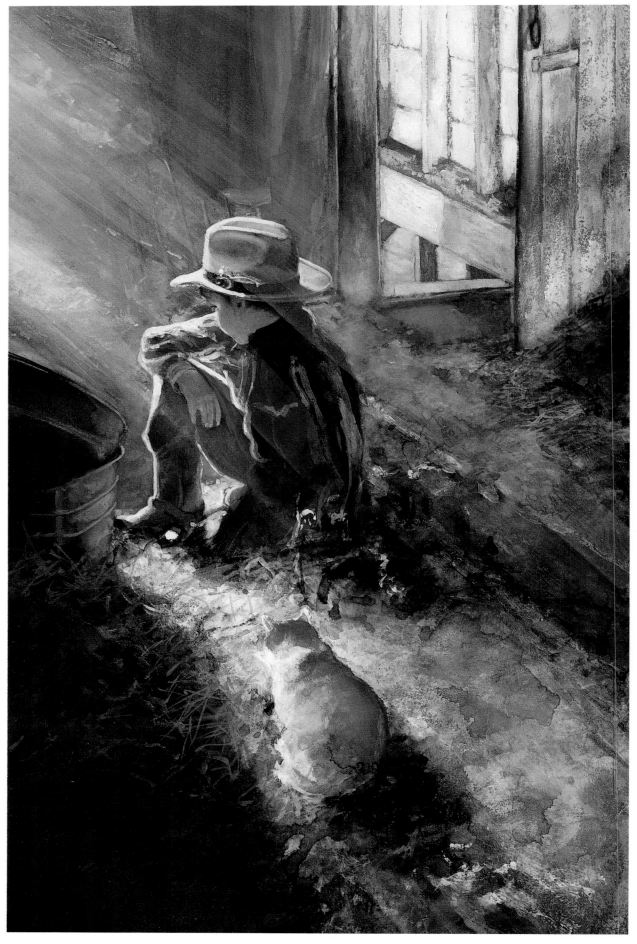

Lynne Yancha, AWS *My Eirik* 12" x 18" Watercolor

I'm fascinated by my feelings towards aloneness. I like to paint "aloneness" with all its nuances. Since childhood I've been lured by the mystique of farm life. To me the barn is alive with dusty shafts of magical light. The massive timbers vault up to a ceiling filled with birds. My thoughts are at rest with the scene.

It wasn't so much the form that interested me as
it was the nature of this bright, earthy woman . . .

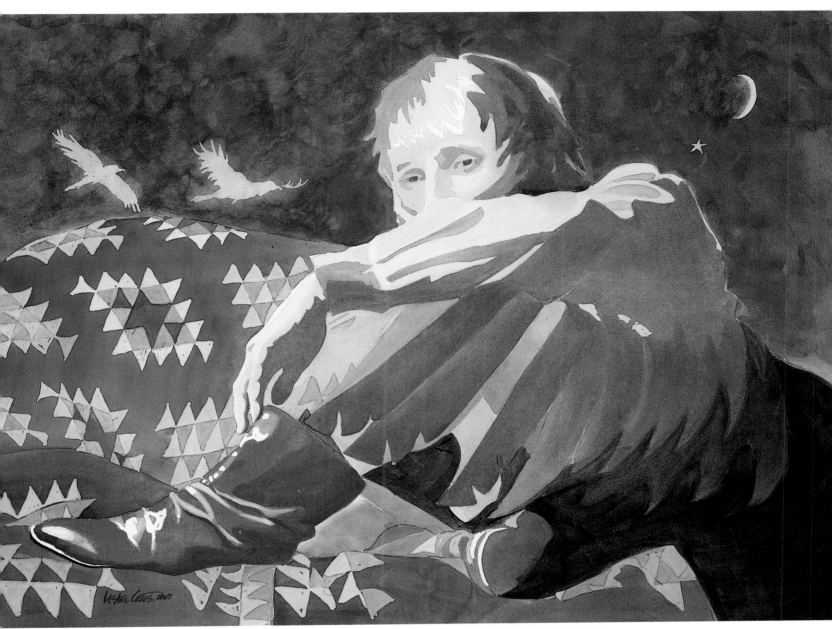

Leslie Cates, NWS *Grounded in Red* 22" x 30" Watercolor

It wasn't so much the form that interested me as it was the nature of this bright, earthy woman who was raised in the Southwest, who had studied the ravens place in Native American lore, who moonbathed each month and had woven, in ribbon, a new raven every morning to count the passage of days between the solstices which measured the cycles of the earth's turnings. Her life was steeped in symbolism and I fancied that she could actually achieve flight if she hadn't been so grounded in red.

Flowers

I added a silk scarf to balance the background color with the colors of the flowers on the tablecloth.

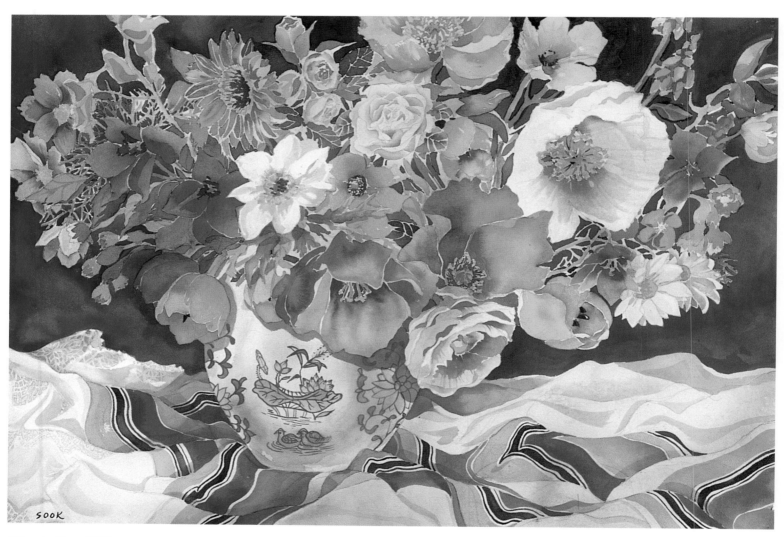

Sook-Kyung Hong *Still Life #4* 21" x 29" **Watercolor**

A bouquet of flowers is my favorite still life subject. I have a small garden where I observe the colors of the petals of my flowers. I paint them as close to reality as I can. In *Still Life #4*, I added a silk scarf to balance the background color with the colors of the flowers on the tablecloth.

*The whites of the flowers dominate and
the general mood is one of warm richness.*

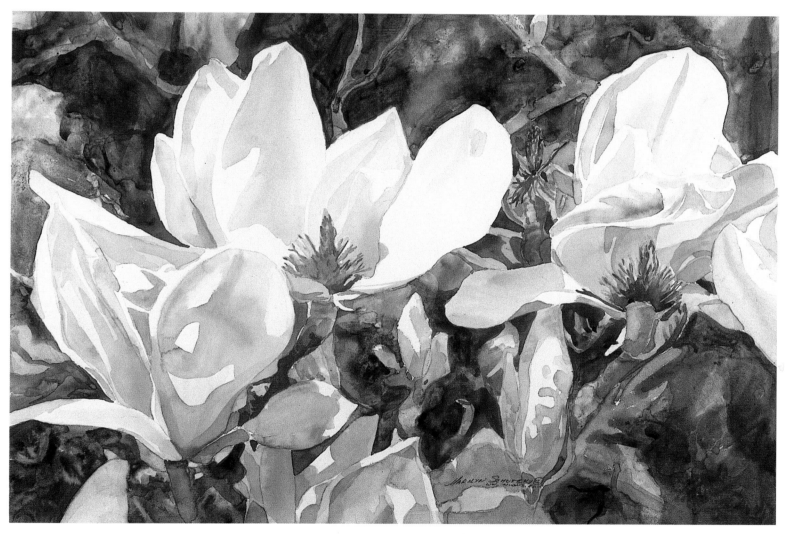

Marilyn Schutzky *Magnolia Grove* 22" x 30" Watercolor & Acrylic

I've always liked magnolias because I've never had the opportunity to grow them where I live. I seek them out wherever they can be found. The thick velvety petals evoke a feeling of elegance and richness with their centers of bright warmth. The glossy leaves bounce light around while underneath there are soft suede backs that absorb much of the bouncing light.

This picture has an underpainting of acrylic medium in the background area only. Metallic copper has been added to the background and in the colorful center. The whites of the flowers dominate and the general mood is one of warm richness. *Magnolia Grove* was painted on Aquarius™ paper.

I drew the poppy shapes with a water soluble graphite pencil . . .

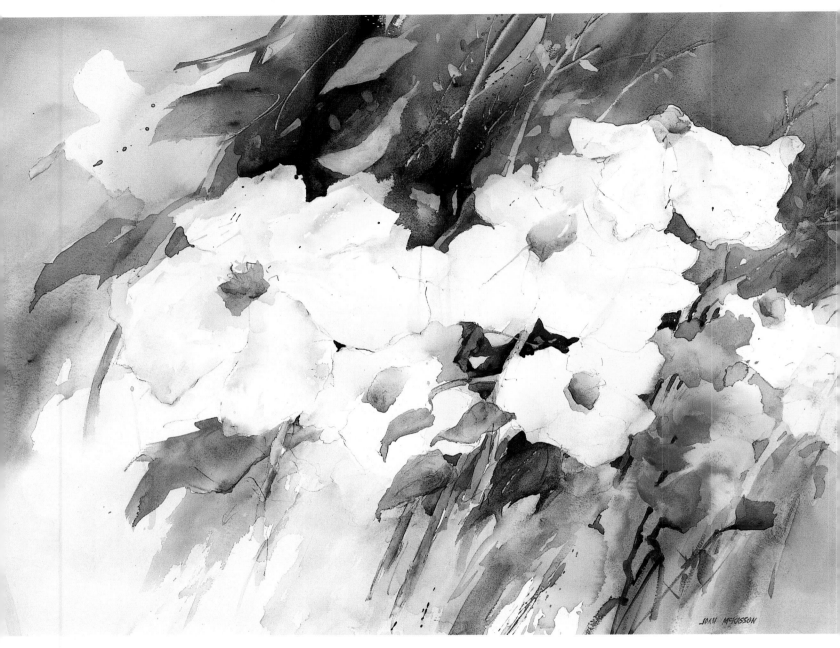

Joan McKasson *Windswept Poppies* 22" X 30" Watercolor & Gouache

While I was teaching a San Diego Watercolor Society workshop, a student brought in some Matilija poppies from her yard. Because the Matilija poppy is one of my favorite flower subjects, I decided to demonstrate how to paint white flowers by having the white of the paper serve for the flowers.

Preferring not to draw my subject first, I splashed clear water on my paper, creating a pattern for the background while leaving the area I visualized for the poppies dry. Adding yellows, reds and blues into these washes, I allowed the paint to mix on the paper, creating the feeling for the sky while at the same time establishing color patterns for the smaller flowers. With the paint still wet, I drew the poppy shapes with a water soluble graphite pencil and brushed in a few leaves and centers for the flowers. Some small flowers were added for contrast. The next step was to establish the dark negative shapes to define the edges of a few of the flowers. I was careful to leave some "lost and found" edges on the flowers to create an overall dynamic shape for the main subject of the painting. Because Matilija poppies have such magnificent large white petals, I added just enough color to the petals to provide contrast but not distract from their beauty. I scraped a few stems on with a palette knife and then added splatter for outdoor texture. In my studio, I studied the painting carefully so as to use as few strokes as possible to complete the design and retain the sense of immediacy. I did not want to lose the wind-tossed outdoorsy mood of the piece.

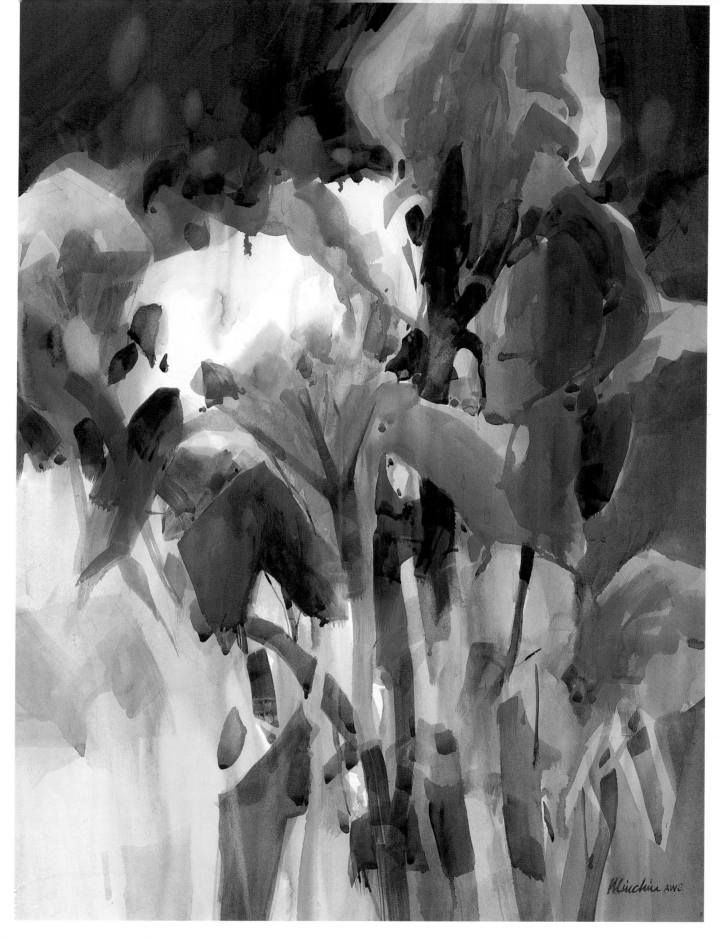

Edward Minchin, AWS, MWS *Iris Splendor* 21" x 29" Watercolor & Acrylic

I was inspired to paint *Iris Splendor* by the vivid light playing over the flowers. The intensity of the color rather than the composition or subject matter caught my eye. I painted very fast with a great deal of energy and emotion, leaving out much of the detail. I just focused on capturing the feeling and pure essence of the subject in that brilliant light. Once I had begun painting, I barely glanced at the subject, working more from memory and those first intoxicating impressions.

. . . I invent whatever the painting needs.

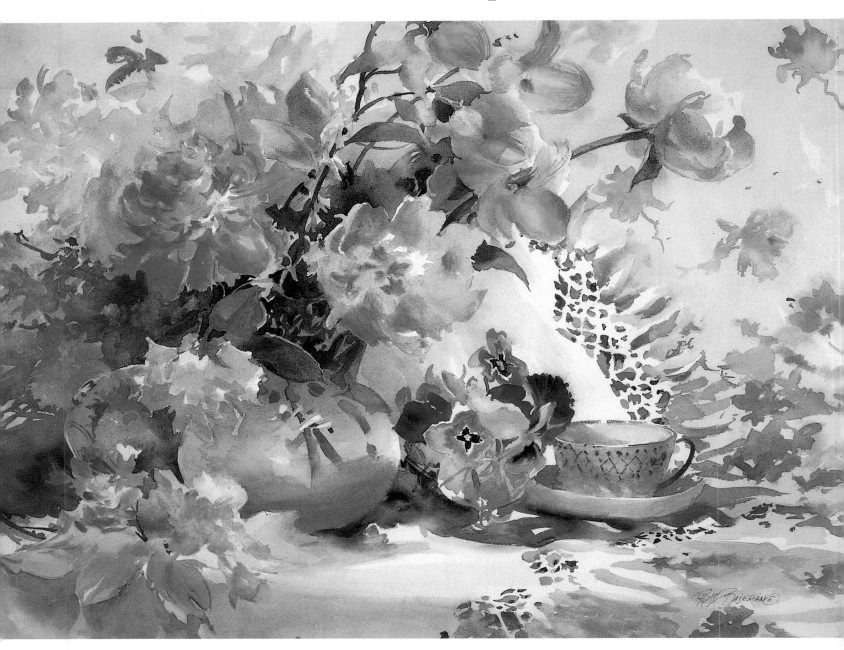

Ruth Baderian *Victorian Tea* 22" x 30" Watercolor

The notion that artists wait for waves of inspiration and emotion to wash over them before they paint is largely a myth, in my opinion. Rather, it is the time spent solving technical problems that eventually opens new areas of free-flowing ideas. Some days ideas flow easier than others! A lovely spring day, bursting with buds and new foliage, set the stage for *Victorian Tea* and the ideas did flow that day.

In picking the flowers and foliage, I chose those which varied in size, shape, color and texture and promised to work with the containers and the background I had in mind. I played with the arrangement until the colors and design seemed to click. To me the arrangement takes the place of a preliminary sketch, and I always say that a good arrangement takes me three quarters of the way through the painting process. After that I invent whatever the painting needs. As a former flower arranger, I am turned on by live plant material. It can produce powerful graceful lines, suggesting patterns and shapes that would be hard to invent. I worked with a spotlight on the flowers to further enhance the design— simplifying shapes by allowing elements to blend into the shadows and to create important accents with light. I decided to use clear, round containers to establish a sense of continuity. Backgrounds that work naturally with the foreground elements are hard to come by. Here I deliberately chose a patterned tablecloth that repeated the flower motif and seems to rise up behind the flowers, linking foreground and background to produce a three-dimensional feel. The diagonal positioning of the cloth and the fringe creates a sense of movement and helps carry the eye through the painting to the focal point — that group of flowers which contains the painting's strongest contrast in value, color and edge.

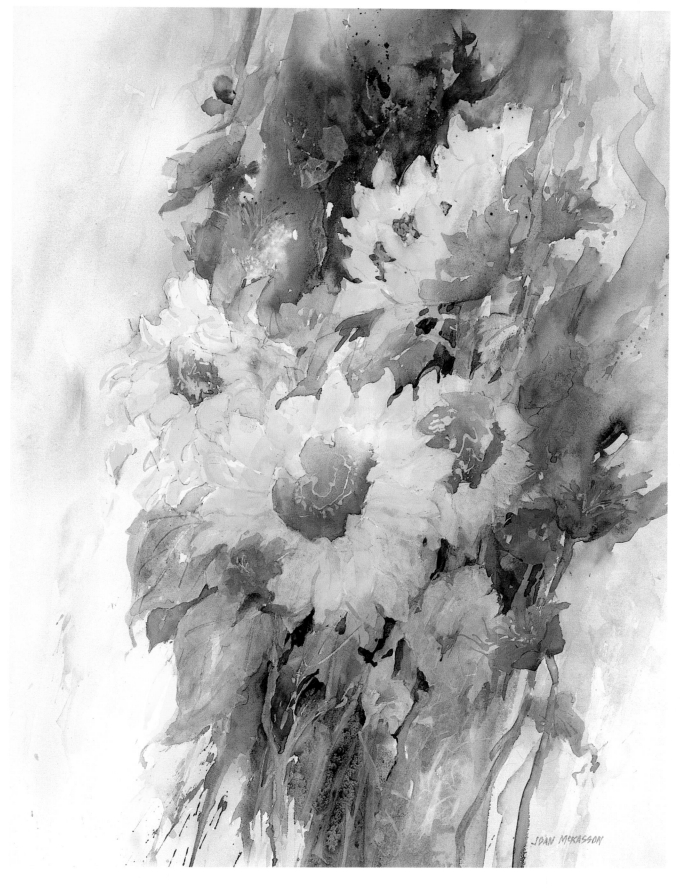

Joan McKasson *Sunflowers & Thistles* 22" x 30" Watercolor Collage

I remember painting **Sunflowers & Thistles** with great enthusiasm. I brushed in clear water shapes, encouraging the water to flow. I added new gamboge and yellow ochre into the wet passages for the sunflowers and allowed the pigment to run. Following this I introduced red, purple and green mixtures, establishing the sunflower centers, thistles and the leaves. I used a water soluble pencil to draw the shapes of the flowers and while the paint was wet established some guidelines to develop the flower images. Other linear accents were added as calligraphy. Oriental paper and pre-painted tissue paper were added as collage to enhance the textural feeling I was looking for in this wilderness statement. A light atmospheric background and dark mysterious negative shapes were added to bring out the sun-washed vitality of the sunflowers.

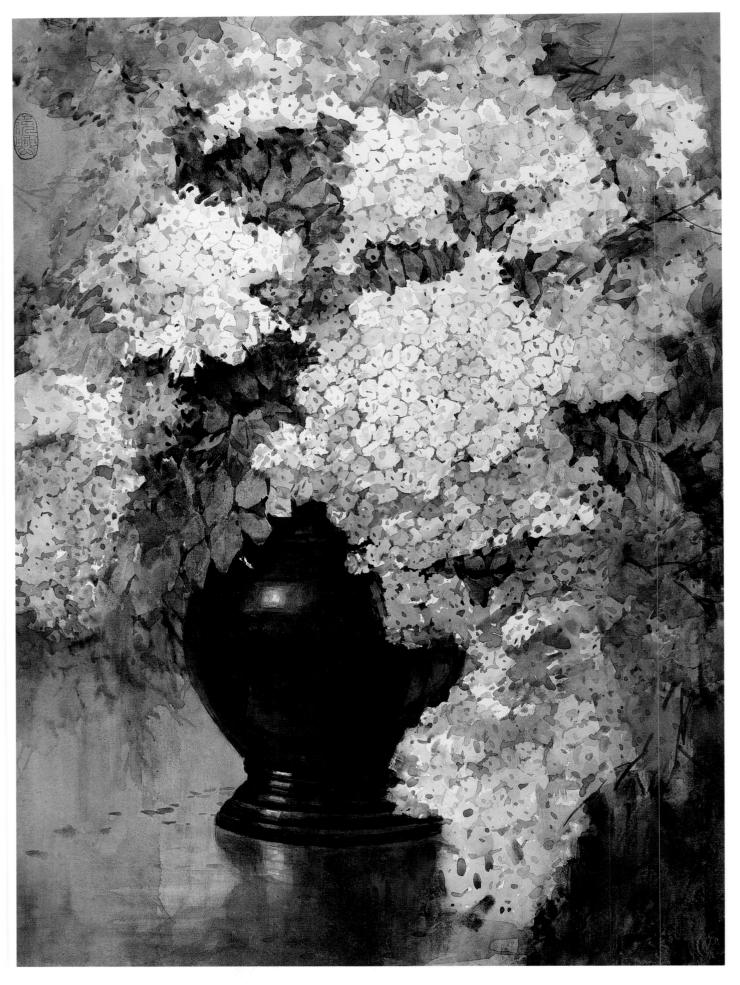

Mei Shu *Lilac in a Vase* **22'' x 30'' Watercolor**

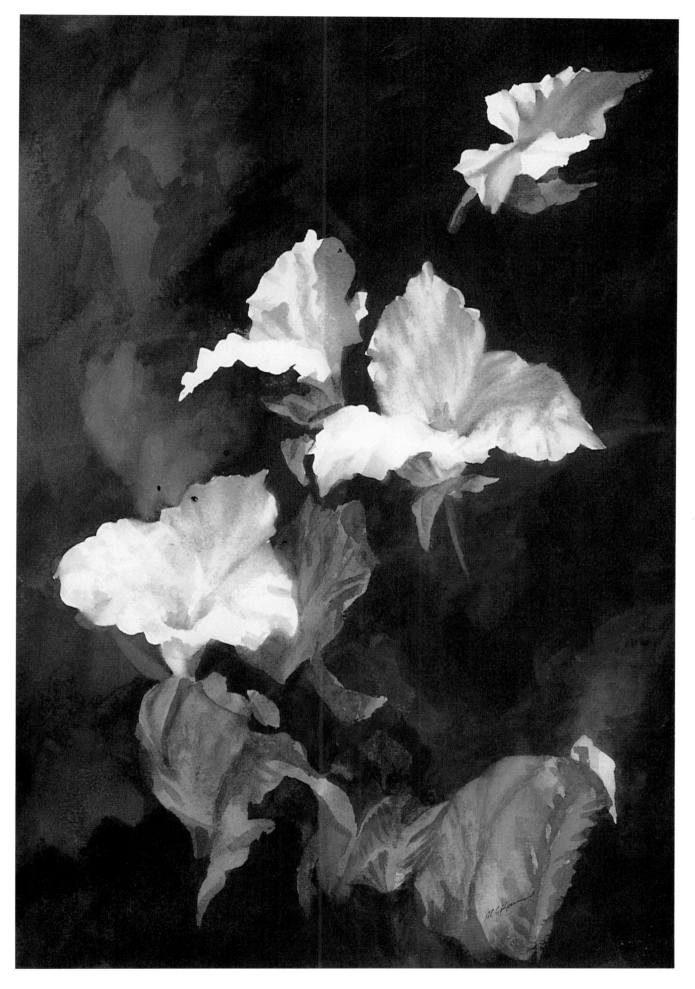

M. C. Kanouse *Trillium* **14" x 20" Watercolor**

*To achieve the glowing whites, clear color was applied
in minute mosaic "chunks" within the petaled areas,
giving them the appearance of faceted brilliance.*

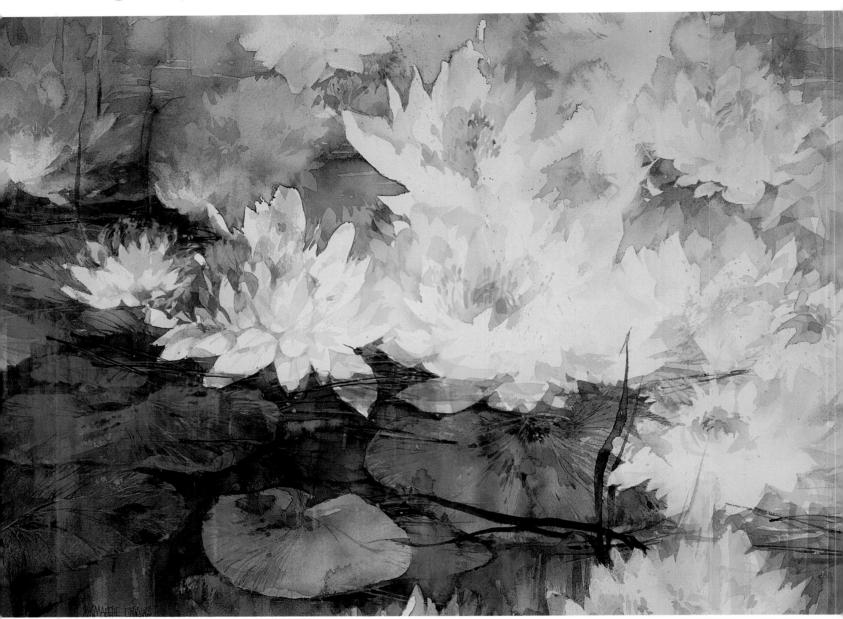

Maggie Linn, AWS *Water Lily Ballet* 16" x 22" Watercolor

The canoe quietly slices the warm undulating waters. The wind begins to push the water lilies in slow, almost imperceptible movements. A raucous call from an unseen bluejay— answered by a chickadee— seems to heighten unspoken expectations while I explore this mysterious region of the lake.

The fragrance of the water lilies, and the hum of the bees and other insects becomes heavier in the late afternoon sun. Gusting playfully, the wind lifts the green lily pads, making them flap and wave their russet undersides. The water lilies tilt and shift, showing off their glowing whiteness. Later, as the wind finally chases itself into the cool woods, I follow it on the newfound stream, leaving behind a stiller lake. Slowly the water lilies fold their petals for the night.

To achieve the glowing whites, clear color was applied in minute mosaic "chunks" within the petaled areas, giving them the appearance of faceted brilliance.

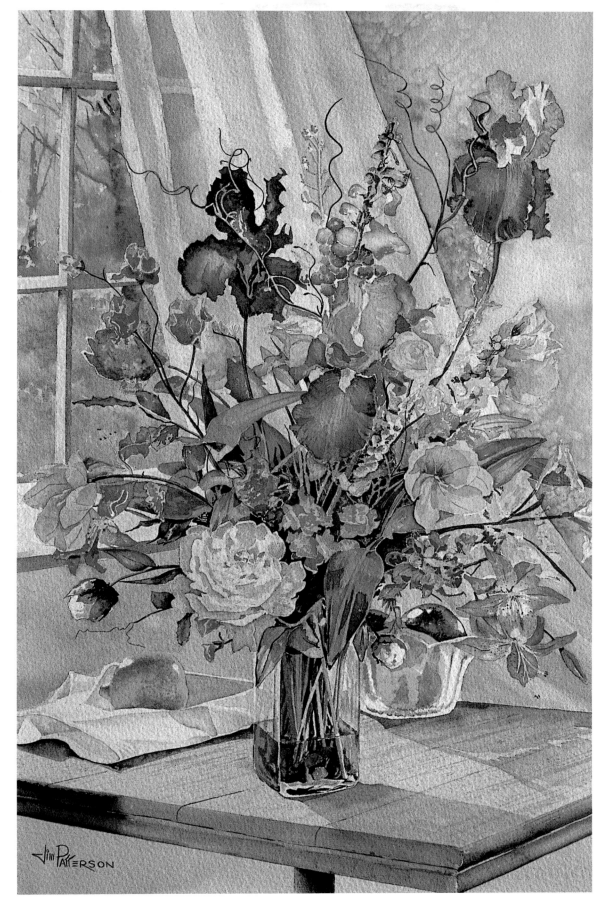

Jim Patterson *Bright Bouquet* 14" x 20" Watercolor

The morning light created a pattern of shadows over the table surface. Lemons and lime were added to complete the composition. The background was rendered in light values so it would not distract from the flowers but still give the feeling that the curtains are stirring in a light breeze. I've tried to pull the viewer from the window to the flowers, then down to the vase and fruit on the table and then back to the center of interest to show movement from shape to shape. Overall the painting embodies a realistic/semi-abstract quality. This painting approach has been very effective in capturing the beauty that I see in Nature. It allows my technique to flow throughout the painting, providing a balance of color and composition that awakens the imagination of the viewer.

*I decided to enhance the contrast by making the
background very dark. I adjusted the
line of the table for better composition.*

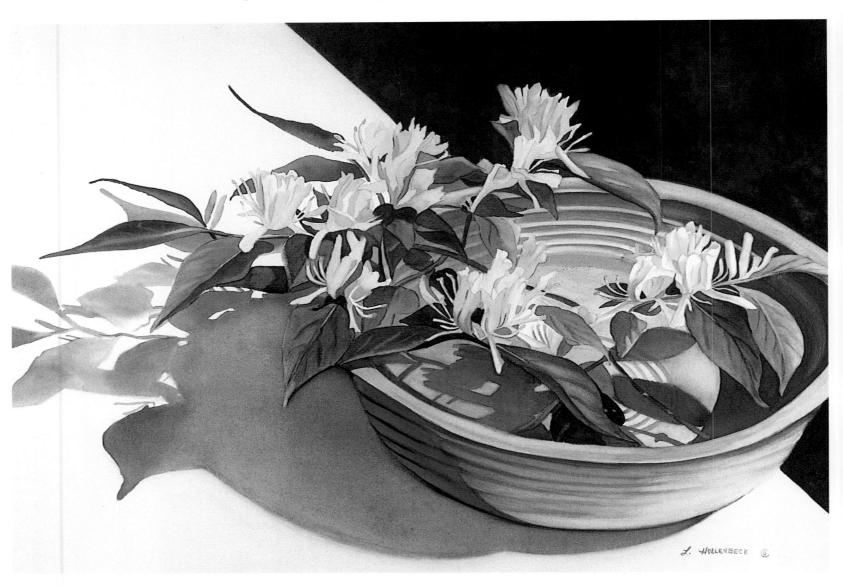

Lori Hollenbeck *Honeysuckle* 21" x 29" Watercolor

I brought a sprig of honeysuckle into my studio and laid it in a blue bowl. The sun shining through the window created a lovely shadow on the white table. The flowers were very delicate and the shadow contrasted against the hard graphic edge of the table.

While painting **Honeysuckle**, I decided to enhance the contrast by making the background very dark. I adjusted the line of the table for better composition. I love realistic watercolor painting.

I glazed many layers of transparent pigment on the plant to build up the intensity of colors and let the strong light enrich them.

Virginia Blackstock *Canyon Palette* 28" x 36" Watercolor

My family and I were hiking into Horseshoe Canyon, west of Canyonlands, when I came upon this beautiful Indian Paint Brush growing between huge sun-bleached stones. I felt as though I had discovered a treasure trove of gold. The Paint Brush stood in brilliant sunlight and its color almost bonded with the deep shadow patterns. I was compelled to fall behind the others, to sketch and study the subject's delicate brushlike petals. I glazed many layers of transparent pigment on the plant to build up the intensity of colors and let the strong light enrich them.

Bernyce Alpert Winick, AWS *Cantábile* 21" x 29" Watercolor

Watercolor excites me —

The freshness and the depth of it,

The movement and the flow of it,

The mixing and the blending of it,

The manipulation, and finally,

The control of it.

. . . a full range of values . . . keep the eye moving throughout the painting . . .

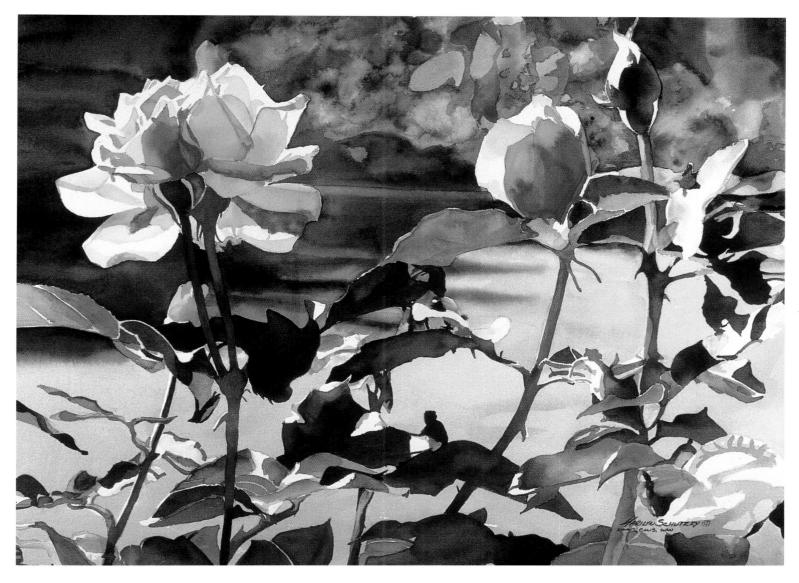

Marilyn Schutzky *A Rose is a Rose* **22" x 30" Watercolor**

I found these roses in the Buchart Gardens, Vancouver Island, Canada. For me, the excitement of this painting lies in the incredible patterns made by the bright sunlight and the deep shadows that are cast. I used transparent watercolor on Arches™ 300 lb. paper with wet-on-wet in the background. The foreground roses are painted with multiple glazes. This amount of bright sunlight requires a full range of values. Values keep the eye moving throughout the painting and, of course, are paramount in setting off the center of interest.

The whites dance throughout the painting, connecting in some places and disappearing in others.

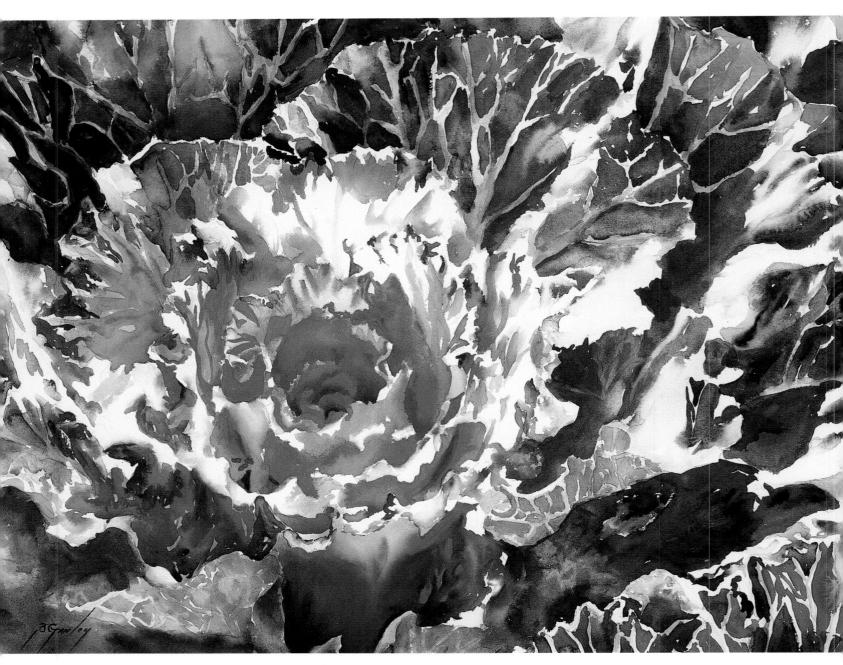

Betty Ganley *La Plumage* **19" x 25" Watercolor**

The intense sun did amazing things to this lovely cabbage flower. The areas where sun bounced directly off the surface of the flower were left glaringly white with just touches of blue reflecting the sky. Other areas of the green leaves which turn skyward were painted a cool green — using mixtures of viridian and cobalt or ultramarine. The areas turned towards the ground reflect the warmer earth tones.

After sections of the leaves were dampened, paint was applied to the wet section and allowed to spread on its own. This established the softer edges which were complemented by the more obvious hard edges. Some of those hard edges were left white or very light to very dark. This produced a lovely crispness and sparkle. The whites dance throughout the painting, connecting in some places and disappearing in others.

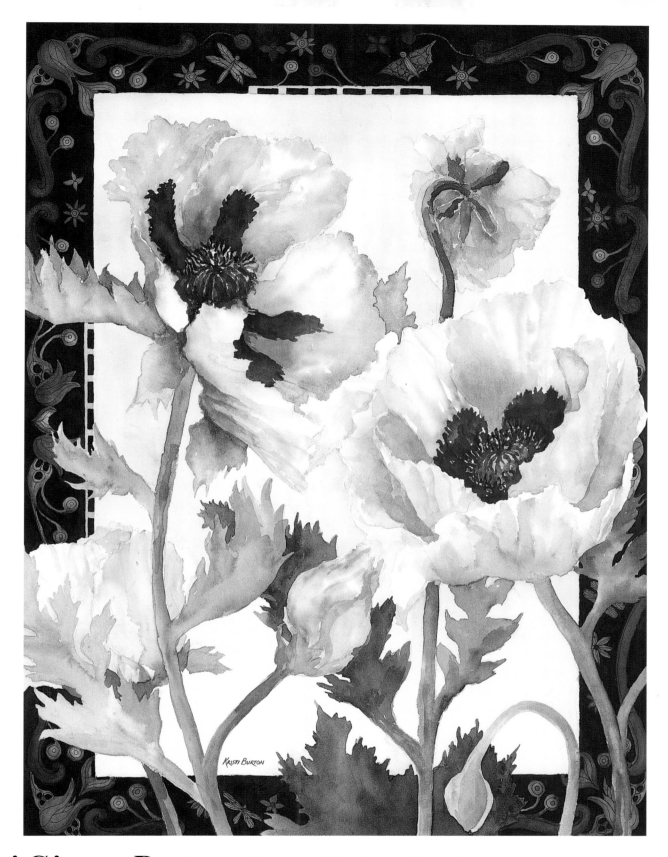

Kristi Gjesme Burton *Friday Harbor Poppies* 22" x 30" Watercolor

Every year, I see a new type of poppy in the San Juan islands that didn't seem to be here before. *Friday Harbor Poppies* was painted in one long sitting, spontaneously, using mostly quinacridone pigments. The border and background evolved later after some contemplation and were much more deliberate. Painting on two separate occasions this way reminded me how much I appreciate the wonderful immediacy of watercolor, because it allows me full expression of my many moods.

While painting, I became absorbed with the transparent color of the petals, which seemed to be just on the salmon side of pink. I am especially fascinated by the poppy centers. Floral subject matter was discouraged during my formal art education, and for a long time I didn't paint flowers. In fact, for a long time I didn't paint at all. The abundant wonders of nature are a spiritual source of inspiration for me. I love to paint and explore each new flower or any of the other hundreds of images still waiting, like children on a waterslide, to be next.

Spring was the inspiration for this painting with its promise of a warm summer soon to come.

Joan Cawthorn *Patio Flowers* 15" x 22" Watercolor & Gouache

Travel

*Painting on location, though very distracting,
is an excellent way to develop excitement.*

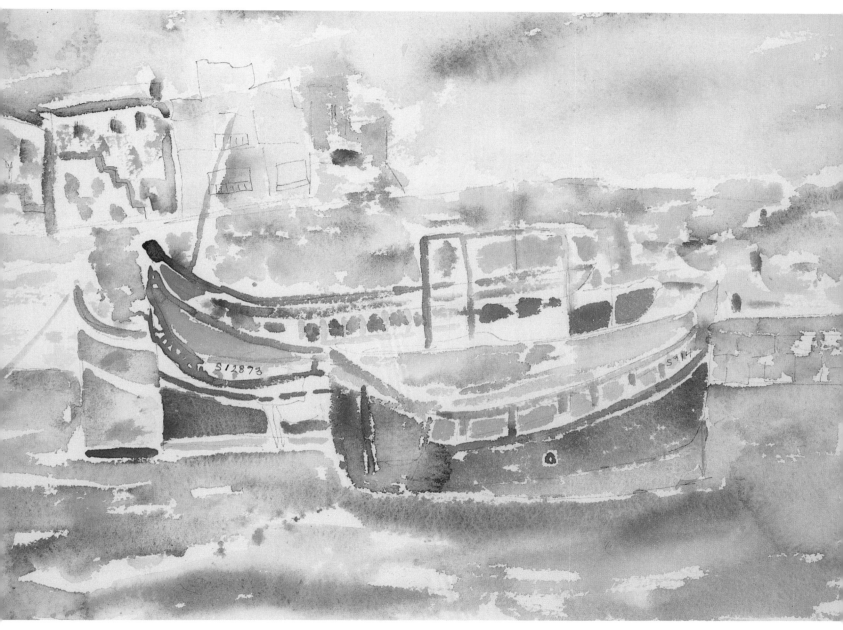

Christine M. Unwin, NWS *Malta* 22" x 30" Watercolor

Last spring I took a group of artists on a Mediterranean cruise. Malta was our first stop, and we decided to go to the pier which some of the artists had visited the year previous. On a quarter sheet of 300 lb. paper I did a quick sketch of the colorful fishing boats. Painting on location, though very distracting, is an excellent way to develop excitement.

I began to paint the Mackinac Race from photographs taken onboard the press boats.

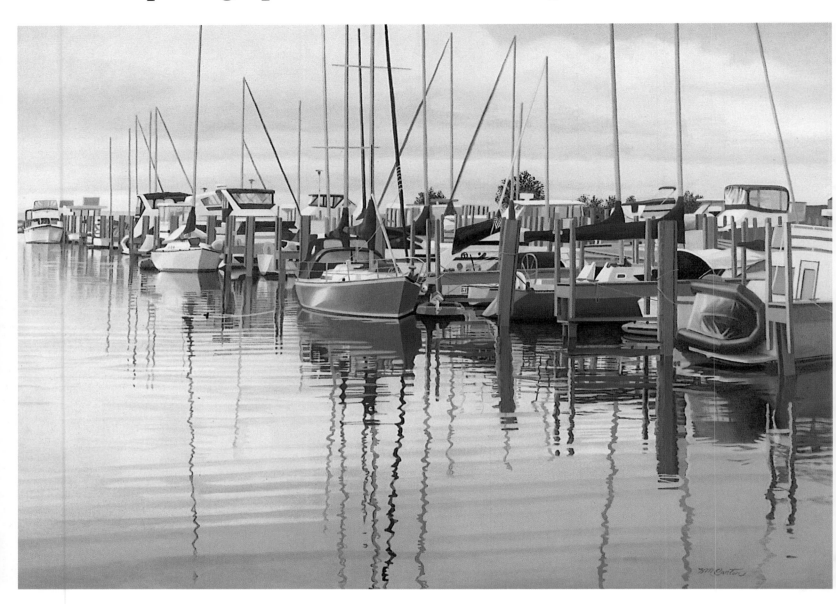

Karen Carter VanGamper *Mackinaw City Marina* 36" x 48" Oil

Mackinaw City Marina is a sample of the evolution of my painting style into predominantly marine and nautical subjects. My work has always included a great deal of landscape painting. Water scenes of marinas and boats became my primary interest after I began to paint the Mackinac Race from photographs taken onboard the press boats. The race committee allowed me to photograph the Port Huron to Mackinac Yacht Race from one of several official boats on the starting line. I was named Official Artist of the Mackinac Race one year, and I have had exhibits at the Port Huron Museum and on Mackinac Island at Mission Point Resort.

Because I had never sailed on the boats I was studying and painting for years, I joined a club in the Detroit area called Sailing Singles. Through this group I met my husband, Henry. We have sailed all over the Great Lakes, photographing and painting many wonderful locations. We have made many friends, some of whom crew with us on our 42-foot ketch sailboat. The boat in the foreground of this painting belongs to a friend who also sails the North Channel and the Great Lakes. Here the boat *Wind Trails* is seen tied to the end of a dock in a very busy marina. Note that the spelling of the Mackinaw City Marina is the Indian spelling, while Mackinac Island is the French.

My work is now created in the studio from photographs taken on our long trips. I often paint marinas, because there are so many wonderful compositions of boats and water reflections, with docks, buildings, and cloud patterns to add interest. I enjoy the challenge of perspective and shadow patterns on white and blue hulls.

I can almost walk into my painting and relive the pleasures of the experience . . .

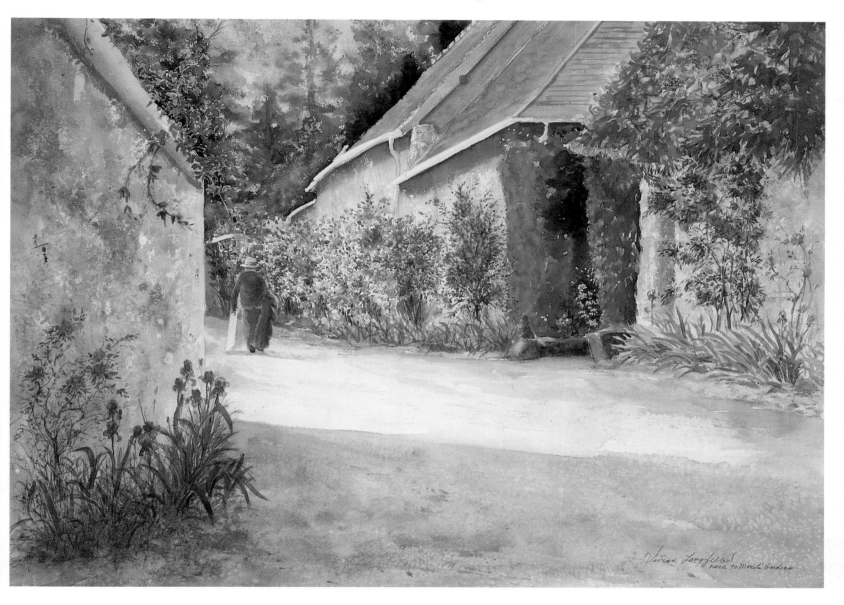

Vivian Longfellow *Road to Monet's Garden* 16" x 20" Watercolor

Memories . . . that's what ***Road to Monet's Garden*** is about. I can almost walk into my painting and relive the pleasures of the experience depicted. Giverny is a village of gardens. I wanted to capture the beauty and variety of the roses along this particular pathway. The direction of the road and the warm yellow of the sunshine sends the traveler into the same moment that the artist passed through.

I was pleased with the bold effect I created!

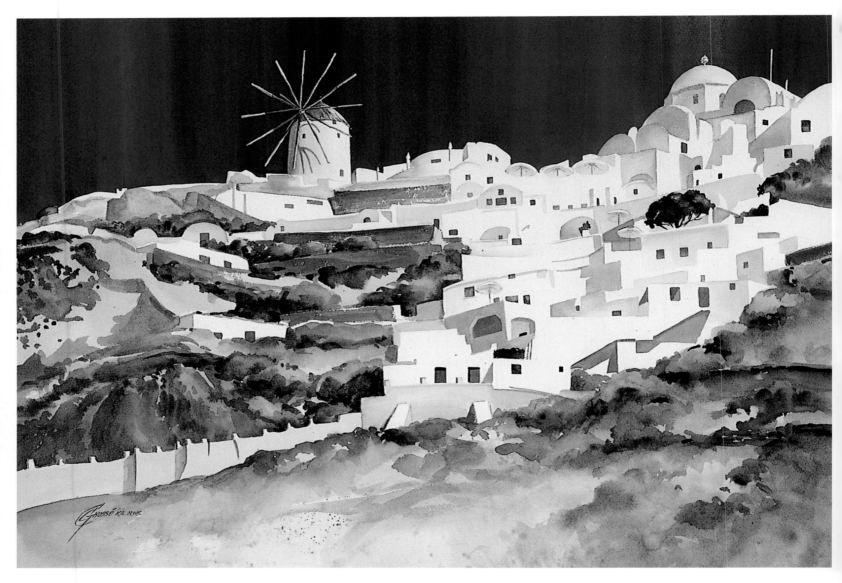

Carolyn Grossé Gawarecki, NWS *Greek Idyll* 21"x28" Watercolor

Santorini is a spectacular place to paint, with white-washed houses and domed churches framed by a deep blue sky and even bluer water. In painting **Greek Idyll**, I decided to join the clusters of buildings dotting the hillside into one large continuous shape rambling over the steep rocky hillside of the volcano's caldera. Liquid mask was used along the upper edges of the buildings and the vanes of the windmill. I wanted to create a vibrant blue sky to make the whites pulsate. Instead of conventional sky brushed in horizontally, I started painting with wide vertical overlapping strokes for a more dynamic effect. I applied the paint wet-in-wet using Winsor Newton™ Thalo Blue to the red shade and kept adding thicker paint until the blue was rich and strong. Then I added Alizarin Crimson and Indigo Blue directly to the area behind the windmill. Shadows on the buildings reflect the blue sky and warm earth tones. In true watercolor fashion, light is placed against dark and warm colors oppose cool colors. I was pleased with the bold effect I created!

. . . this wonderful rooftop composition caught my attention.

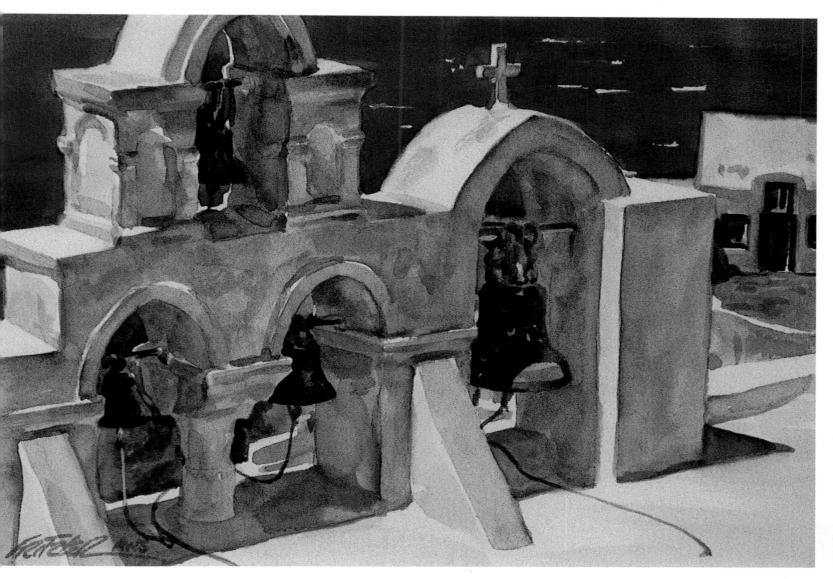

Gerald J. Fritzler, AWS, NWS, MWS *The Bells of Santorini* 6" x 9" Watercolor

 While hiking around the Greek island of Santorini, this wonderful rooftop composition caught my attention. The strength of the design and the lighting were the attraction. The light, shadows and reflected light, together with the deep blue of the sea behind the bell tower really made it outstanding.

 It was the stark contrast and bright light that I was after, along with the beautiful play of warm and cool reflected light in the shadows. The *Bells of Santorini* captures the feeling of the island with its whitewashed structures contrasted against the Aegean Sea.

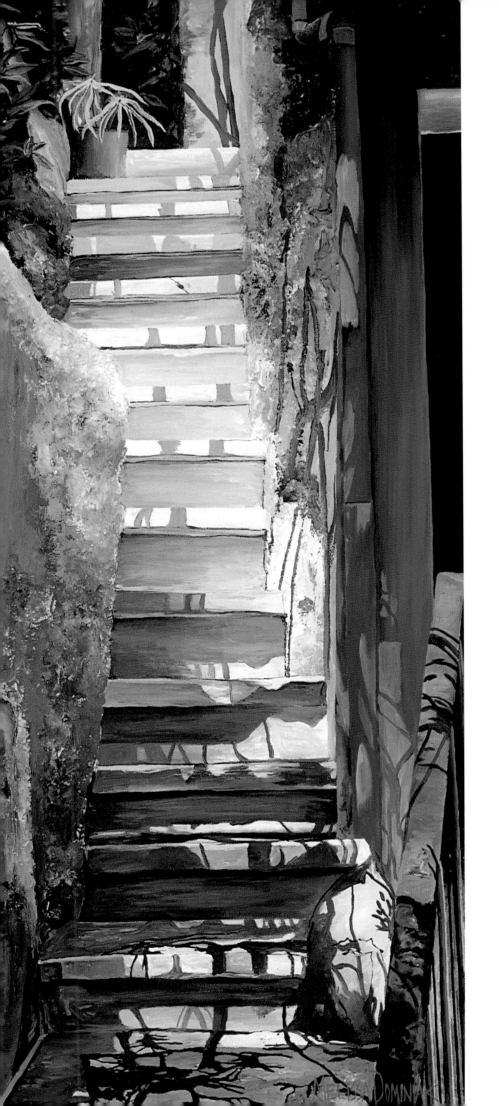

I enjoy choosing colors that make a realistic composition look unrealistic . . .

Melissa A. Dominiak
Staircase in Corfu
25" x 35" Acrylic

The ascending stairway is one of my favorite painting subjects. What an ideal way to create a sense of depth and mystery in a composition!

Since I usually paint from black and white photographs, I have the freedom of selecting my own color schemes. I enjoy choosing colors that make a realistic composition look unrealistic, without the viewer necessarily realizing it, as in **Mediterranean Staircase**. I used an acrylic medium called "ceramic stucco" to emphasize texture and Mediterranean flavor.

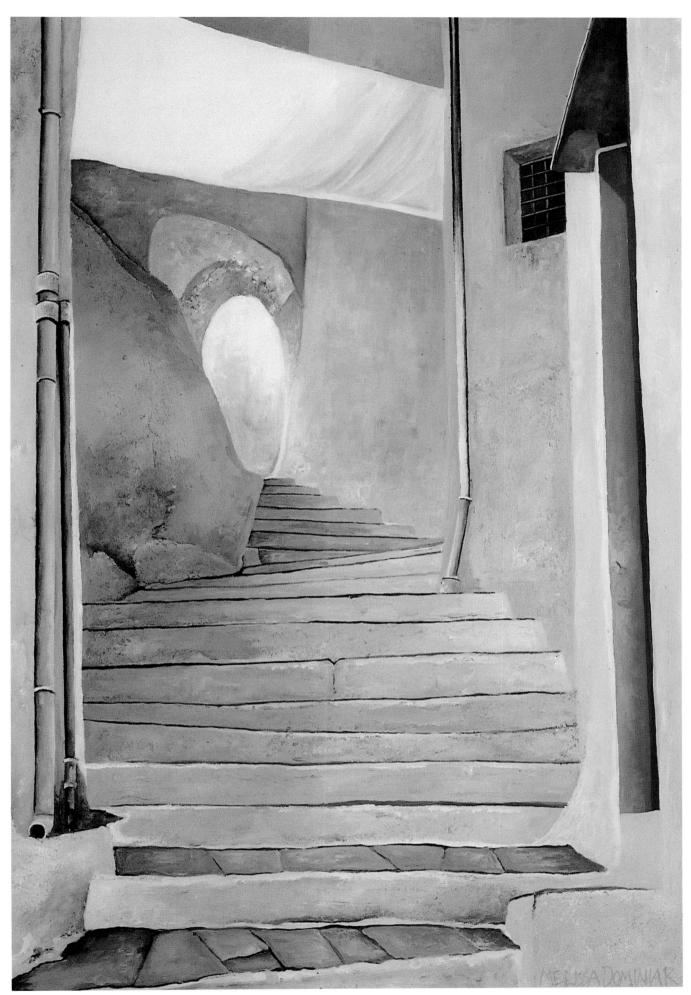

Melissa A. Dominiak *Mediterranean Staircase* 25" x 35" Acrylic

I was careful also to break the horizon line so sea and sky merged together in a more subtle way.

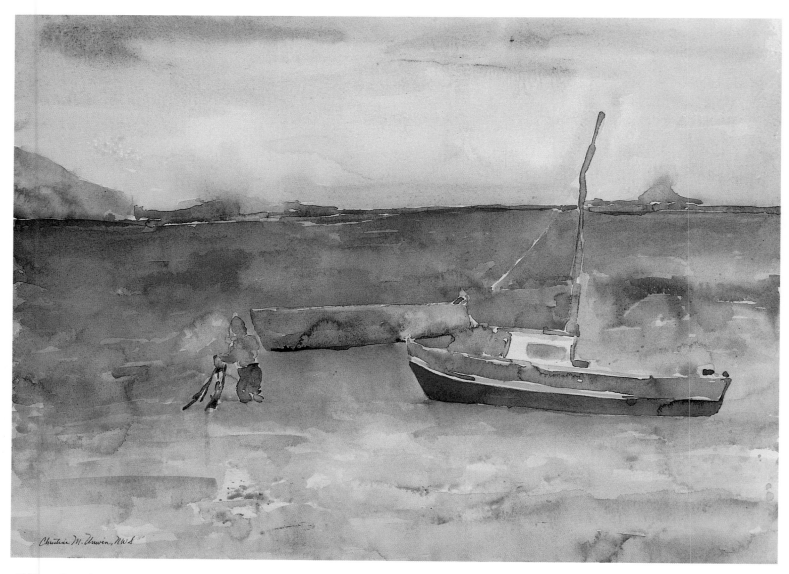

Christine M. Unwin, NWS *Caribbean Boat Man* 22" x 30" Watercolor

I photographed this man pulling his boat out of the water on St. Thomas, US Virgin Islands. He made a great subject. I used a cool dominance of color, using the reds and warm colors in the boat and man as accents. I used a "lost and found" edges technique to avoid having the images look as though they were pasted on. I was careful also to break the horizon line so sea and sky merged together in a more subtle way. A harsh line would have divided the painting. The sea is so transparent and the color so exquisite, that it is a "natural," the perfect choice for the medium of watercolor. You can almost feel the breezy warmth of the day.

I used my "pouring" technique in a larger format with a more personal and off-beat color scheme. Purples and pinks replace the greens and yellows in the coconuts, and set up a temperature contrast with the fronds themselves.

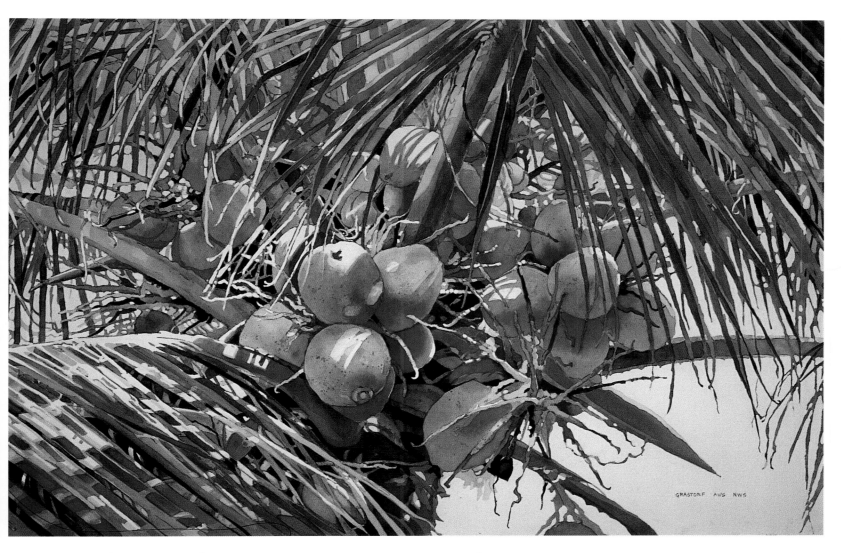

Jean Grastorf, AWS, NWS, MWS *Palm Pattern* 28" x 30" Watercolor

Key West ignites thoughts of sunsets, gingerbread-trimmed houses, brilliant tropical flowers and swaying coconut palms. While teaching at Key West's Garden Club, I was surrounded by these magnificent, sun-splashed trees. In painting my favorite subject, I used my "pouring" technique in a larger format with a more personal and off-beat color scheme. Purples and pinks stand in for greens and yellows in the coconuts, setting a temperature contrast with the fronds themselves.

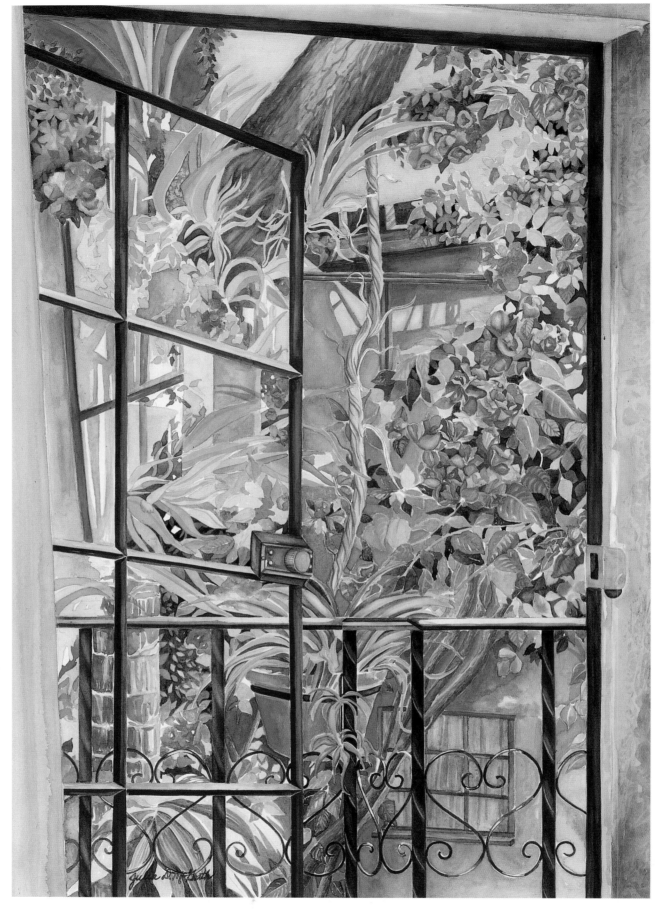

Julia D. McGrath *La Vista de Mi Cuarto* 28 " x 38" Watercolor

For artists, San Miguel de Allende teems with wonderful subjects. Every scene is a visual feast! Colorful people, fascinating architecture and the lush presence of beautiful bougainvillea everywhere. My second floor room at the inn had this iron and glass door which opened onto the courtyard below. It had a curtain for privacy, but I kept it open whenever I could. How glorious to awaken every morning to the sunny warmth and sparkle of yet another beautiful Mexican day. "The view from my room" was the first and last thing I saw everyday and so became my favorite subject — *La Vista de Mi Cuarto*.

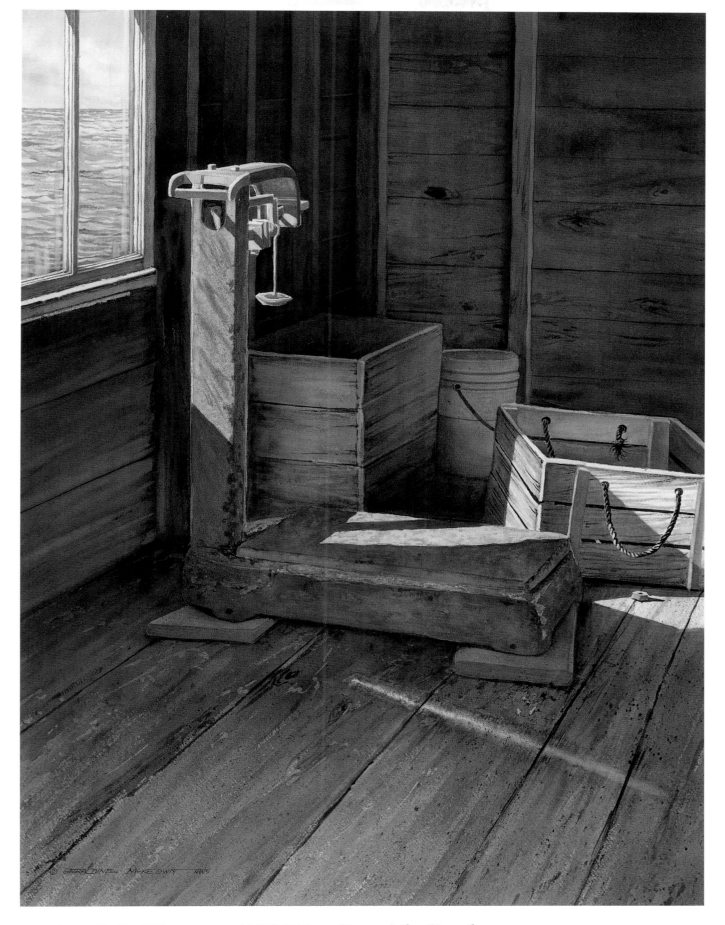

Geraldine McKeown, NWS *Seaside Scales* 19" x 26" Watercolor

My summer studio is located on an island off the coast of Maine. The idea for *Seaside Scales* came to me while walking the wharves of the lobster fishermen. I was intrigued by the rich, luminous quality of the color of the blue scales which was caused by the light bouncing off the water outside the window.

I achieved the effect I wanted by combining the granular nature of manganese blue with Prussian blue. The rusted metal area was created by dropping light red into the blue mixture while it was still wet.

Shutters, laundry, roof lines and fishing boats provided the shapes and shadows I needed to capture the essence of this delightful place.

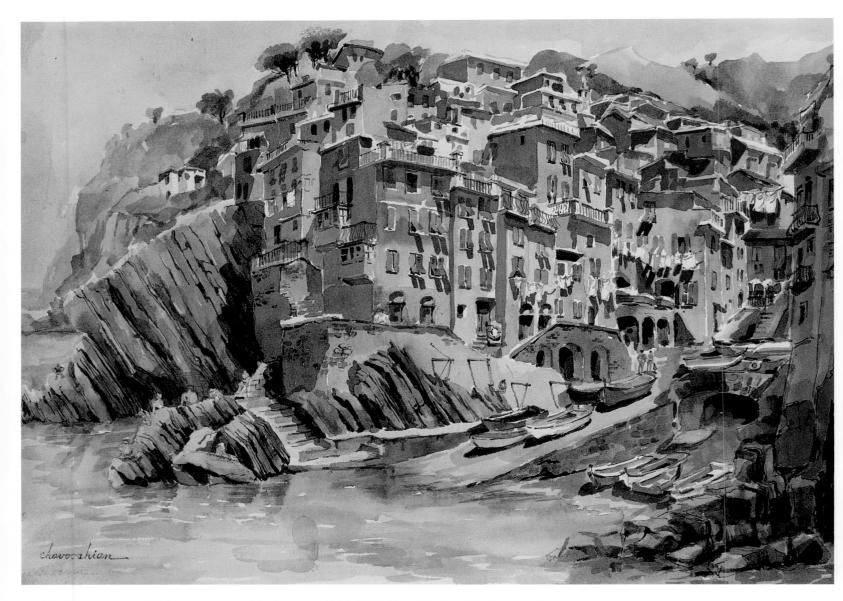

Marge Chavooshian, NWS *Rio Maggiore* 14" x 20" Watercolor

My favorite painting subjects are urban street scenes, buildings — especially complicated façades with their multitude of complex geometric shapes created by sunlight. Because I paint primarily on location, I am forced to deal with the passage of time, weather changes, and, of course, light conditions. As a result, I have learned to focus intently to capture the most salient characteristics of a scene.

I painted ***Rio Maggiore*** while I was in my bathing suit, sitting on the rocks of the Italian coast. Shutters, laundry, roof lines and fishing boats provided the shapes and shadows I needed to capture the essence of this delightful place.

I created linkages of many shapes and values through colors which I mixed directly on the paper.

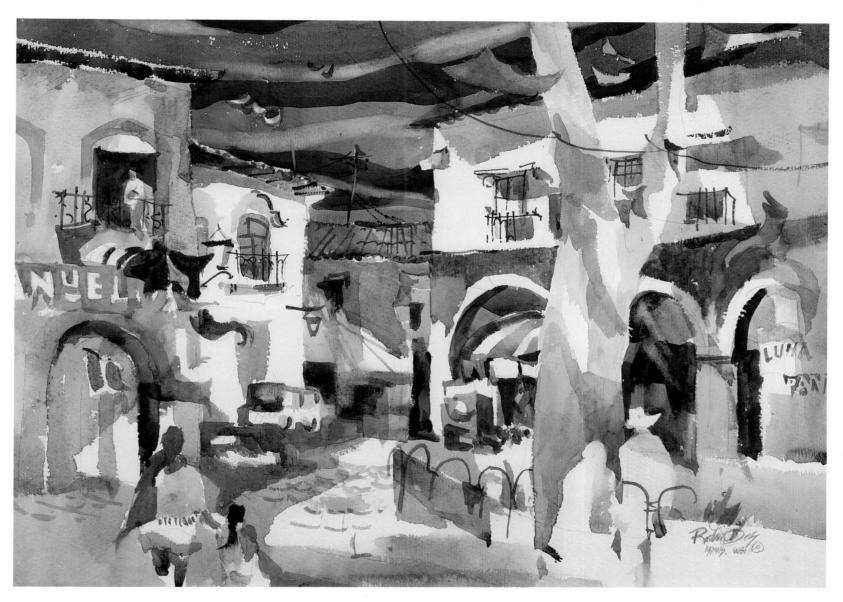

Ratinda Das, NWS, MWS *Plaza Grande, Act I* 22" X 30" Watercolor

One of the most interesting features in any colonial Mexican town is the *central plaza*, focal point for the activities of the townspeople. Vendors set up their shops, mothers stroll with their children, people engage in spirited conversations. These things go on all day and late into the evening.

I spent an entire day watching and recording these activities. The ***Plaza Grande, Act I*** scene took place in Patzcuaro, Mexico. It was painted early in the morning when the sun rose slowly from behind the buildings in the plaza and drenched the façades with warm light. A few early risers wandered by, someone was peeking through a balcony window, other people were already sitting on the plaza benches — as though preparing for an act that is to follow. I tried to catch the atmosphere just before the hustle and bustle of daily activities. The painting was done on a piece of handmade paper from India, the texture and the absorbency of which works well for my outdoor paintings. I created linkages of many shapes and values through colors I mixed directly on the paper. They granulate and retain their own characteristics. The sky was added last to heighten the visual drama and create a "kinetic unity."

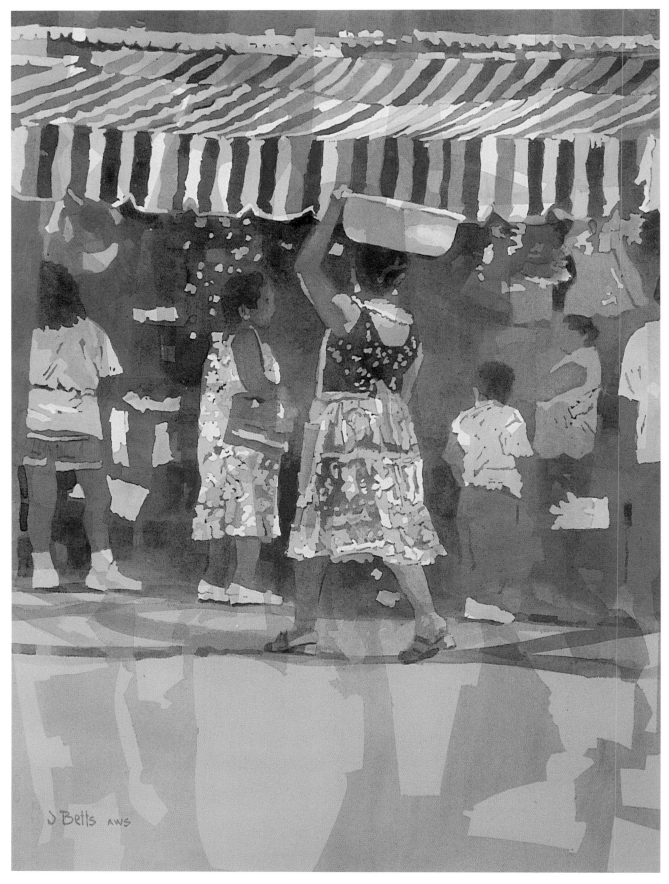

Judi Betts, AWS, NWS, MWS *Mariachi Market* *22" x 30" Watercolor*

Mexican outdoor markets are not only lively, they're a fount of exciting "magical shapes." In this painting, I chose a T-shaped formation to be my focal point and major design element. This shape consists of the awning and central figures. Repetition of vertical elements were used to create unity. I avoided realistic detail by utilizing abstract shapes which give continuity and set up rhythm. Repeating the small awning stripes, with their minor irregularities and color transition, causes vibration. Verticals function to echo the strength of figures and negative shapes. An overall abstract underpainting allows shapes to appear to be repeated in the fabric patterns. To develop tension, I used a configuration of tall and short people.

I used figures, marching toward a church, to form dominant vertical shapes.

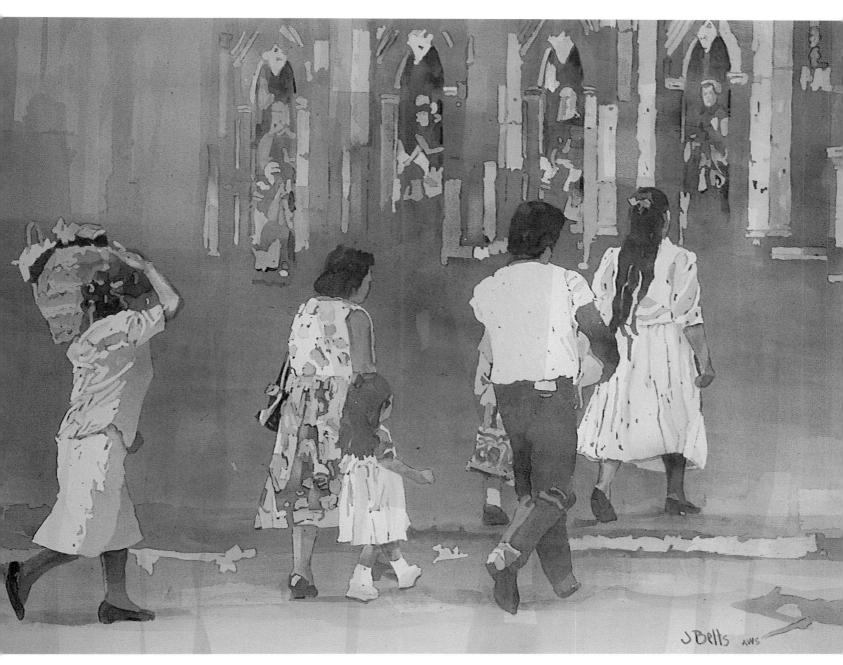

Judi Betts, AWS, NWS, MWS *The Saints* *22" x 30" Watercolor*

Strong religious feeling runs deep in Mexico. In this painting I strived to capture the presence of religion as a vital force in everyday life, but without depicting religious ceremony. I used figures, marching toward a church, to form dominant vertical shapes. A hint of stained glass and sculptural images repeat the vertical. The main figure is made important by simplifying her load and retaining as much light value as possible. A few bright colors create interest and entertain the viewer. The underpainting repeats the dominance of vertical shapes seen in figures and decorative symbolism.

When I feel strongly about a subject, my emotion somehow gets onto the page.

Sheila B. Parsons *Bien Venido* 20" x 30" Watercolor

My goal was to express the lushness and the light of Mexico when I painted the entry gate to Hacienda El Cóbano in Colima, Mexico. El Cóbano was formerly owned by the University of Oklahoma and used as a center for painting classes. One of the teachers was my mentor, Milford Zornes, and I worked as his assistant on many occasions. I shared many adventures there with him and have marvelous memories of the place.

Although I usually paint on location, I did this image from photographs I had taken on previous trips. The flowers were a riot of color and the space within the walls of the hacienda contrasted starkly with the dry and dusty road out front. I challenged myself and my students to do the painting with a large, quiet, empty area next to a very complicated busy area. The lacy pattern on the wrought iron gate, the decorative wall detail and the bougainvillea flowers were perfect for the lesson.

I selected a split complement color scheme — red/orange/blue-green — for drama. I used a large light area with small areas of darks to achieve an overall midtone for my value plan. My composition plan was straight out of Zornes' teaching techniques because I used strong horizontal feel and strong vertical lines which meet at unequal distances from every edge. However, what I think makes the painting "sing" is the feeling I have for El Cóbano, Colima, for the culture and the people I knew and loved there. Colima was my training ground as an artist and as a "have brush, will travel" teacher of painting. When I feel strongly about a subject, my emotion somehow gets onto the page. I knew I had a *keeper* with *Bien Venido*. I hope you enjoy it too!

Creatures

It's fun to watch viewers react to the subject.

Dick Green, MWS *Don't Bug Me* 22" x 30" Watercolor

Unusual subjects are great, but really secondary to my objective of creating a dynamic tension through opposing forces. Texture, color and shadows act to mute these forces. I also left the background untouched as a foil for the strong composition. It's fun to watch viewers react to the subject.

Chica Brunsvold, NWS *Bonding with Noah* 22" x 30" Acrylic

I begin each painting with a free and spontaneous non-objective layering of transparent, primary colors. By using alcohol, splattering, dripping, wiping and scraping, I create a wide sweeping variety of textural shapes. Once this stage is dry, I study the painting, viewing it upside down, reversed in a mirror, or in the semi-dark, always searching for hidden images. I may see a total abstract, a floral or landscape, but most often what I discover are birds and animals. I develop them as they appear. The process is full of surprises and may take a very long time to complete. The final painting often ends up being quite whimsical in nature. Bright opaque paint seems most appropriate for these playful creatures.

I enjoy injecting a bit of humor. *Zooillogicals®* is a metaphor for "peaceful interaction" which unfortunately so often is lacking in real life.

112

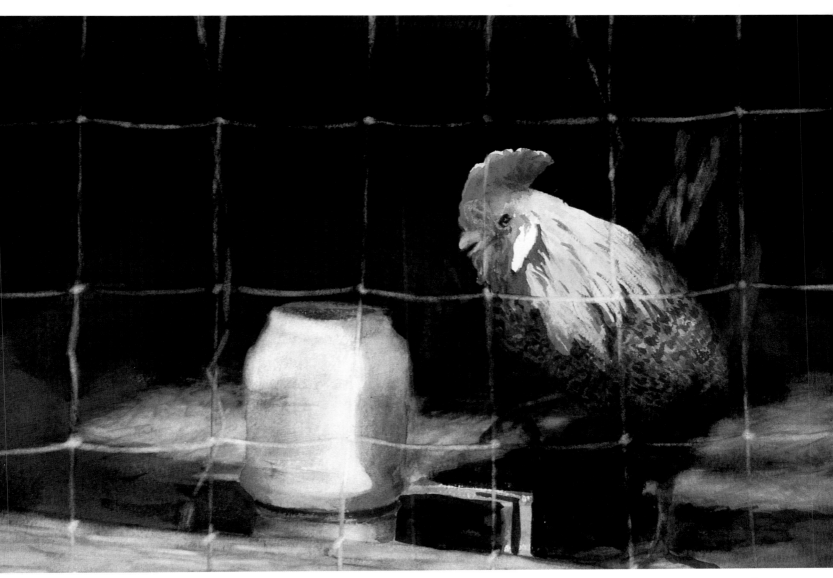

M. C. Kanouse *Huerta's Chickens* **13" x 19" Watercolor**

Different Messages

*I painted brown forms reminiscent of his work,
adding my own shapes in the form of oranges.*

Johnnie Crosby *Gottlieb with Oranges* 22" x 30" Watercolor

I came upon a page in The History of Modern Art which featured Adolph Gottlieb's work. It inspired me to do a painting in similar style. I painted brown forms reminiscent of his work, adding my own shapes in the form of oranges. One never knows when or where inspiration will strike. I am pleased with this painting.

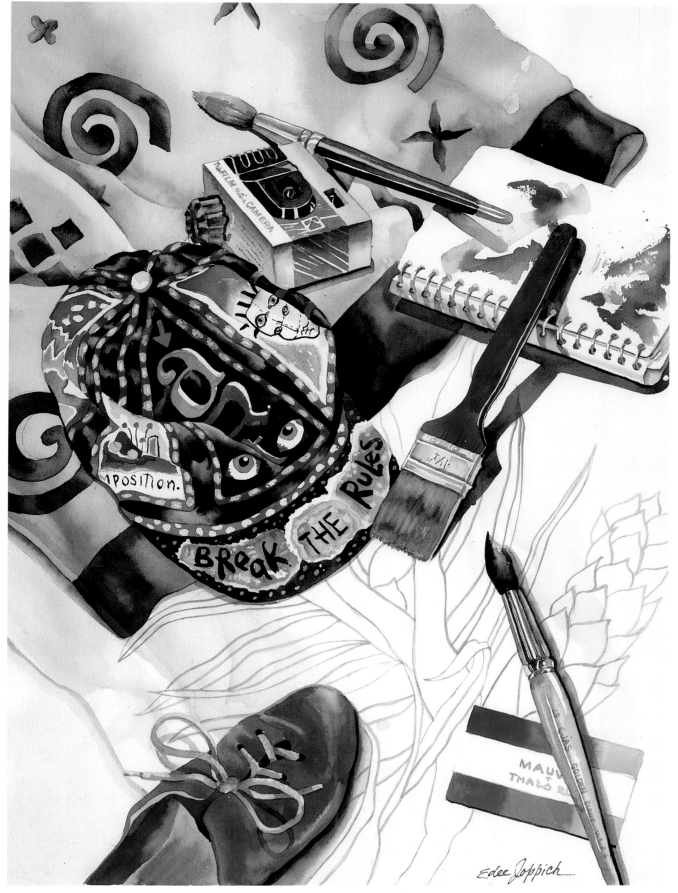

Edee Joppich *Break the Rules* 29" x 36" Watercolor

I challenged my students to paint a self-portrait that did not include their own likenesses. I was intrigued with the idea of assembling objects representative of "me" into a composition. The painting cap declares my oft-repeated admonition to artists: "Learn the rules before you break them!" A camera and a drawing from a trip to Belize tell of my obsession with taking pictures and painting in far away places. The background features a favorite dress. The color card is from my color system. Since I continue to buy shoes and brushes, they had to be inclucled in my *Break the Rules* self-portrait.

I feel lucky to have my art as a way of accessing the most unconscious and powerful part of my "self."

Peggy Zehring *Uxmal* 30" x 66" Mixed Media

When I visited the Mayan ruin Uxmal in Mexico, I was surprised by the uplifting, spiritual feeling I experienced there — quite unlike the emotions I have felt at other Mayan archeological sites. Later, I learned that in its time Uxmal may have been a village for the training of priests and priestesses. This would explain the absence of sacrificial altars and death symbolism more commonly evident in nearby Chichén Itzá and especially at Copan in Honduras.

The most powerful symbol I remember from Uxmal is the cross which can be turned to become an x. I made many of these, turning them endlessly before they finally came to rest. In addition to symbols, I enjoy working with many materials in unusual ways: chalk dust, marble dust, ash, sand, burlap and collage. I hold everything together with acrylic mediums. Here, I collaged parts of Mayan texts which seem to explain important things we've forgotten. I found the worn burlap in an old abandoned Colorado ranch barn, but I imagine it as the fabric of choice for Mayan priests and priestesses in training.

By recreating my most memorable experiences and feelings on canvas, I can better understand what happens to me. I feel lucky to have my art as a way of accessing the most unconscious and powerful part of my "self."

116

Kathleen Conover, MWS *Image the Flight* 32" x 40" Mixed

Image the Flight is from my continuing series of paintings which explore various images of flight as symbols for transformation, transcendence, freedom, spirituality and creativity. The most recent paintings include architectural details and figures in reference to my international travels. "Winged Victory" from the Louvre provided the visual inspiration for *Image the Flight*. I enjoy juxtaposing the structure and rigidness of architectural elements with a gestural, free painting style expressive of movement.

117

Tall Pines I was inspired by the pine trees of New Mexico's Gila National Forest and was produced on a full sheet of Whatman™ 200 lb. cold press paper. It is hand-embossed, scored, machine stitched and collaged with cut stars. It won the 29th Annual California Watercolor Association's Experimental Award.

The scoring enabled me to use the linear pattern to design triangular geometric trees, much as a Native American might interpret them in a weaving. The colors were selected very carefully. The blue represents both the immense indigo sky and the flowing streams near Georgia O'Keefe's home. The rust and ochres are the colors of New Mexican soil.

I begin my watercolors by soaking the paper for several hours. The curved edges which suggest the rolling hills and rivers were cut from mat board. The wet paper is placed on top of the cut pieces, and the edges are rubbed, one at a time, with a plastic handle. A complete composition of raised lines is created before color is applied. While the paper is still wet, fresh Winsor Newton™ paint is poured from bowls and spread with brushes. Pure white paper is retained for contrast. Next the composition is scored; parallel lines are lightly scratched in the wet paper. This is most evident in the center left, below the chocolate moon.

The rice paper is painted from the same bowls of watercolor, then dried, cut into star shapes and glued onto the painting. The final step was to machine stitch, using various colors of thread. This helps anchor the collage and reinforce the linear pattern. The surface of the **Tall Pines I** is rich with a tapestry-like feel. My experimenting has created textural quilts in paper and paint.

Wanda Gringhuis Anderson *Tall Pines I*
22" x 30" Hand Embossed Watercolor

118

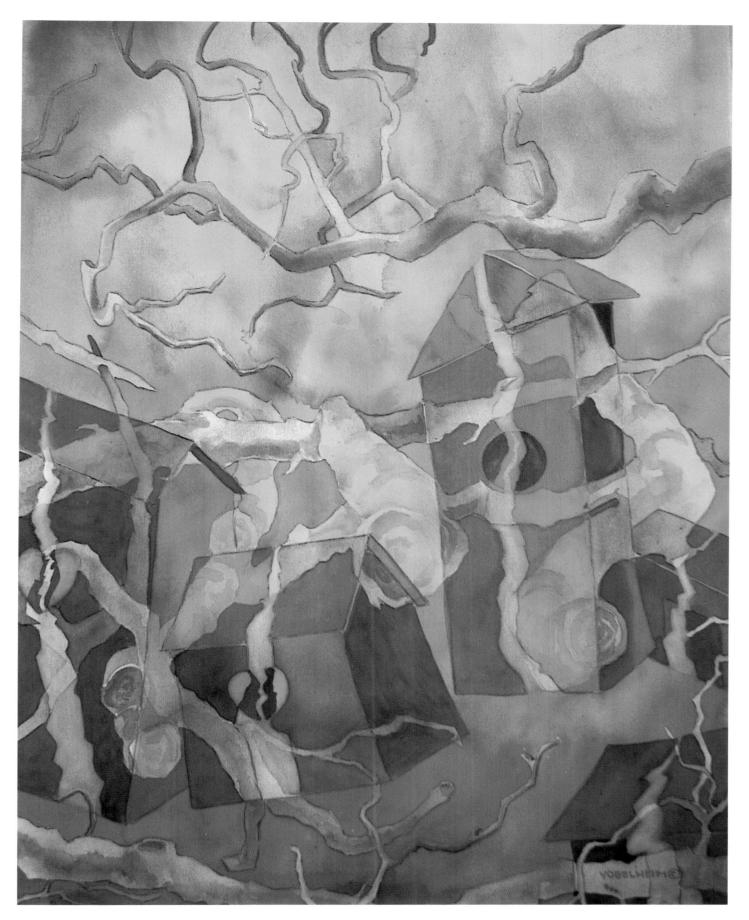

Donna Vogelheim, NWS *A House Divided* 22" x 30" Watercolor

This painting depicts the emotional reaction experienced in one's life when unexpected change occurs through illness, or the loss of or separation from family or friends. The home as the traditional center of stability and refuge is torn apart when such events are thrust upon us.

This painting is in symbolic homage to my mother.

Barbara Zimmerman *Mamacita Por Favor* 30" x 38" Watercolor

This painting is in symbolic homage to my mother. All her life she was devoted to her church, home and family. Hence the rosary, hutch, i.e. "altar" and symbolic plates denoting the Afterlife. My mother was soft, shy and warm like a rabbit. This watercolor was done with much love for a lovely, gentle woman.

120

Square Man is one of a series of encaustic paintings I created in 1998 during a college class. I had been working for about five years on various mixed media techniques, including the combination of water-based and oil-based paints, inks, egg tempera, encaustic, tissue and other papers, found objects, string, sand, and so forth. The dominant feature of any work always is the paint. I put more emphasis on line, color, texture and content than on composition or shape-making. As the personal element in my work became as important as the technique, working with favorite images, words, letters, marks, etc. made the work seem more meaningful. I worked with these particulars, independent of each other, and the space became free and unconscious, then carefully calculated.

I enjoy combining the grave with the humorous. Although whimsical, my art often has a serious side to it. I feel painting should be like a game, where one stays involved and searching, and where goals are sequentially revealed as surprises. Although this is a relatively small piece, much of my work is larger in scale. I feel I have suceeded in a painting when the viewer looks into the work, and feels compelled to stay for a while, even if he or she does not particularly like the result.

Evelyn Ecale Schultz *Square Man*
18" x 23" Encaustic Mixed Medium

121

Notice the over-all triangular shapes that grew into three figures — my friends and myself.

Mary Anne Staples *Summer Fantasy* 22" x 30" Watercolor

Summer Fantasy was painted during a "paint-out" with two of my friends while we were vacationing at the beach for a week. The drawing came from a lace design. Notice the over-all triangular shapes that grew into three figures — my friends and myself. It was painted with transparent watercolor using a dark background with light areas on the figures to emphasize their importance. Color relationships were important as decorations.

I loved the innocence of the girl on the left, and though the other girl looks a little malicious, I like her as well!

Joan Painter Jones *Childhood* 13" x 26" Watercolor & Acrylic

Childhood is part of a series on the family. I loosely adapted from drawings of little girls my daughter had done when she was young, adding collage from my old watercolors, and using acrylic paint in a watery manner. I loved the innocence of the girl on the left, and though the other girl looks a little malicious, I like her as well! The girl on the left represents freedom to me, the other is about ties to home and "stuff."

Patsy Smith, NWS *Royal Enchantment* 22" x 30" Watermedia

 I brush, pour and print my watermedia onto the paper surface. Chaos rules. I study the work. More paint is applied by brush, with printing and scraping to create form and space. I enhance the shapes by painting in deep shades of rich color, while I separate the space with glazes of tinted light colors. Depending on the mood of the painting, I sometimes introduce exciting arbitrarily outlined colors as I did in this painting. I follow my intuition which leads me through the magic of the designing process to the finished painting. My paintings are often wimiscal. I spend many entertaining and rewarding hours in my studio.

Symbolism and metaphor in art have always interested me.

Marsha Stoddard Weigand *Familial Portrait* 17" x 23" Watercolor

Symbolism and metaphor in art have always interested me. My still life paintings are composed with the items which have a personal meaning and significance outside of their intrinsic functional use. The significance could relate to a person, memory or even a feeling. It is not important the viewer understand that significance. In fact, I hope the painting instills something personal in the viewer's thoughts.

Music

The movement in the composition is created by having objects touch one another . . .

Yvonne Wood *Playing Their Quiet Song* **23" x 29" Watercolor**

My love for musical instruments has always set a happy, tranquil mood in my still life paintings. I pay careful attention to the patterns created by the sunlight. The reflective metallic surfaces of the vase and trumpet pick up the abstract designs of adjacent objects. Each reflection is painted into tiny bits of intensified colors. The use of plate-finish Bristol™ board allows the color to run together, and stay on the surface with luminous results.

The movement in the composition is created by having objects touch one another, unifying the painting. The white lace curtains give lightness to the background, and are balanced by the white table top in the foreground. Dramatically rich colors repeat themselves thoughout the painting. I incorporate the interplay of abstract patterns within the realism of my set-ups.

Jackie Brooks, NWS, MWS *Double Concerto* 28" x 41" Watercolor Collage

The subjects of this painting are two violins and the "Double Violin Concerto" by Johann Sebastian Bach. For the sake of my composition, I made the violins different sizes. One lucky aspect of being a painter, which fascinates me, is that I am not bound to accuracy of scale or other "realities." The music collaged on the paper is the score of the "Double Violin Concerto." An added bonus was that the music collaged on the back of one of the instruments appears to be a reflection. I had not planned that, but was pleased with the surprise.

In this painting the contrast of colors, the darks and the lights move you around and about and over the keys in a rhythmic dance.

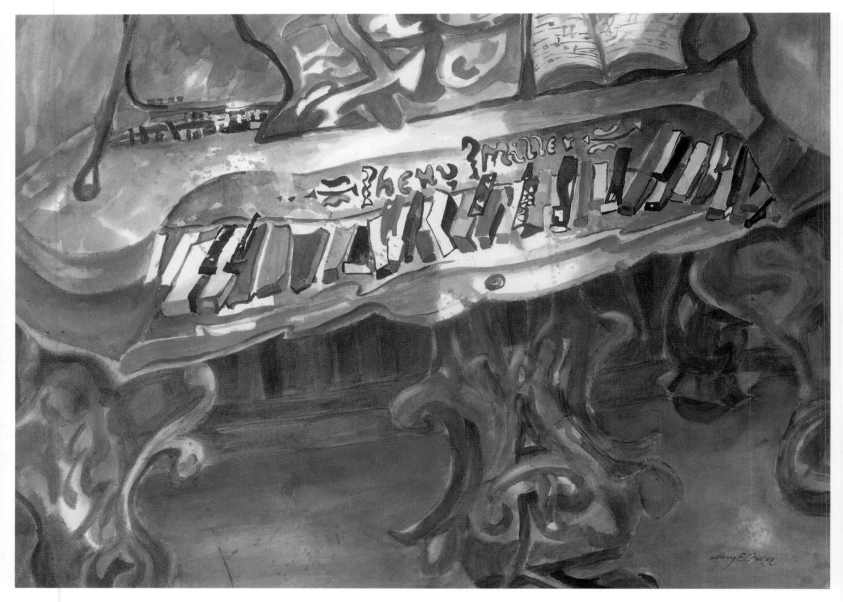

Mary Elizabeth Fisher *Jumping Keys* 22" x 30" Watercolor

Music has always been an important part of my life. When I see a musical instrument, especially a piano, I want to make an imaginative work that emphasizes the part of the piano that interests me most. In this painting the contrast of colors, the darks and the lights move you around and about and over the keys in a rhythmic dance. There is no one in the room playing the piano but it will not sit idly in the corner gathering dust.

The result was on the way to becoming ho-hum when I hit upon the idea of adding the extra hands to suggest the rapid motion of the musician.

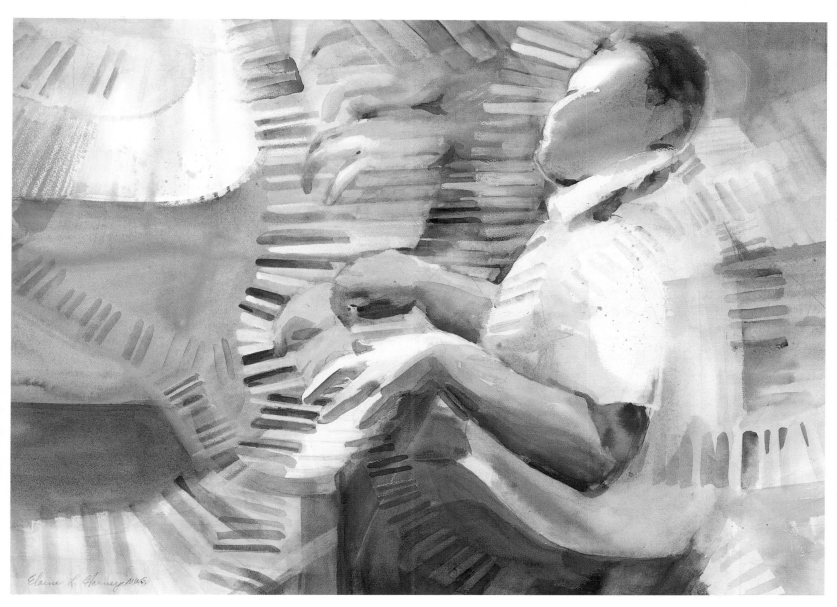

Elaine Harvey, NWS *Getting into his Work* 21" x 26" Watercolor

Getting into his Work was inspired by the exuberance of a musician at a jazz festival. I first tried thumbnail sketches of various arrangements of the player, piano, and also some figures in the audience and a microphone. My exploratory sketches even included a view from above, but none of the sketches included the concept that brought the final painting to life. That idea had to come to me, as do many of my best ideas, during the painting process. I settled upon the close-up horizontal format and began painting in transparent watercolor, intending a fairly traditional painting. The result was on the way to becoming ho-hum when I hit on the idea of adding the extra hands to suggest the rapid motion of the musician. Because the painting was high key, I was still able, with a little lifting and negative painting, to create the extra hands. The extra piano keys were then added with the help of a little white watercolor crayon which I brushed over with water to smoothly blend into the rest of the painting. My original motivation in adding the extra keyboards was to improve the composition and add interest to the space, but they turned out to be the element that really defines the meaning of the painting. This man is completely immersed in music, and "getting into his work!"

Abstracts

Now, I find more excitement and creativity by adding texture and collage material which gives the painting more depth and volume.

Jeri Fellwock *Moon Visions VI* **22" x 30" Acrylic**

I've been working on my "moon series" for the past few years. It has been one of my favorite series and one of the most successful. A painting series gives me a chance to explore, to expand and to take the paintings to their fullest and most creative extent.

My recent paintings evolved from my first conception of the moon paintings. At first, I was exploring shapes and color. Now, I find more excitement and creativity by adding texture and collage material, which gives the painting more depth and volume. Building up layers of paint provides a nice glow and adds dimension to the mystery of the moons.

I then scribbled with crayon and colored pencils making random marks in an effort to break up the space into small, medium and large shapes.

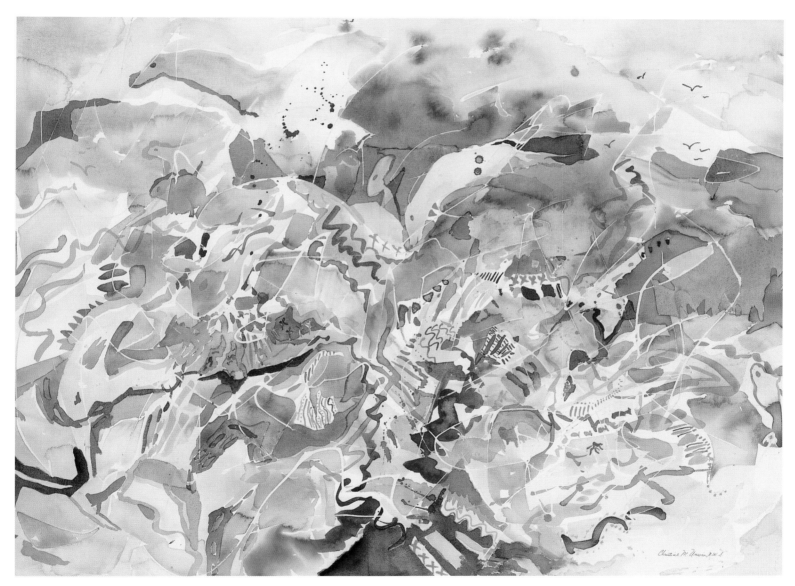

Christine M. Unwin, NWS *Dinosaurs* 22" x 30" Watercolor

I drizzled rubber cement in circular motions over the page before I started painting this picture. I then scribbled with crayon and colored pencils making random marks in an effort to break up the space into small, medium and large shapes. Then I flooded the sheet with water and charged in paint by just touching the tip of a loaded brush to the puddles of waters and let the paint flow. After the first wash dried, shapes began to emerge. I added glazes (thinly transparent veils of color) to emphasize the shapes. *They became Dinosaurs.* This intuitive way of painting is fun and can lead the artist into new and unexpected directions.

Painting "en plein air" surrounded by the beauty of nature is a great joy.

Danguole Jurgutis *Lake Michigan Dunes* 24" x 24" Acrylic

Painting "en plein air" surrounded by the beauty of nature is a great joy. To capture the "sounds" of nature and the movement of nature on my own terms is quite a challenge. Here, as in my abstract mixed media work, I use expressive line and the play of positive and negative shapes to find a unique composition. *Lake Michigan Dunes*, although artistically invented, still transports me back to that wonderful summer day.

Danguole Jurgutis *Beyond It All* 24" x 24" **Acrylic**

Nature's forms, seen and sensed, abstracted and invented, and the movement and search for "unknown worlds" are the mantra of this painting and other paintings in my "Odyssey" series. For added dimension, I find it interesting to include symbols from many cultures: Egyptian, Chinese, etc., such as the sphere symbolizing eternity or the evocative spiral representing the search for the meaning of life. An undulating varied line is used to create movement, patterns and moods. My works are not explicit. I strive to be mysterious. I like the viewers to bring their own experience into each piece. *Beyond It All* was chosen to be included in the "Michigan Watercolor Society's 50th Anniversary" exhibition at the Detroit Institute of Art.

The three works were made to complete thoughts concerning birth, life and death or the stages when we are cocooned, revealed and then glorified.

Susan Kell *Revealed* 15" x 30" Acrylic &Mixed Media

Revealed has two companion pieces, *Cocooned* and *Glorified*. The three works were made to complete thoughts concerning birth, life and death or the stages when we are cocooned, revealed and then glorified. The spiritual implications are obvious from the titles and from the observation of the works themselves.

These three works are part of a larger series I created to pay homage to a mature black willow tree I harvested from my property. Being a gardener and respectful of nature, it grieved me to harvest a mature tree, but alas, the black willow has all the idiosyncrasies of the weeping willow with none of its redeeming grace and charm. As a visual ode to the tree, I collected the last twigs it dropped on a daily basis and executed a series of acrylic painting constructions.

The use of assorted papers, twigs, acrylic paint and mediums brought these works into a three-dimensional area. That three-dimensional quality further reinforces the concept of a higher entity which encompasses both the tree of inspiration and our own living selves.

The search for personal non-verbal expression motivates me to rely on several problem-solving techniques — trial and error, intuition, analysis.

Barbara Freedman, NWS *Ladder on the Right* 16" x 24" Collage Mixed Media

The search for personal non-verbal expression motivates me to rely on several problem-solving techniques — trial and error, intuition, analysis. While I paint I am constantly searching for symbols to represent my images. Photos from travels and personal experience aid my pursuit. The painting **Ladder on the Right** features motifs derived from a recent home construction adventure. While our home was being built, I was able to view the walls through windows and ladders, allowing me to take the familiar and reinvent the scene.

My goal is to push the observer to analyze the shapes through the texture and color of collage papers and watercolor paints. This painting uses the ladder as a symbol for growth, i.e., climbing the ladder . . . in an imaginary environment. A mood is being expressed that I hope will captivate and hold the viewers' interest.

To create this painting, I used a combination of oriental collage papers, watercolor pigments and Caran D'Ache™ crayons to achieve a variety of textures. Fabriano™ 300 1b. cold press paper provides a strong support surface for all these materials and reacts well to many watercolor techniques.

Barbara Zimmerman *Enigma* 29" x 36" Mixed Media

I hope this painting will evoke a sense of the enigmatic for the viewer. When I started, there wasn't a specific subject I had in mind. Organic shapes mingle with the linear to keep the viewer's interest. This painting was done on Arches™ 140 lb. watercolor paper.

*I incorporate the design elements of quilts
into my paintings . . . by stitching pieces of
my collage on my sewing machine.*

Laura Whitesides Host *Home Sweet Home* 4" x 17" Mixed Watermedia

I am intrigued by women's handiwork done throughout the ages in different cultures. Quilts were considered "women's work" and for many it was the only way a woman could express her creative side, let alone the only time for socializing. Although quilts were necessary for the family, the custom of only women making them indicates the extent of limitations imposed on women's lifestyles.

I incorporate the design elements of quilts into my paintings, from the "school house" pattern to the delightful crazy quilt format, by stitching pieces of my collage on my sewing machine.

I used watercolor, gesso, inks and Caran D'Ache™ crayons in creating this painting, then tore it up and reassembled it, making use of the torn edges.

Carolyn H. Pederson, NWS, MWS *Inner Symphony* **22" x 30" Watermedia Collage**

 I work in series, allowing an idea to evolve over time. This painting was part of a recent solo show entitled "Between Two Worlds." All the paintings were inspired by lines left on the beach by the withdrawing sea.

 The ebb and flow of the rhythms of the universe are captured by the use of both implied and actual texture. I used watercolor, gesso, inks and Caran D'Ache™ crayons in creating this painting, then tore it up and reassembled it, making use of the torn edges. The resulting painting expresses one reality as seen from another. *Inner Symphony* both contracts and expands in space, inviting the viewer to journey "Between Two Worlds."

" ... White space and sequenced marks are evidence of an energetic; playful interaction between the artist and the surface ... "

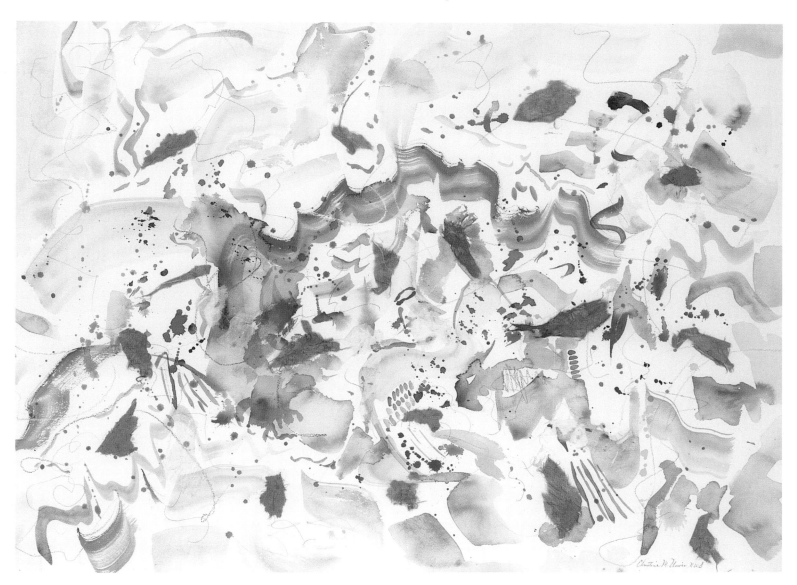

Christine M. Unwin, NWS *Southwest Rhythm* 22" x 30" Watercolor

This painting was awarded a prize in a juried art show in Farmington, Michigan. The juror was Ken Gross. I loved the juror's comments and asked for and received his permission to quote them in this book.

"Bold, playful movement demonstrated in bold, playful, dance-like images. White space and sequenced marks are evidence of an energetic playful interaction between the artist and the surface. Bright in appearance as well as feeling."

Ken Gross, Director of the Alfred Berkowitz Museum
on the University of Michigan, Dearborn campus.

Mary Alice Braukman, NWS *Jewels in the Falls* 10" x 12" Mixed Watermedia & Collage

Jewels in the Falls is the result of a painting demonstration in one of my workshops. My collage materials include small torn shapes from unresolved watercolor paintings, rice paper and scraps from a magazine transfer. As I painted over the collage material, it glistened like water running over rocks in a mountain stream.

I generally use an acrylic matte medium or a soft gel as a binder. I like to work on a four- or five-ply illustration or museum board. The direction in which I tear the watercolor papers or heavier materials creates a multi-layered effect.

The content is non-objective yet based upon water and rock forms which run through, under and over geometric structures.

Peggy Brown, AWS, NWS, MWS *Crosscurrents* 14" x 21" Watercolor

Crosscurrents is seventh in a series of "Crosscurrents." Each is based upon a new design and color making each different from the rest. All of the paintings have the following trait in common: *The content is non-objective yet based upon water and rock forms which run through, under and over geometric structures.*

Both natural and man-made objects inspire my paintings. The geometric forms are a continuation of my work from years past when I painted abstractly many Victorian homes, accenting the positive/negative aspects of the houses and their surroundings. The organic lines flowing through and uniting the geometrics are landscape forms. As for technique, I begin by layering wet watercolor paint onto a wet piece of paper. During subsequent glazes, I use wet pieces of torn paper to control and define the edges of the geometric shapes. The image is completed by drawing with graphite and water soluble color pencils. I try to express images that lie on, above, and below the surface of the painting.

I begin each piece by laying down multiple glazes of acrylics, sometimes up to 50 layers, in an attempt to texturize and enrich the surface of the paper or canvas.

Gerry Willging *Rockport* 15" x 22" Acrylic

For many years, I was primarily a portrait painter, but I soon discovered the challenge of experimental watermedia, and a love of the process of painting abstract and non-representational work. I begin each piece by laying down multiple glazes of acrylics, sometimes up to 50 layers, in an attempt to texturize and enrich the surface of the paper or canvas. Scraping, scratching, and stamping is followed by applications of water color pencils, crayons, wax, drywall tape or anything else that will enrich the painting. I continue to add shapes to this chaos until I begin to see an image or design emerge that is striking. This painting followed such a course, and during its development it personally reminded me of Rockport, Massachusetts on a sunny day.

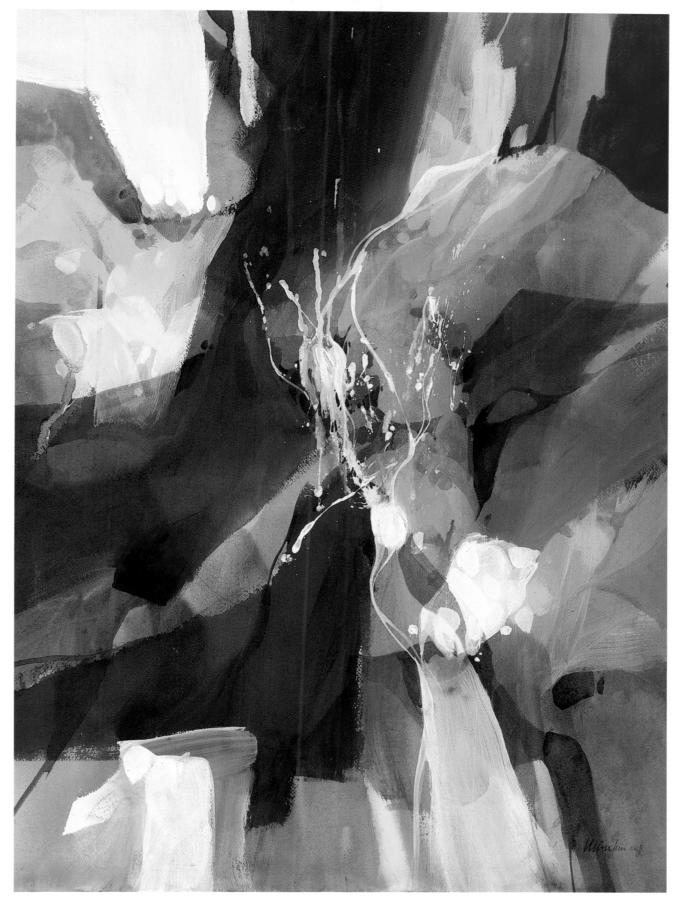

Edward Minchin, AWS , MWS *Tree Support* 21" x 29" Watercolor & Acrylic

Tree Support began with simple vigorous spontaneous transparent watercolor washes on pre-wetted Arches™ cold press paper. Without a subject or composition in mind, I applied stronger colors, then switched to acrylic transparent and opaque paints. In this case, I allowed the painting to lead, looking only for shapes that appeared to flow from one color or value to another, giving the painting a cohesiveness. To maintain the purity of the colors, I kept the warm and cool colors separate. After locating the large dominant shape, I finished the painting by applying fine free-flowing directional lines. At no time did I try to push the painting into any form of realism. Only after considering the painting was finished did I discover the subject and gave it a title.

Man Made Structures

I began experimenting with ways to apply color without using brushes.

Nancy Fortunato *Pattern Makers* 18" x 20" Watercolor

When it comes to watercolor, I'm inclined to ignore tried-and-true methods in favor of new challenges. Several years ago I began experimenting with ways to apply color without using brushes. This led to my fascination with what I refer to as "poured paintings." My "pouring" technique, consists of applying paint by spraying, spattering, and pouring it onto the paper after masking off the design. I have found that this allows the work to retain a very spontaneous feeling and produces clear, transparent color.

Pattern Makers began with much mental preparation. I had to visualize the finished product in my mind so that I would know what the colors and shapes would look like. I kept simplifying and working out the patterns and compositional requirements. I envisioned how the light bathes the space and in turn gives form to the shapes. The negative space was considered as carefully as the positive space. The figures in *Pattern Makers* had to be redone three times before I was satisfied.

I enjoy the rich texture and colors that Nature gives old equipment throughout years of wear.

William Borden *Rachet* 20" x 29" Watercolor

This section of farm equipment was part of a large collection of old and broken implements stored behind a northern Michigan flea market. I don't know what kind of work it was created to do. Whatever its original purpose, its reason for existence is long past. It seemed to be waving with an outstretched arm to attract my attention, and that was all it took. I enjoy painting the interesting shapes of farm equipment which some forgotten engineer designed long ago for some specific work, also forgotten. I enjoy the rich texture and colors that Nature gives old equipment throughout years of wear. I'm happy I found *Rachet* and was able to capture part of it to pass along.

I was trying to teach my students how to make a watercolor painting look like it's melting.

Jerry Stitt, NWS *Golden Gate* **20" x 26" Watercolor**

Golden Gate was painted during an on-site workshop class. I was trying to teach my students how to make a watercolor painting look like it's melting.

146

I used a resist to block out the staging and brilliant reflections from the sun on the piers, and I muted the columns with a touch of ivory black to soften the greenish-gray.

Casey Whitten *Bridges are America's Cathedrals* 22" x 30" Watercolor & Gouache

A lifelong fascination with boats and marine activities led me to do a series of paintings depicting the New Roosevelt Bridge in Stuart, Florida. While boating, my husband and I took many interesting photos during the construction. This is one of our favorites.

From beneath the bridge, the sight was awesome, reminding me of a great cathedral. The strong diagonals with the bright crane just off center presented an interesting and challenging composition. I used a resist to block out the staging and brilliant reflections from the sun on the piers, and I muted the columns with a touch of ivory black to soften the greenish-gray. I overlaid the smokestacks with gesso, covered them with gouache and brightened them with Daniel Smith's Quinacridone Gold, giving them a special texture and glow that helped this painting win an award the first time it was shown at the Art Associates of Martin County's 30th Anniversary Exhibit.

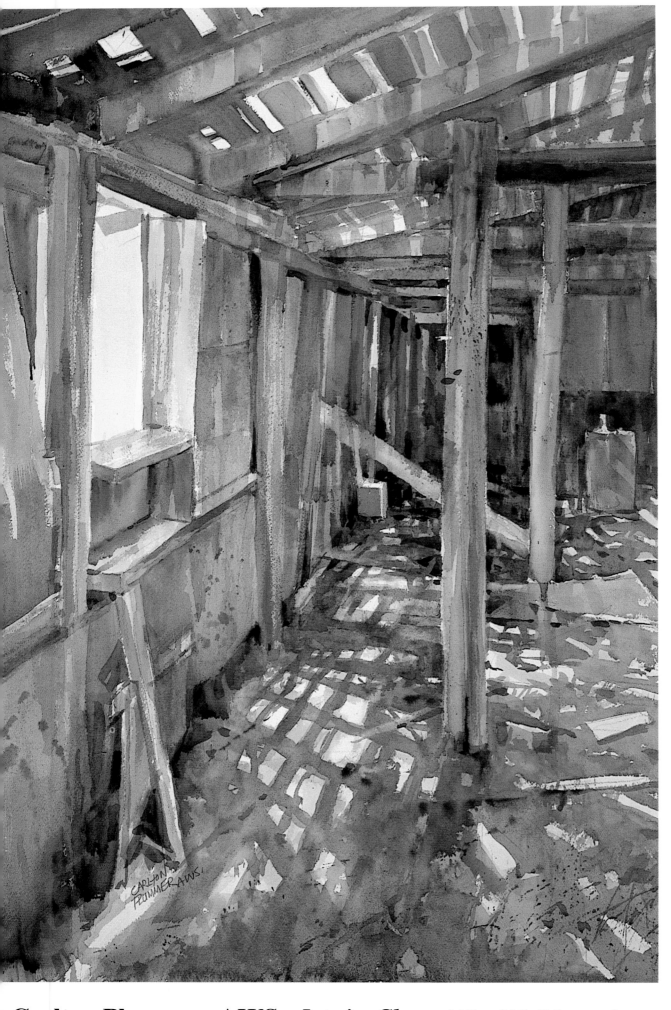

Interior Glow evolved as a result of my teaching a workshop in Pocatello, Idaho. The class gathered at a huge derelict barn on a mountainside where I demonstrated the dynamics of lighting. Light and dark patterns from filtered sunlight through openings in the barn roof combined with a maze of intersecting vertical, horizontal and diagonal beams to create drama and mystery. Complements of warm and cool colors play against each other, adding more spice to the situation. Depth was augmented by the strong perspective angle which leads the viewer back into the composition.

Carlton Plummer, AWS *Interior Glow* 22" x 30" Watercolor

It was this quality of light and shadow which appealed to me as the subject for a painting.

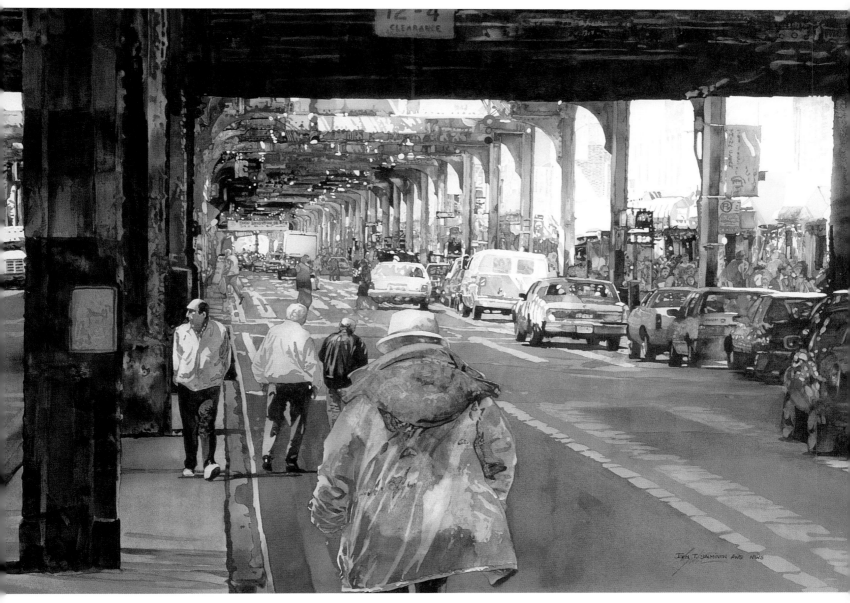

John T. Salminen, AWS, NWS, MWS *Brighton Beach Ave.* 30" x 40" Watercolor

This scene beneath the elevated train tracks is one of activity and daily commerce in the bustling "Little Odessa" section of Brooklyn. The inhabitants appear oblivious of the dappled light falling on them as the sun filters through the latticework of the overhead structure. It was this quality of light and shadow which appealed to me as the subject for a painting. The delicate light patterns contrast with the massive solidity of the elevated trestle. The figures provide scale.

Brighton Beach Ave. is painted on Arches™ 140 lb. cold pressed paper which I purchase in long rolls (44" x 10 yards) to allow me to paint in a larger format. I used an eraser on the damp surface to add texture to the man's jacket in the foreground. This paper holds up very well when this technique is used.

Town & Country

As the brilliant sun penetrates the mist, the air takes on a visible quality blurring the distant figures and buildings.

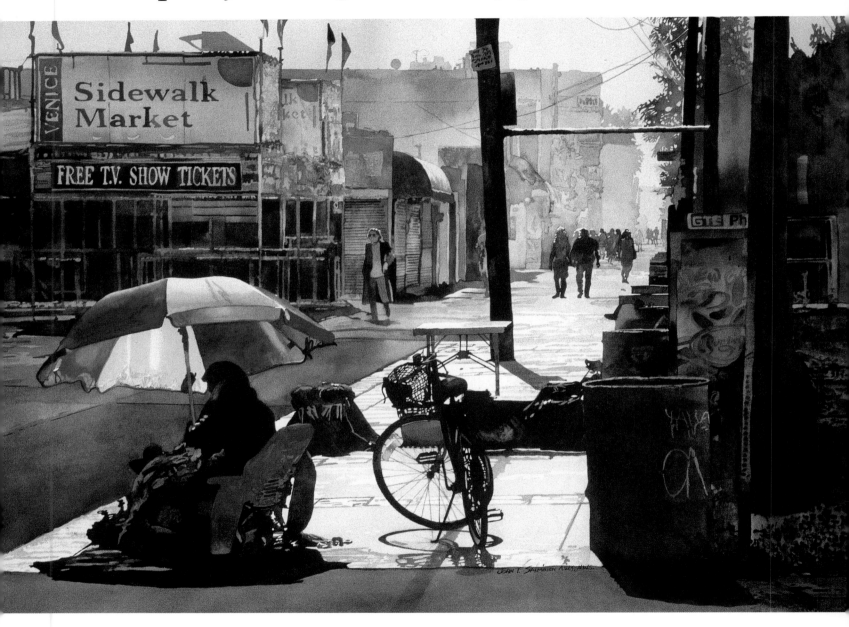

John T. Salminen, AWS, NWS, MWS *Venice, California* 30" x 40" Watercolor

I tried to capture the quality of light which is unique to the California coast. The atmosphere, heavy with early morning moisture is rolling in from the Pacific Ocean. As the brilliant sun penetrates the mist, the air takes on a visible quality blurring the distant figures and buildings. The warmth of the sun envelopes the street vendor. The illusion of depth is strengthened by the sharp focus of the vendor's sun-lit umbrella.

Venice, California is painted on Arches™ 140 lb. cold pressed paper I purchase in long rolls (44" x 10 yards) to allow me to work in a larger format. I prefer this paper because of its durability when subjected to lifting techniques.

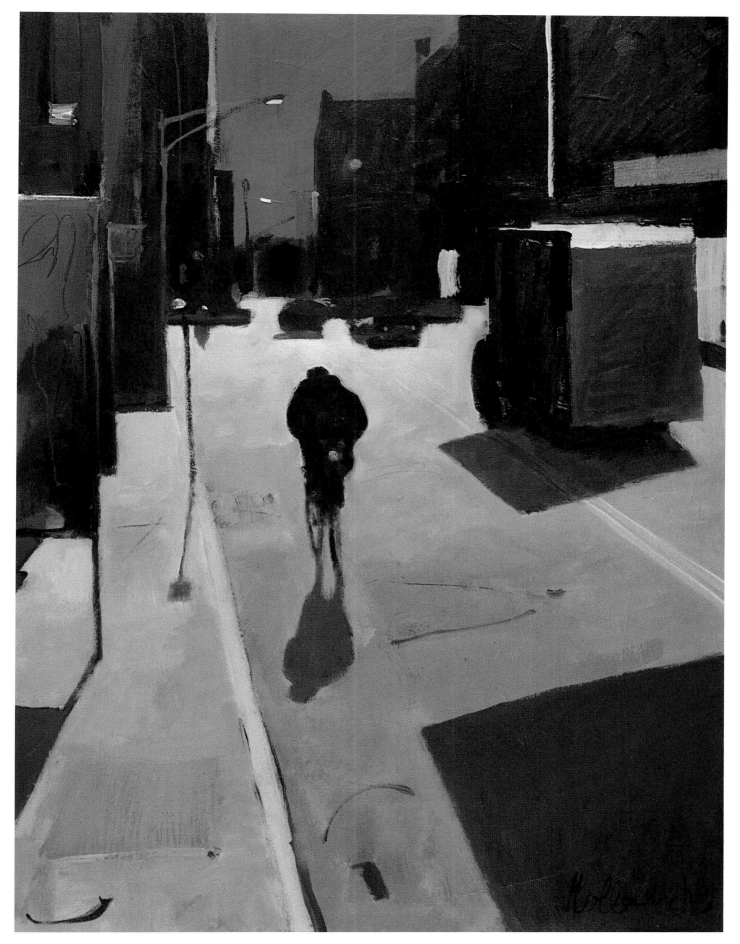

Serge Hollerbach, AWS *City Shadows* **30" x 40" Acrylic**

Art can be many things, but directly or indirectly it always describes the human condition. I consider myself a witness, a recorder of the various physical and emotional conditions we experience in our lives.

I focused on the smaller areas and periodically looked from a distance to make sure they flowed together.

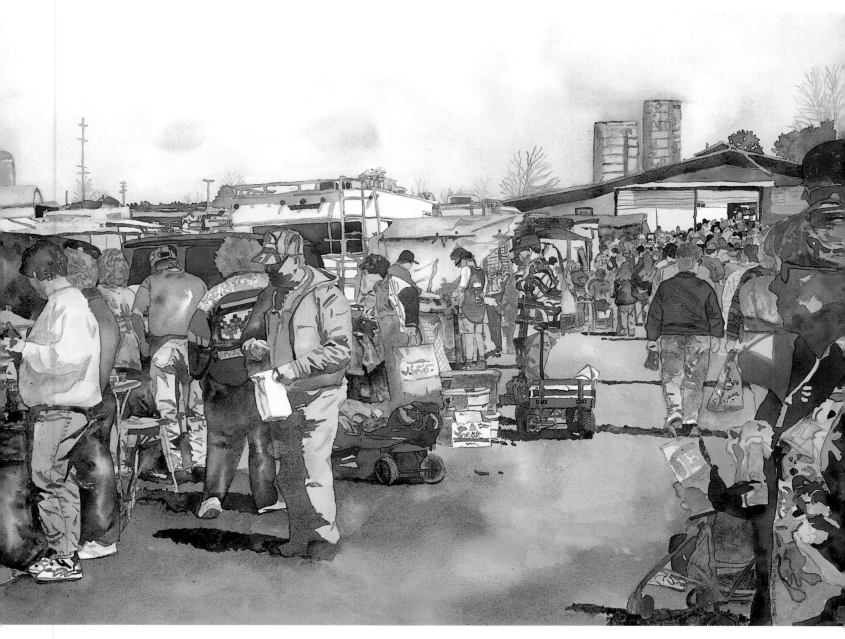

Susan M. Vitali *Treasure Hunt #2* 22" x 30" Watercolor

I enjoyed both painting the patterns found in *Treasure Hunt #2* and organizing the shapes, values and colors to work together in a complicated subject. I focused on the smaller areas and periodically looked from a distance to make sure they flowed together. The subject was drawn from a photo I took at a flea market associated with the Amish Quilt Auction in Clare, Michigan. This painting is about people interacting with others, and searching for treasures.

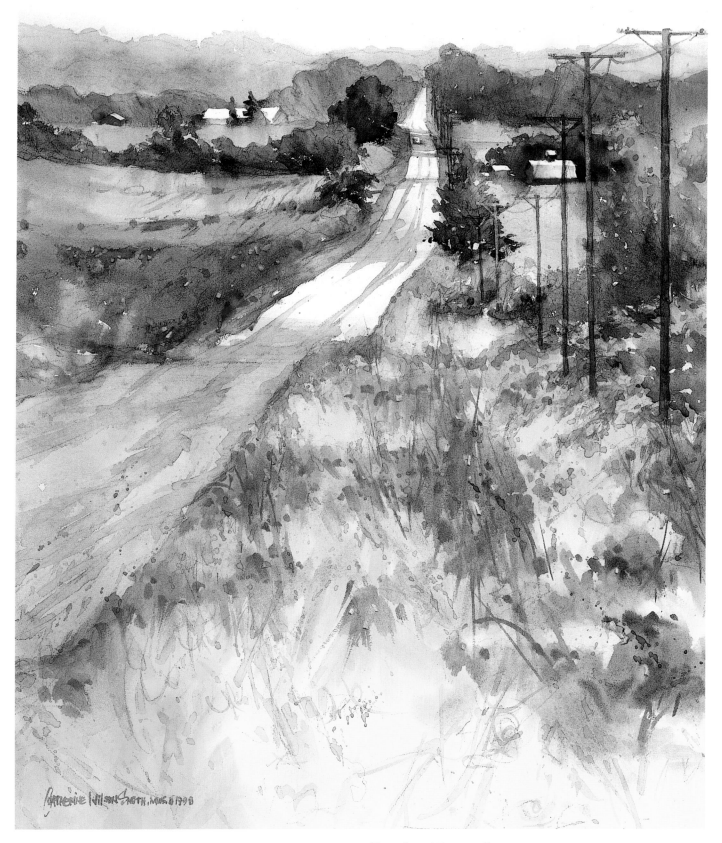

Catherine Wilson Smith, MWS *Satin Road* 22" x 29" Watercolor

Satin Road is an example of how I like to transform a subject. The road symbolizes more than an engaging shape that ushers the viewer into a painting. It represents my own sense of adventure. I like to travel roads that lead me to "communion-like" experiences with the land. Such intimacy can transform a mundane subject. Often taking an entire day to take photographs, I like to walk the land and fully experience it. I depend on all my senses, allowing myself to become saturated with useful information which will help me personalize the experience.

Light and color can also transform a subject. Beginning on a saturated sheet, I use pure, primary colors, allowing them to move and mix on the surface. This approach promoted the condition of filtered light, while showing off the vibrant colors.

I'm always drawn to high contrast, vivid colors and subjects that lend themselves to an intimate approach.

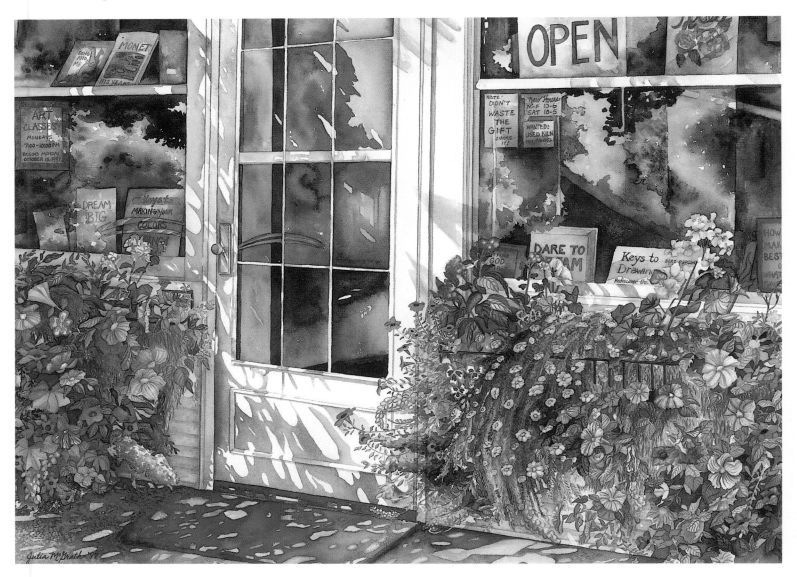

Julia D. McGrath *Reflections of Leland* 31" x 37" Watercolor

When I look for a subject to paint, I'm always drawn to high contrast, vivid colors and subjects that lend themselves to an intimate approach. I choose something I can zoom in on and make more personal.

In ***Reflections of Leland***, rather than make it a painting about the store front itself, I chose to make it an allegorical painting of a part of myself. Perhaps a "reflection" of my inner thoughts.

Emotionally stirred by the beauty and bounty of the flower boxes, as well as the dance of the sunlight and shadows on the surfaces, I personalized some of the books in the windows by making my thoughts the titles of the books.

*The key to successful painting is in the planning,
but don't overplan or you may lose your
enthusiasm for the subject.*

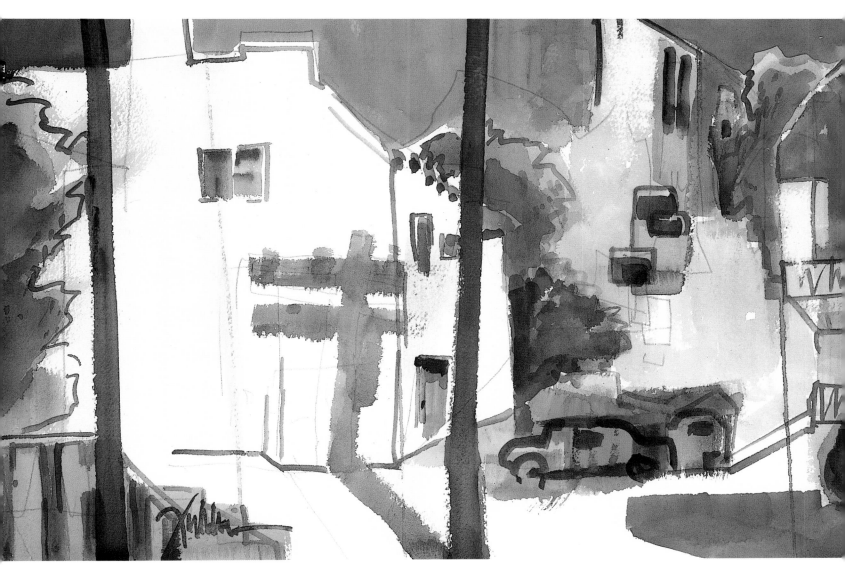

Henry Fukuhara, NWS *Shadow* 18" x 24" Watercolor

One sunny morning in Venice, California, I turned the corner, and there it was. The bright sun was casting the solitary shadow of the telephone pole. I knew this scene must be painted. I looked for the large shape to anchor the secondary shapes and did a value study. While doing this, I thought: *simplify, simplify*. When I paint, the details are the last thing I think about. Frank Webb teaches: "Plan to fail if you don't plan." The key to successful painting is in the planning, but don't overplan or you may lose your enthusiasm for the subject.

Calligraphy

"I must do my own work and live my own life in my own way because I'm responsible for both." Rudyard Kipling

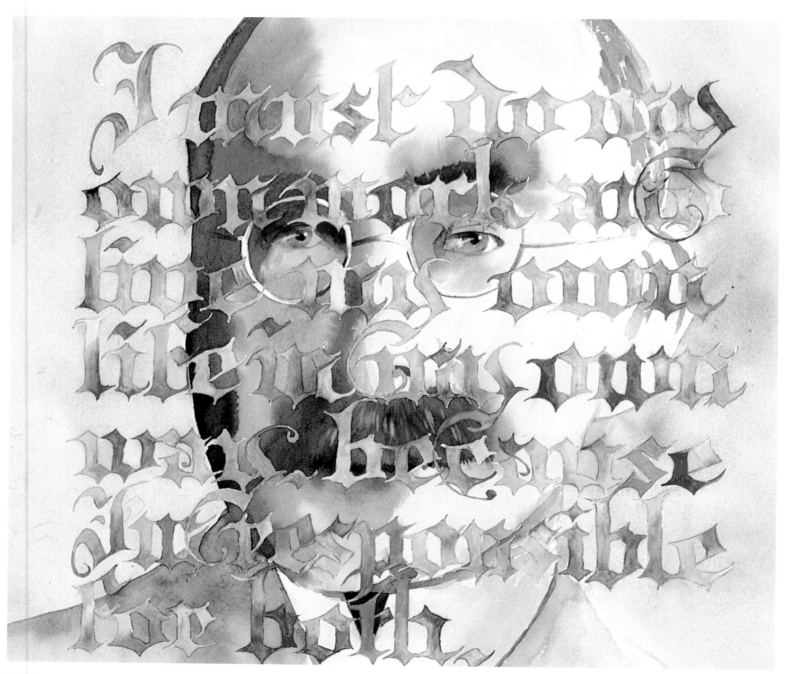

Dick Green, MWS *Words of Kipling* **19" x 21" Watercolor**

In this painting I felt the emphasis should be on the words. I first placed clear water on each letter and then dropped in a variety of pigments which were left to mix naturally, allowing for a unified appearance. By keeping the application of pigment transparent the words seem to glow. Neutral Hue was reserved for the image of Kipling.

I love the medium's spontaneity, fluidity and portability.

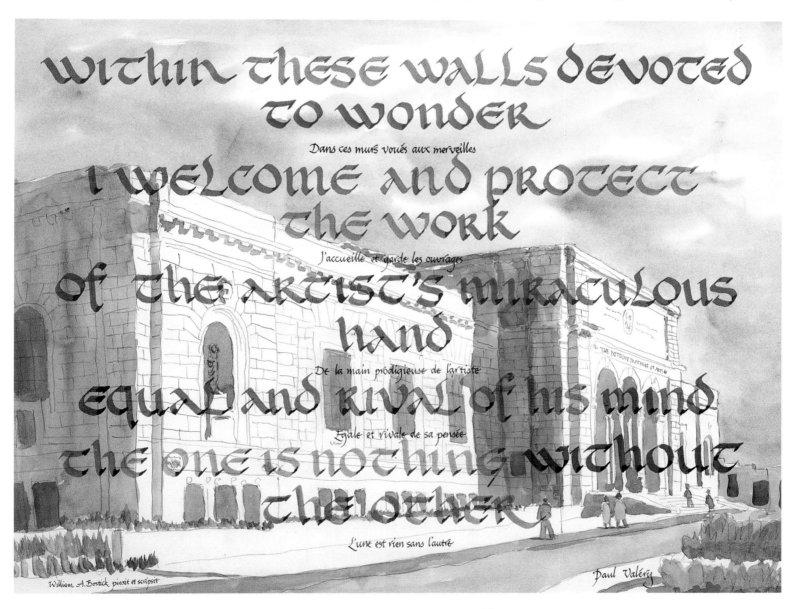

Within these walls devoted to wonder
Dans ces murs voués aux merveilles
I welcome and protect the work
J'accueille et garde les ouvrages
of the artist's miraculous hand
De la main prodigieuse de l'artiste
equal and rival of his mind
Égale et rivale de sa pensée
the one is nothing without the other
L'une est rien sans l'autre

William A. Bostick, pinxit et scripsit Paul Valéry

William A. Bostick *Within these Walls* 22" x 28" Watercolor

Within these Walls embodies a number of interests which are very important to me: watercolor, calligraphy, the Detroit Institute of Arts and French culture. I've been painting watercolors for 63 years. I love the medium's spontaneity, fluidity and portability. I started doing calligraphy about 40 years ago, but only recently have I combined it with my painting. For 30 years I was Administrator and Secretary of the Detroit Institute of Arts and for about half this period I also managed its Annual Exhibition for Michigan Artists, so that this great museum is sort of my artistic alma mater.

The poignant words of the eminent French essayist Paul Valéry who wrote "Within these Walls" for the opening of a new French museum, seemed to unite all these disparate elements in a tribute to the art museum's role in preserving and glorifying the product of the artist's hand and mind in a way that a painting alone could not.

The Artists

Gerald J. Fritzler, AWS, NWS, MWS, Box 253, Mesa, CO 81643
p. 99 — *The Bells of Santorini* © Gerald J. Fritzler
collection of Walter Gray/Dan Blanchard
Henry Fukuhara, NWS, 1214 Marine St., Santa Monica, CA 90405
p. 155 — *Shadow* © Henry Fukuhara, collection of Richard Harris
Betty Ganley, 713 Forest Park Rd., Great Falls, VA 22066
p. 92 — *La Plumage* © Betty Ganley, collection of the artist
Carolyn Grossé Gawarecki, NWS,
7018 Vagabond Dr., Falls Church, VA 22042
p. 98 — *Greek Idyll* © Carolyn Grossé Gawarecki
collection of Rona Loiederman, Potomac, Maryland
p. 12 — *Starred Pears* © Carolyn Grossé Gawarecki
collection of the artist
Jean Grastorf, AWS, NWS, MWS
6049 4th Ave. North, St. Petersburg, FL 33710
p. 103 — *Palm Pattern* © Jean Grastorf, collection of the artist
Dick Green, MWS, 4617 Southmore Dr., Bloomington, MN 55437
p. 111 — *Don't Bug Me* © Dick Green, collection of the artist
p. 156 — *Words of Kipling* © Dick Green
courtesy of Dunnegan Gallery of Art, Bolivar, Missouri
Greta Greenfield, MWS, 5545 Flagstaff Rd., Boulder, CO 80302
p. 57 — *Moonlit Mountain* © Greta Greenfield
collection of the artist
Elaine Hahn, AWS, NWS, 8823 Lakehill Dr., Lorton, VA 22079
p. 8-9 — *Reflections* © Elaine Hahn
collection of Coconut Grove Art Fair Association, Miami, Florida
p. 55 — *Somethings Missing* © Elaine Hahn
collection of the artist
Mitzie Jean Hale, 16425 Skyridge Lane, Fountain Hills, AZ 85268
p. 30 — *Jessica in a Field of Sunflowers* © Mitzie Jean Hale
collection of Roberta Hale
Elaine L. Harvey, NWS, 1602 Sunburst Dr., El Cajon, CA 92021
p. 129 — *Getting into his Work* © Elaine L. Harvey
collection of the artist
Bill Herring, Box 223, Clint, TX 79836
p. 74 — *Guadalupe Mountains* © Bill Herring
collection of the artist
p. 60 — Snow Mountain © Bill Herring, collection of the artist
Lori Hollenbeck,
Merriehill, Bibbys Ln., Macclesfield, Cheshire UK, SK10, 2PJ
p. 88 — *Honeysuckle* © Lori Hollenbeck, collection of the artist
Serge Hollerbach, AWS, 304 West 75th St., New York, NY 10023
p. 29 — *Blond Girl with Newspaper* © Serge Hollerbach
collection of the artist
p. 151 — *City Shadows* © Serge Hollerbach, collection of the artist
Sook-Kyung Hong, 34601 Princeton, Farmington Hills, MI 48331
p. 11 — *Peppers II* © Sook-Kyung Hong, collection of the artist
p. 78 — *Still Life #4* © Sook-Kyung Hong
collection of Mr. and Mrs. J. Y. Park
Laura Whitesides Host, 639 Puritan, Birmingham, MI 48009
p. 137 — *Home Sweet Home* © Laura Whitesides Host
collection of the artist
Rebecca Houck, 4440 S. Nine Mile Road, Auburn, MI 48611
p. 65 — *Sunrise/Sunset* © Rebecca Houck
collection of the artist
Yumiko Ichikawa, 1706 Downey St., Radford, VA 24141
p. 16 — *Imari & Lilies* © Yumiko Ichikawa
collection of the artist
Taylor Ikin, 4513 Lumb Ave., Tampa, FL 33629
p. 51 — *Hide & Seek* © Taylor Ikin
collection of Harrod Properties, Tampa, Florida
Paul C. Jackson, 2918 Bluegrass Court, Columbia, MO 65201
p. 22-23 — *The Collector* © Paul C. Jackson
collection of the artist

Joan Painter Jones, 7050 Talladay, Milan, MI 48160
p. 123 — *Childhood* © Joan Painter Jones
collection of the artist
Edee Joppich, 24923 Springbrook, Farmington Hills, MI 48334
p. 115 — *Break the Rules* © Edee Joppich
collection of Jacqueline Killingsworth
p. 46 — *Miles to Go - SFO* © Edee Joppich
collection of the artist
Danguole Jurgutis, 32484 Chesterbrook, Farmington Hills, MI 48334
p. 133 — *Beyond It All* © Danguole Jurgutis
collection of the artist
p. 132 — *Lake Michigan Dunes* © Danguole Jurgutis
collection of — private collection
M. C. Kanouse, 6346 Tahoe Lane SE, Grand Rapids, MI 49546
p. 113 — *Huerta's Chickens* © M. C. Kanouse
collection of — private collection
p. 85 — *Trillium* © M. C. Kanouse
collection University of Michigan
Susan Kell, 1955 Vianne, Rochester Hills, MI 48309
p. 134 — *Revealed* © Susan Kell, collection of the artist
Margaret Graham Kranking, NWS, MWS
3504 Taylor St., Chevy Chase, MD 20815
p. 21 — *Morning Light, Charleston* © Margaret Graham Kranking
collection Commander and Mrs. David W. Kranking
Robbie Laird, 712 West Mt. Ridge Rd., Lake Almanor, CA 96137
p. 67 — *Haleakala Sunrise* © Robbie Laird
collection of the artist
p. 66 — *Volcano in the Mist* © Robbie Laird
collection of the artist
Douglas Lew, MWS, 4382 Browndale Ave., Edina, MN 55424
p. 32 — *Bahama Girl* © Douglas Lew, collection of the artist
Maggie Linn, AWS, 921 N. Front St., Marquette, MI 49855
p. 86 — *Water Lily Ballet* © Maggie Linn
collection of Mr. & Mrs. Robert Weber, Marquette, Michigan
Vivian Longfellow, 14401 Huron, Taylor, MI 48180
p. 97 — *Road to Monet's Garden* © Vivian Longfellow
collection of Ed and Mary Haasch, Tarpon Springs, Florida
Joseph Maniscalco, 5232 Mirror Lake Ct., Orchard Lake, MI 48323
p. 34 — *Jay* © Joseph Maniscalco, collection of the artist
Willellyn McFarland, NWS, 7937 E. 4th Place, Downey, CA 90241
p. 69 — *Catalina Hillside* © Willellyn McFarland
collection of Mr. and Mrs. Ed Welz
Julia D. McGrath, 1980 Dunhill Dr., Milford, MI 48381
p. 104 — *La Vista de mi Curato* © Julia D. McGrath
collection of Janis Madias
p. 154 — *Reflections of Leland* © Julia D. McGrath
collection of — private collection
Joan McKasson, 7976 Lake Cayuga Dr., San Diego, CA 92119
p. 83 — *Sunflowers & Thistles* © Joan McKasson
collection — private collection
p. 80 — *Windswept Poppies* © Joan McKasson
collection — private collection
Geraldine McKeown, NWS, 227 Gallaher Road, Elkton, MD 21921
p. 105 — *Seaside Scales* © Geraldine McKeown
collection of the artist
Edward Minchin, AWS, MWS, PO Box 160, Rockland, MA 02370
p. 81 — *Iris Splendor* © Edward Minchin, collection of the artist
p. 143 — *Tree Support* © Edward Minchin
collection of the artist
Linda Banks Ord, 11 Emerald Glen, Laguna Niguel, CA 92677
p. 31 — *Florence Series, #2* © Linda Banks Ord
collection of the artist
p. 35 — *The Louvre Series, #2* © Linda Banks Ord
collection of the artist

Sheila B. Parsons, 1805 Hillman St., Conway AR 72032
 p. 110 — *Bien Venido* © Sheila B. Parsons, collection of the artist
Jim Patterson, 5529 Walnut Circle West, West Bloomfield, MI 48322
 p. 87 — *Bright Bouquet* © Jim Patterson
 collection of — private collection
Carolyn H. Pedersen, NWS, MWS, 119 Birch Lane, New City, NY 10956
 p. 138 — *Inner Symphony* © Carolyn H. Pedersen
 collection of Dr. and Mrs. Barry Friedman
Dan Petersen, NWS, 23294 Indian Well Ct., Ripon, CA 95366
 p. 58 — *Ring of Gold* © Dan Petersen
 collection of Dr. and Mrs. James Curl
Carlton Plummer, AWS, 10 Monument Hill Rd., Chelmsford, MA 01824
 p. 148 — *Interior Glow* © Carlton Plummer, collection of the artist
Joan Plummer, 10 Monument Hill Rd., Chelmsford, MA 01824
 p. 24 — *Frangible Lights* © Joan Plummer, collection of the artist
Cathy Quiel, P. O. Box 61353, Santa Barbara, CA 93160
 p. 27 — *Submerged I* © Cathy Quiel, collection of Richard Scott
 p. 42 — *Three Men Tall* © Cathy Quiel, collection of the artist
Audrey Sanders Ratterman, 6763 Yarborough, Shelby Twp., MI 48316
 p. 19 — *Glass & Lace* © Audrey Sanders Ratterman
 collection — private collection
Roland Roycroft, AWS, MWS, 8479 Orchard Hill Rd., Beulah, MI 49617
 p. 64 — *Changing Seasons* © Roland Roycroft
 collection of the artist
Arleen Ruggeri, NWS, 3314 Music Lane, Grand Junction, CO 81506
 p. 75 — *Patchwork & Leather* © Arleen Ruggeri
 collection of Nancy and Carl Costello
John T. Salminen, AWS, NWS, MWS, 6021 Arnold Rd., Duluth, MN 55803
 p. 149 — *Brighton Beach Ave.* © John T. Salminen
 collection of Thomas L. Kraig
 p. 150 — *Venice, California* © John T. Salminen
 courtesy of Bryant Galleries, Jackson, Mississippi
Evelyn Ecale Schultz, 550 Edgewood Ave., Elmhurst, IL 60126
 p. 121 — *Square Man* © Evelyn Ecale Schultz
 collection of Robin & Jim Brower, Elmhurst, Illinois
Marilyn Schutzky, 7340 East Turquoise Ave., Scottsdale, AZ 85258
 p. 79 — *Magnolia Grove* © Marilyn Schutzky, collection of the artist
 p. 91 — *A Rose is a Rose* © Marilyn Schutzky
 collection — private collection
Mei Shu, 1006 Walker Dr., Radford, VA 24141
 p. 84 — *Lilac in a Vace* © Mei Shu, collection of the artist
Catherine Wilson Smith, MWS, 9N273 Oak Tree La., Elgin, IL 60123
 p. 153 — *Satin Road* © Catherine Wilson Smith
 courtesy of Gallery at Salishan, Glen Eden Beach, Oregon
Patsy Smith, NWS, 821 Apache Dr., North Platte, NE 69101
 p. 124 — *Royal Enchantment* © Patsy Smith, collection of the artist
Mary Ann Staples, 1930 East Gonzales St., Pensacola, FL 32501
 p. 122 — *Summer Fantasy* © Mary Ann Staples
 collection of the artist
Jerry Stitt, NWS, 1001 Bridgeway #225, Sausalito, CA 94965
 p. 146 — *Golden Gate* © Jerry Stitt, collection of the artist
Deanna Thibault, 1566 W. San Lucas Dr., Tuscon, AZ 85704
 p. 71 — *Landshapes III* © Deanna Thibault
 collection of the artist
Gwen Tomkow, NWS, PO Box 2263, Farmington Hills, MI 48333
 p. 72 — *Path in the Night* © Gwen Tomkow
 collection of Linda J. Lane
 p. 73 — *Velvet Dunes* © Gwen Tomkow, collection of Eric Kohls
Linda J. Chapman Turner, MWS, Rt. 2 Box J, Jane Lew, WV 26378
 p. 45 — *Water Nymph* © Linda J. Chapman Turner
 collection of the artist
 p. 26 — *White Wash* © Linda J. Chapman Turner
 collection of the artist

Christine M. Unwin, NWS
 6850 Brookshire Dr., West Bloomfield, MI 48322
 p. 2 — *Maui Memory* © Christine M. Unwin,
 collection of the artist
 p. 6 & 7 — *Peonies* © Christine M. Unwin, collection of the artist
 p. 15 — *Cathy's Vegetables, Santa Fe* © Christine M. Unwin
 collection of Cathy Rudy and John Selkirk
 p. 39 — *Nonna* © Christine M. Unwin, collection of the artist
 p. 44 — *Amalfi Sun Worshipper* © Christine M. Unwin
 collection of the artist
 p. 95 — *Malta* © Christine M. Unwin, collection of the artist
 p. 102 — *Caribbean Boat Man* © Christine M. Unwin
 collection of the artist
 p. 131 — *Dinosaurs* © Christine M. Unwin, collection of the artist
 p. 139 — *Southwest Rhythm* © Christine M. Unwin, collection of the artist
Karen Carter Van Gamper, 5085 Buckingham Place, Troy, MI 48098
 p. 96 — *Mackinaw City Marina* © Karen Carter Van Gamper,
 collection of the artist
Susan Vitali, 43783 Park Grove, Northville, MI 48167
 p. 18 — *High Tea* (prints available) © Susan Vitali
 collection of the artist
 p. 152 — *Treasure Hunt #2* © Susan Vitali, collection of the artist
Donna M. Vogelheim, NWS, 36419 Saxony, Farmington, MI 48335
 p. 119 — *A House Divided* © Donna Vogelheim
 collection of the artist
 p. 17 — *Pterodactyl Apples* © Donna Vogelheim
 collection of Aretha Franklin
Mary Joan Waid, 61 Crosby Street, New York, NY 10012
 p. 38 — *Grandmother's Mirror* © Mary Joan Waid
 collection of the artist
Carol Wallace, 48 West Hill Road, Winsted, CT 06098
 p. 50 — *Strange Encounters of the Tropical Kind* © Carol Wallace
 collection of the artist
Marsha Stoddard Weigand, 22207 Innsbrook Dr., Northville, MI 48167
 p. 125 — *Familial Portrait* © Marsha Stoddard Weigand
 collection of the artist
Casey Whitten, 4180 SE Buoy Lane, Stuart, FL 34997
 p. 147 — *Bridges are America's Cathedrals* © Casey Whitten
 collection of — private collection
Gerry Willging, 5026 Silver Arrow Dr., Rancho Palos Verdes, CA 90275
 p. 142 — *Rockport* © Gerry Willging
 collection of the artist
Douglas Wiltraut, 969 Catasauqua Road, Whitehall, PA 18052
 p. 47 — *Reds* © Douglas Wiltraut, collection of Raymond E. Holland
Bernyce Alpert Winick, AWS, 923 Beth Lane, Woodmere, NY 11598
 p. 90 — *Cantábile* © Bernyce Alpert Winick
 collection of the artist
Yvonne Wood, 3 Babcock Rd., Rockport, MA 01966
 p. 126 — *Playing Their Quiet Song* © Yvonne Wood
 courtesy of Jill Spanbauer Gallery, Naples, Florida
Lynne Yancha, AWS, RR #1, Box 223-AA, Mt. Pleasant Mills, PA 17853
 p. 43 — *Interwoven Memories* © Lynne Yancha
 collection of — private collection
 p. 76 — *My Eirik* © Lynne Yancha
 collection of Dan and Anna Ruth Martin, York, Pennsylvania
Peggy Zehring, P. O. Box 967, LaVeta, CO 81055
 p. 116 — *Uxmal* © Peggy Zehring, collection of the artist
Barbara Zimmerman, 3719 McKeith Rd., Midland, MI 48642
 p. 136 — *Enigma* © Barbara Zimmerman, collection of the artist
 p. 120 — *Mamacita Por Favor* © Barbara Zimmerman
 collection of the artist

AWS = Signature Member of the American Watercolor Society
NWS = Signature Member of the National Watercolor Society
MWS = Signature Member of the Midwest Watercolor Society

Watercolor Workshop Video
"LOOSEN UP AND LET IT FLOW"
A Complete Watercolor Workshop

Includes demos of floral, collage, abstract, still life, and landscape painting plus critiques of student's work. Consists of three volumes, each 1 ½ hours long and includes critiques of actual student's work done at Chris' Taos, New Mexico and Tucson, Arizona workshops. The video workshop is suitable for all levels of painters. It begins with basic watercolor techniques and quickly moves to more advanced techniques. The student is prompted to stop the video and try each technique at the end of each lesson. The student benefits from the critiques of other students work when they see how other students interpreted the lessons. It's almost like being present at a live workshop.

3 Volume Set - $199.00 + $6.00 S & H - Individual Volumes - $69.50 + $3.50 S & H each

Other Books by Creative Art Press

Chris Unwin's: The Artistic Touch
ISBN No. is 0-9642712-0-6 - $29.95 + $3.50 S&H

"This lavishly illustrated volume would be worth its price even without the text. It's fun reading."

American Artist Magazine

Chris Unwin's: The Artistic Touch 2
ISBN No. is 0-9642712-1-4 - $29.95 + $3.50 S&H

"This gorgeous book will entrance watercolorists at all levels with its richly varied and one-of a kind collection of fine watercolor paintings . . . more than just a one-time instructional manual. The outstanding, emotive quality that characterizes all of the artwork gracing these pages nurtures the creative soul and begs to be revisited again and again."

The Artist's Magazine

Children's Books

Marsha Heatwole's: Jambo, Watoto! (Hello, Children!)
ISBN No. is 0-9642712-3-0 $15.95 + $2.25 S&H

Exceptional — "Children between the ages of four and eight will identify with the cheetah's struggle between freedom and obedience and delight in the whimsical drawings and lively text infused with African words (defined in a glossary) . . . Marsha Heatwole magically captures each of the cheetah's unique personalities (bossy, gentle, bored and lazy) in her paintings."

ForeWord Magazine

Marsha Heatwole's: Primary Cats
ISBN No. is 0-9642712-2-2 $7.95 + $2.25 S&H

"From the vivid cover . . . to the turn of the last page, children (ages 4-6) will be delighted by the antics of these fun-loving felines . . . perfect for . . . a child's understanding of colors."
Reviewer's Choice — Children's Bookwatch — Midwest Book Review

To order books, videos, or to register for one of Chris Unwin's art workshops in the United States, Europe, or on one of her cruise workshops, call:

1-800-750-7010